JFK

Remembered

JFK
Remembered

Jacques Lowe

With a foreword by Arthur Schlesinger, Jr.

Random House, New York

LIBRARY OF CONGRESS CATALOGING-IN-PUBLICATION DATA

JFK remembered / Jacques Lowe. — 1st ed.

p. cm.

ISBN 0-679-42399-0

1. Kennedy, John F. (John Fitzgerald), 1917–1963 — Pictorial works. 2. Presidents — United States — Pictorial works. I. Title.

E842.1.L64 1993

973.922'092 — dc20 93-4181

[B]

Design: Joseph Guglietti

Manufactured in Italy

98765432

First Edition

To my children Sacha, Thomasina, and Kristina with love

Foreword

When I served in the White House an eon ago as a special assistant to President Kennedy, I became gradually aware of a spritelike presence hovering quietly on the edge of historic scenes, camera in hand, unobtrusively creating a record for posterity. Wholly lacking the paparazzi arrogance that marks the photocracy of our age — "Look here," "Stand there," "Sit down," "Get up," "Smile" — orders casually barked at presidents, popes, and dictators — Jacques Lowe was monumentally self-effacing. This, I believe, is why his camera caught so much human truth. There are no orchestrated "photo opportunities" here. One was hardly aware that he was in the room. Instead of rising to an imperious lens like fish to a lure, people went about their business and remained their natural selves.

I soon recognized in Jacques Lowe a fellow historian. His passion was to record actualities — not to reconstruct them for the sake of a prettier photograph. And, though writers like to reverse the Chinese proverb and say that one word is worth a thousand pictures, we secretly know how potent pictures are — how much Brady, for example, controls our images of the Civil War.

To say that John Kennedy and his family were photogenic has a smack of condescension, a trivializing effect. He was a serious man — at least, he took his responsibilities seriously, though never himself. He was urgently concerned with momentous issues — avoiding nuclear war, restraining the arms race, reducing Soviet-American tensions, achieving racial justice, fighting poverty and want, offering hope and role to the young. He believed in the power of reason to reach tolerable resolutions of intolerable problems. He was reserved, meditative, often solitary — all moods marvelously caught by Jacques Lowe's camera. He was an ironist in his slant on himself and history, but was also an optimist; and he never permitted irony to sever the nerve of action.

Above all, he enjoyed the Presidency. Like Theodore and Franklin Roosevelt, like (it must be allowed) Ronald Reagan, he had fun in the White House. Enjoying the Presidency is not an irrelevancy. The sense that the President is in good humor buoys and reassures a nation. All this Jacques has recorded too.

And he has done all this as a historian, not as a press agent. Contrary to the myth, Kennedy wasted no time fabricating images. He was a relaxed man, secure and imperturbable, who gambled on himself and felt no need for hype. In Jacques Lowe he found the photographer who gave the natural rhythms of the Kennedy White House enduring form.

Arthur Schlesinger, Jr.

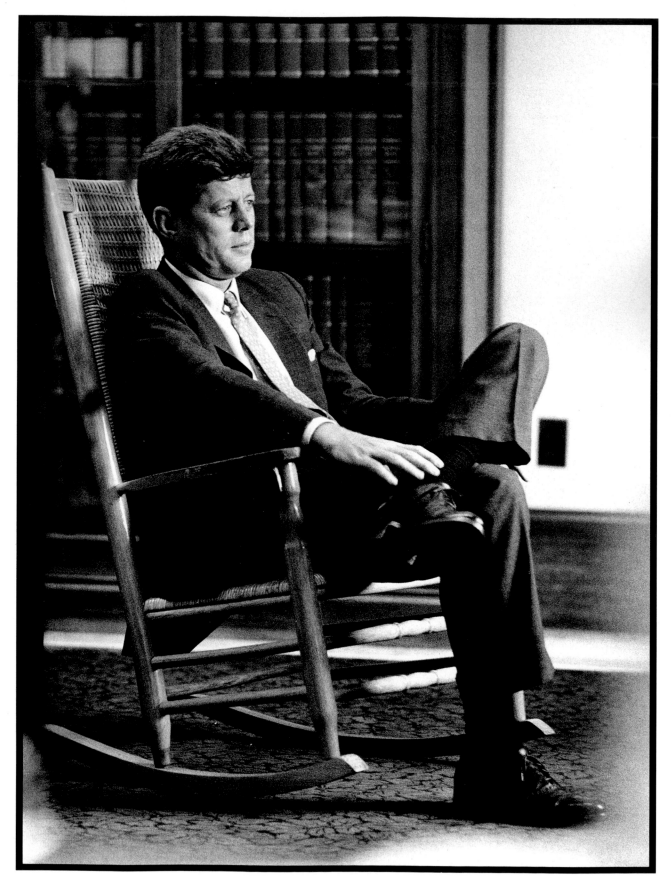

SENATOR JOHN F. KENNEDY IN HIS SENATE OFFICE, ROOM 362. FALL 1958

Over the years the rocking chair became a symbol of the Kennedy years. But the chair had a deeper purpose. Kennedy had suffered from severe back troubles ever since his PT-109, his command ship, was sliced in half by a Japanese destroyer during World War II, and the chair was vital in relieving his recurring pain. In 1954 he had undergone a lumbar spine operation. It had failed. An infection set in, and he received the Catholic Church's last rites. He survived and in February of 1955 submitted himself to a second operation, in spite of the obvious risks. The operation was more successful, but recuperation was long and painful and he was never fully cured. He used the time in the hospital to write his Pulitzer Prize–winning book, *Profiles in Courage.*

▼

I am preparing a set of images for JFK's approval, to be aired on the NBC TV special *JFK Report #1.*

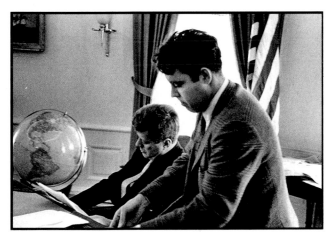

THE OVAL OFFICE. JULY 1961

In August of 1943, we faced death in the Solomon islands. That any of us survived is a tribute to the man who was our commanding officer, Lieutenant John F. Kennedy, U.S.N.R. His courage, his calmness in the face of danger, his remarkable qualities of leadership were all tested in a way that few men are tested in their lifetimes.

Ray Starkey, Maurice Kowal, Patrick McMahon, John Maguire, Barney Ross, Edman Edgar Mauer

I first met the then Senator John F. Kennedy in the summer of 1958. I was in my mid-twenties.

Two years earlier I had become friends with his younger brother Robert. I had been assigned by three different magazines during the same week to photograph Bobby Kennedy, an up-and-coming young Washington lawyer just appointed as the majority counsel to the McClellan Committee, also known as the Labor Rackets Committee. The coincidence of shuttling back and forth between New York and Washington for a week had resulted in an invitation to dinner at young Bobby's home and an overnight stay.

During the summers of '56 and '57 we spent much time together. I brought my own young children to Hyannis Port and McLean, Virginia, to participate with the rest of the many kids in what seemed to be perpetual bedlam. There was football, endless games, and never-ending activity. And there were animals. Horses and donkeys and dogs and cats and geese; even goldfish had their place.

And the young photographer, in hog heaven, photographed. After a year I presented Bobby with a gift, 124 large photographs.

He was beside himself with joy and instantly ordered another set. When reminded that this was a rather large number of pictures, he agreed to reduce the number by twelve. When pressed, he said the pictures were a present for his father's upcoming birthday. I made another set.

When ships were sinking and young Americans were dying I firmly resolved to serve my country in peace, as honestly as I tried to serve in war.

John F. Kennedy, opening speech for the congressional campaign, April 25, 1946

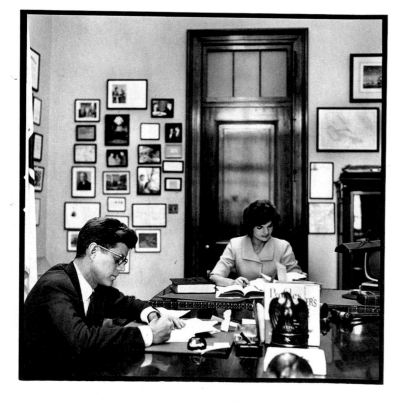

WASHINGTON, D.C. FALL 1958

▲
Jackie Kennedy would often assist the Senator in the early days of their marriage. Here they are in his Capitol Hill office.

▶
Senator Kennedy discusses a problem on the phone while a group of labor leaders wait for his decision

Two months later the phone rang in my house in Manhattan. It was midnight. A slightly inebriated voice announced it was Joe Kennedy on the phone. The young photographer, unwilling to believe such an illustrious figure was calling and convinced it was a hoax, announced that he was Santa Claus. "No, no," said the voice, "this is Joe Kennedy and today is my birthday… and Bobby gave me these pictures as a present… and this is the best present I ever got and this is the finest set of pictures I've ever seen… and would you come and photograph my other son?"

When I arrived at Cape Cod two Sundays later, Jack Kennedy had returned from two weeks of campaigning for a weekend of rest, after which his schedule called for another hectic ten days of campaigning. He presumably was running for reelection to the Senate from Massachusetts. I later found out he was running for president, and he did not want to see a photographer.

He was grumpy, awkward, and preoccupied. Still, his respect for his father and his general good manners dictated civility. So after some reluctance to cooperate, he acquiesced. I took my photographs of Jack, Jackie and Caroline, and Joe Kennedy, who choreographed the confrontation. It became late. I joined the Kennedys for dinner (I remember clam chowder was on the menu) and stayed overnight. In the morning I went back to New York, developed the film, and sent off the contact sheets. I heard nothing further for weeks. I thought I had bungled the job.

In late September the phone rang, again near midnight. It was the Senator. He was in New

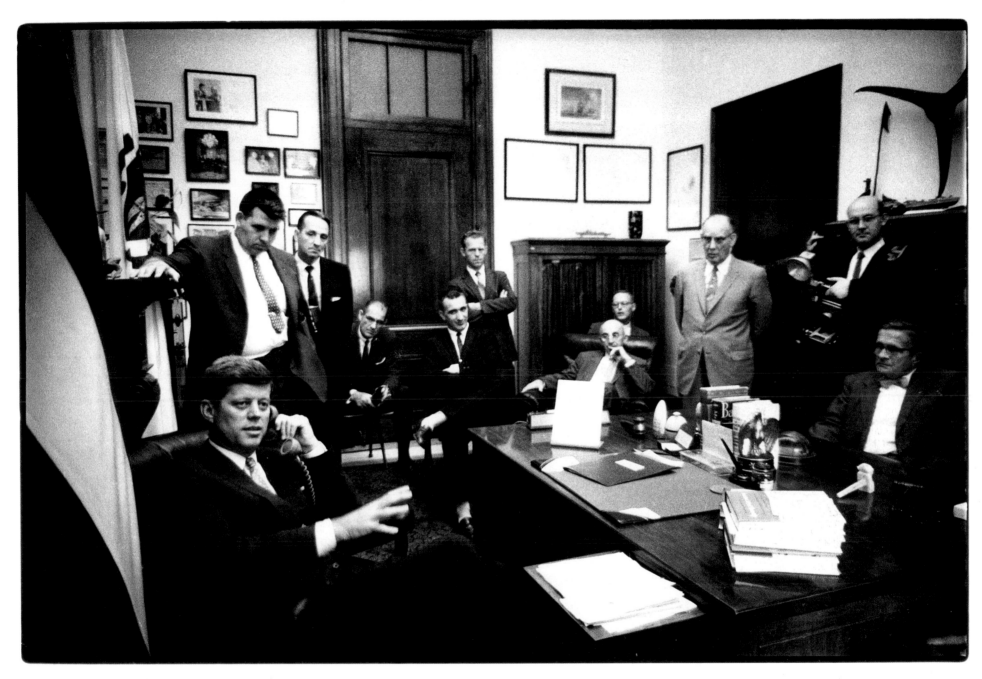

WASHINGTON, D.C. FALL 1958

GEORGETOWN. SPRING 1959

▲

Senator Kennedy, Jackie, and Caroline in the
backyard of 3307 N Street.

▶

Senator Kennedy, Jackie, and Caroline in the
hallway of their Georgetown house, 3307 N Street,
as he is leaving for Capitol Hill.

York, he said, for the evening. He was staying at
the *Margery*, a huge apartment complex on Park
Avenue owned by Joe Kennedy. Could I come by
now and see him? I said I would.

When the door opened to my ring I was greeted
by the Senator himself. He was dressed in a towel.
Jackie was in a bathtub down the hall, as I could
tell by the splashing water as she shouted a happy
welcome. Jack and I sat down on a low couch in
front of an even lower glass coffee table. The contact
sheets were spread out on it. He apologized for
being so grumpy on that Sunday in Hyannis Port,
explained how tired he had been, and asked for my
forgiveness. Miraculously, he said, the pictures came
out great; I must be a fine photographer. As we
went over the pictures, I had to slip to the floor,
glancing awkwardly past the towel to his face. We
selected a Christmas card picture that evening and
other pictures for different applications. I was
relieved when I finally could get up from the
floor. We had a late drink. Jackie joined us. And I
finally left with high praise ringing in my ears. It
was one-thirty in the morning.

*Just as I went into politics because Joe died, if anything happened to me
tomorrow, my brother Bobby would run for my seat in the Senate. And if
Bobby died Teddy would take over for him.*

John F. Kennedy, from *The Remarkable Kennedys*, by Joe McCarthy, based on an interview
with Bob Considine

GEORGETOWN. SPRING 1959

It is regrettable that the gap between the intellectual and the politician seems to be growing. Instead of synthesis, clash and discord now characterize the relations between the two groups much of the time. Authors, scholars, and intellectuals can praise every aspect of American society but the political. My desk is flooded with books, articles, and pamphlets criticizing Congress. But rarely if ever have I seen any intellectual bestow praise on either the political profession or any political body for its accomplishments, its ability, or its integrity – much less for its intelligence....

But in fairness, the way of the intellectual is not altogether serene; in fact, so great has become popular suspicion that a recent survey of American intellectuals elicited from one of our foremost literary figures the guarded response, "I ain't no intellectual."

It seems to me that the time has come for intellectuals and politicians alike to put aside those horrible weapons of modern internecine warfare, the barbed thrust, the acid pen, and, most sinister of all, the rhetorical blast. Let us consider not what we fear separately but what we share together....

The duty of the scholar, particularly in a republic such as ours, is to contribute his objective views and his sense of liberty to the affairs of his state and nation....

Freedom of expression is not divisible into political and intellectual expression. The lock on the door of the legislature, the Parliament, or the assembly hall – by order of the king, the Commissar, or the Führer – has historically been followed by a lock on the door of the university, the library, or the print shop. And if the first blow for freedom in any subjugated land is struck by a political leader, the second is struck by a book, a newspaper, or a pamphlet....

"Don't teach my boy poetry," an English mother wrote the provost of Harrow. "Don't teach my boy poetry; he is going to stand for Parliament." Well, perhaps she was right – but if more politicians knew poetry, and more poets knew politics, I am convinced the world would be a little better place in which to live on this commencement day of 1955.

John F. Kennedy, Harvard University Commencement Address, 1955

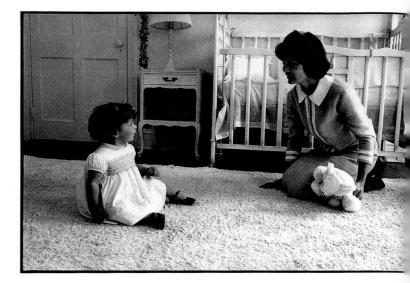

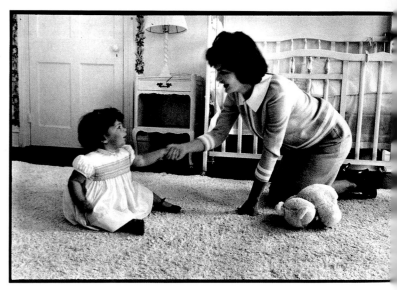

In the spring of 1959 life was still relatively quiet for the young Senator and his wife. Although he had already decided to try for his party's presidential nomination, the Senator spent much time with his family, and Jackie was able to devote herself to decorating the house, entertaining, and spending time with their young daughter, Caroline. On August 23, 1956, Jackie had her first child, which was stillborn, but after giving birth to Caroline in November of 1957, life was beginning to look promising. "I have filled the house with eighteenth-century furniture, which I love, and my pictures — the drawings I collect...but I haven't made it completely all my own because I don't want a house where you have to say to children, 'Don't touch,' or where your husband is uncomfortable..." Jackie was later to say of that period.

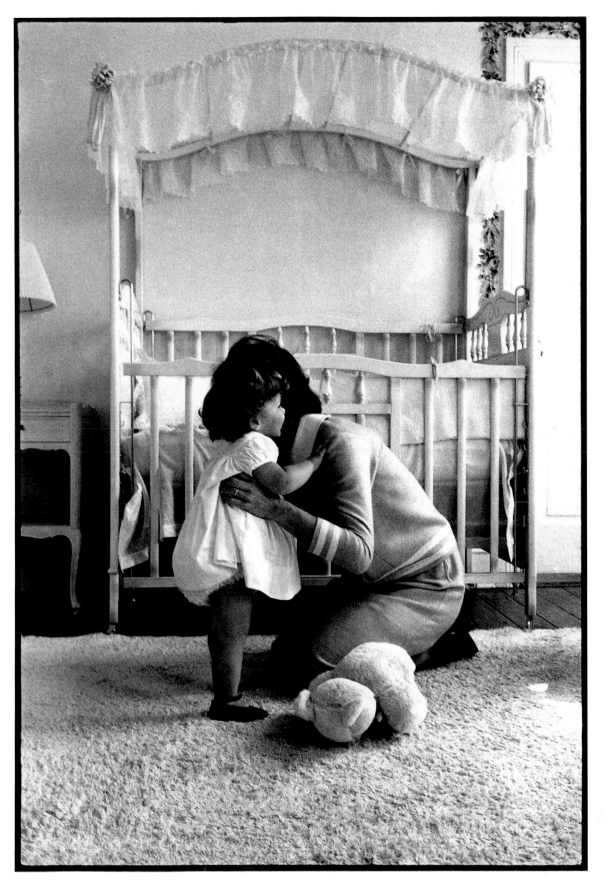

GEORGETOWN. SPRING 1959

Several months later I received a call from Steve Smith. I had no idea who Mr. Smith was, but over the years I would get to know him, husband of JFK's youngest sister, Jean, very well. We would become friends. He said that he worked for Senator Kennedy and he asked me to come to Washington for a meeting. I was to meet him at the Esso building, not in the Senator's office. I flew down two days later.

On arrival at the Esso building, I had difficulty locating Steve's office. The word "Kennedy" was not on the office directory. When I finally located the suite, I entered a high-tech-computer-crammed series of rooms. I thought little of it. I figured Steve was in the computer business.

Steve took me out to lunch and told me how impressed Senator Kennedy and his staff were with my work. He told me that the Senator was frequently engaged in speaking tours around the country and that from time to time they would need photographs of the events. Would I be able to cover some of these trips, and what were my fees? When I asked what kind of photographs he was looking for he said they would leave it up to me. "You're the artist. You have a feeling for the moment. You will be the best judge." That, it turned out, was the only guidance or instruction I would ever receive over the next five years.

Three months after that meeting I received a call from Steve. The Senator was going to Omaha, Nebraska, to speak at a Democratic barbecue/fund-raiser. Could I meet their plane at La Guardia's Butler Aviation terminal the next day early in the morning? We'd be back in New York late the same night. I asked again, "What kind of pictures do you want?" He answered, "I leave it up to you." I said I'd be there.

In the summer of 1958, when I met the Senator for the first time and this picture was taken, he was vigorously running for reelection to the U.S. Senate. Although by then he'd become immensely popular in his own state of Massachusetts and would have won reelection by staying home and making occasional statements from his porch à la Calvin Coolidge, he was determined to win by a landslide in order to enhance his chances and visibility in his quest for national office. That weekend he was very tired. He didn't want to see a photographer, but he also wouldn't say no to his father, who had asked me to come to Hyannis Port. But he perked up whenever I asked him to sit with Caroline. This image was to become famous and was used continuously in the presidential campaign.

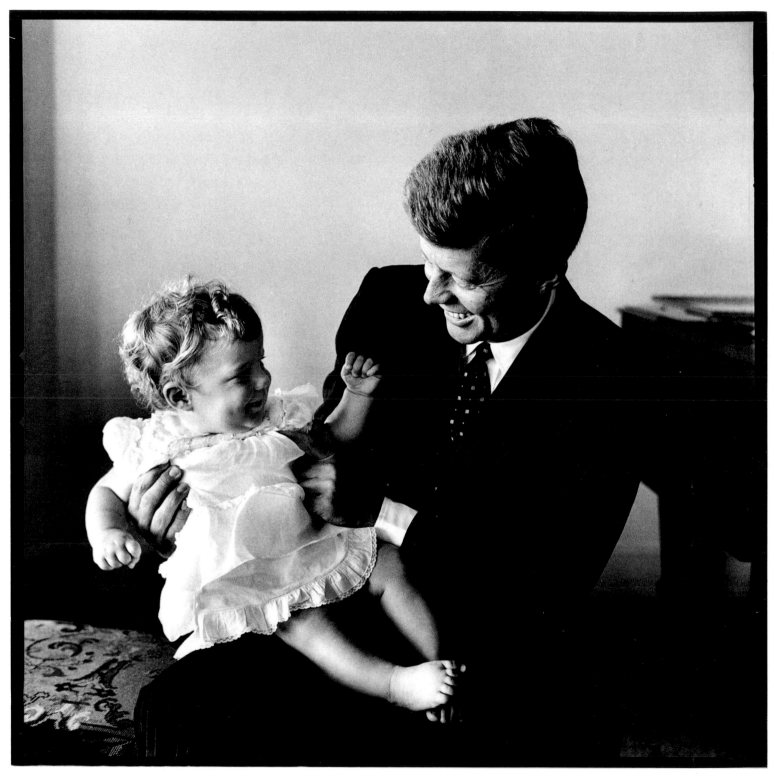

HYANNIS PORT, AMBASSADOR JOSEPH KENNEDY'S HOUSE. AUGUST 1958

Next day, a Sunday, I turned up at Butler Aviation, a private air leasing company, and asked for the Kennedy plane. It was a DC-3. The plane was well appointed, with couches, a dining area, and a kitchen. Aside from Senator Kennedy, my fellow passengers were Ted Sorensen of his Senate staff, Hy Raskin, a political operator, and Bob Healy, a reporter from *The Boston Globe*. The trip was uneventful. We had a lunch consisting of the Senator's favorite dish, Boston clam chowder, followed by hot dogs. I had no idea that I had just become a member of a presidential campaign.

What did strike me, though still subconsciously, was a sense of destiny connected with this journey to the heartland of America. I felt the electricity emanating from this man, the charisma attracting these midwestern crowds like a magnet. Here they were, jovial, upright Rotarians and worthy members of the chamber of commerce, in their ill-fitting suits and loud ties, nearly frozen in adoration of this patrician Eastern politician who would test their mettle and ingrained reserve a few months later, when — although a Catholic — he would announce his intention to run for the presidency. The long trip back to New York afforded time to reflect. Years later, I would be shocked when the image chosen by Mrs. Kennedy for JFK's "In Memoriam" mass card would be a photograph I had taken this very first time out on the campaign trail.

This photograph of grandfather and grandchild, Ambassador Joseph P. Kennedy and Caroline, was taken on the same weekend as the photo on page 17. Joe Kennedy, Sr., had lost one son who had been destined — in his mind — for the presidency: Joe Kennedy, Jr., in World War II. He was now making every effort to have his second-born son succeed in that ambition.

Two things I always knew about you. One that you are smart and two that you are a swell guy. Love, Dad.

Joseph P. Kennedy, in a telegram congratulating Jack on his cum laude graduation from Harvard and his magna cum laude grade on his thesis in political science

One has…to give credit to Joe Kennedy that he was sitting right there with the bombs…there was no lack of being on the job…but most notably in 1940, he thought that England was sure to be beaten. He put this in most colorful language… from the point of view of objective calculation, he couldn't be faulted. The odds were considerably against Britain at the time.

Henry R. Luce, editor in chief, Time-Life Publications

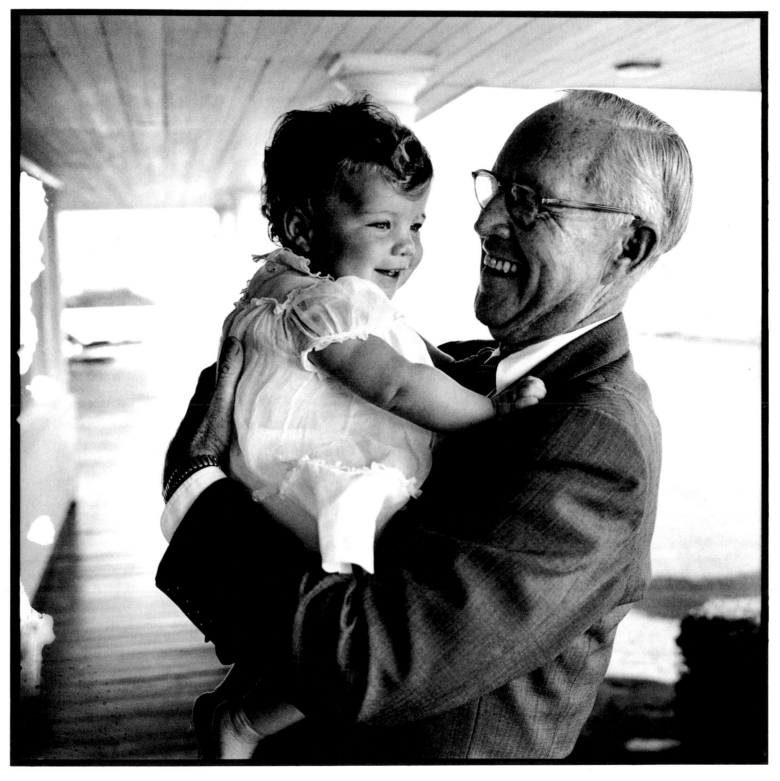

HYANNIS PORT, MASSACHUSETTS. AUGUST 1958

I am announcing my candidacy for the presidency of the United States.... For eighteen years I have been in the service of the United States, first as a naval officer in the Pacific during World War II and for the past fourteen years as a member of Congress. In the last twenty years I have traveled in nearly every continent and country — from Leningrad to Saigon, from Bucharest to Lima. From all this I have developed an image of America as fulfilling a noble and historic role as the defender of freedom in a time of maximum peril — and of the American people as confident, courageous, and persevering. It is with this image that I begin this campaign.

John F. Kennedy, January 2, 1960

In late 1959 Senator Kennedy, Jackie, and an aide, Dave Powers, arrived in Portland, Oregon, in a chartered plane for a campaign appearance. He was one of seven Democratic candidates for his party's presidential nomination. Waiting at the airport to welcome the Senator on that grim, cold day were three supporters, including Congresswoman Edith Green. It was really quite a typical reception at that stage. Yet the picture, showing the lack of support he was getting, became his favorite image of the campaign. In March of 1963, in the Oval Office, I asked the President to sign a book I had written. "Let me show you my favorite picture," he said, and stabbing his finger at the page he said, "Nobody remembers that now." It was true. Only a few months later he would be mobbed by uncontrollable crowds, and women would faint in the audience, a reaction more attuned to a rock-star than a candidate for political office.

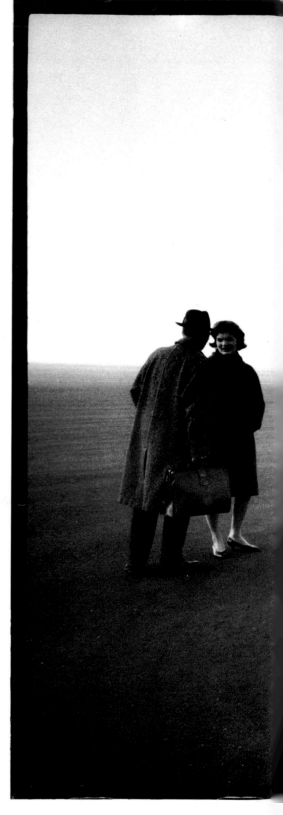

PORTLAND, OREGON. 1959

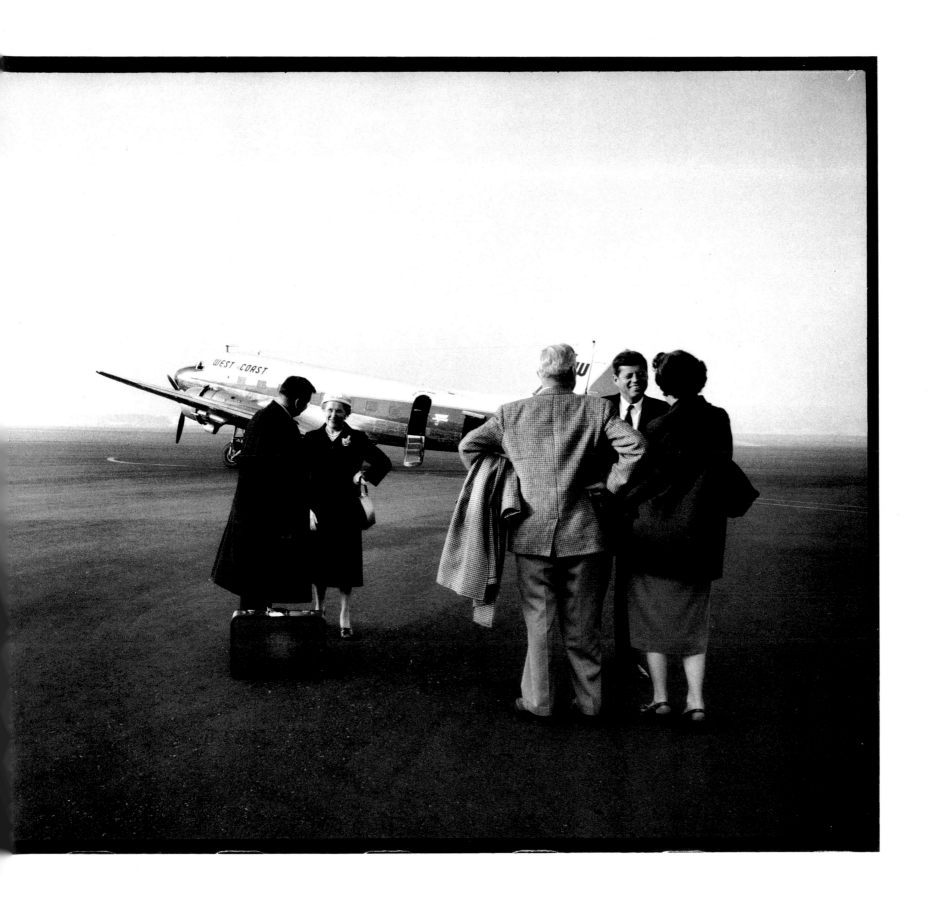

In the spring of 1959 I was asked to go to California on a three-day trip. By that time I had gotten used to these trips. I had brought friends along to impress them with this kind of one-day long-distance picnic, and since the plane was nearly always empty no one ever questioned what they were doing there. I had also by now taken hundreds of photographs, delivered contact sheets, sent and collected bills, and no one had ever asked me for a print. I had become curious about my new client.

My presence on these jaunts had by now become perfectly ordinary. I had simply evolved into a member of the inner circle. And by now I had begun to know and appreciate this senator quite well. Our relationship had evolved into a kind of partnership, in which he would never ask why I was photographing him even though he might be half nude and in the process of changing clothes, and in which I didn't feel constrained to explain my photographic impulses. An unspoken trust had developed between us.

Finally I had slowly come to the realization that "we" were running for president, although I still didn't fully comprehend what that meant. After all, only ten years earlier I had come to this country as a political refugee from Nazi Germany, an emigrant who hardly spoke English.

And in California, for the first time, I felt the excitement, that indefinable quality that transforms a mere human being into a charismatic, almost mesmeric figure. There is a tingling of the blood, a thumping of the heart, that draws people to the candidate.

One of the first political trips I was invited to join was a Democratic barbecue in Omaha on Labor Day weekend. Ted Sorensen, a native Nebraskan and the Senator's top aide, had arranged the visit. The day was not very eventful. There were the usual long-winded speeches and discussions typical of such occasions. I realized, though, that the day had turned into a kind of fashion show; everybody was there to look the Senator over. Toward the end of the day Kennedy gave an outdoor press conference for local reporters. As he sat there, all eyes on him in an adoring and approving fashion, it flashed through my mind that this candidate, then still fairly unknown, might very well succeed. I thought the farfetched and unthinkable: that he might actually win the nomination. I didn't dare think beyond that. Later, this picture would become the first campaign poster; a sea of this image would dominate the convention and the later presidential campaign. Later still it would become his "In Memoriam" mass card and the basis of several international stamps commemorating John F. Kennedy.

He was a tremendous listener. I think that picture that his wife put on his mass card at the time of his funeral was the greatest picture of him I have ever seen. It shows him completely engrossed in what is being said to him. And he had a tremendous interest in what your thinking was — which, of course, is a characteristic of many great men.

Stuart Symington, former senator, presidential candidate in 1960, and Kennedy friend

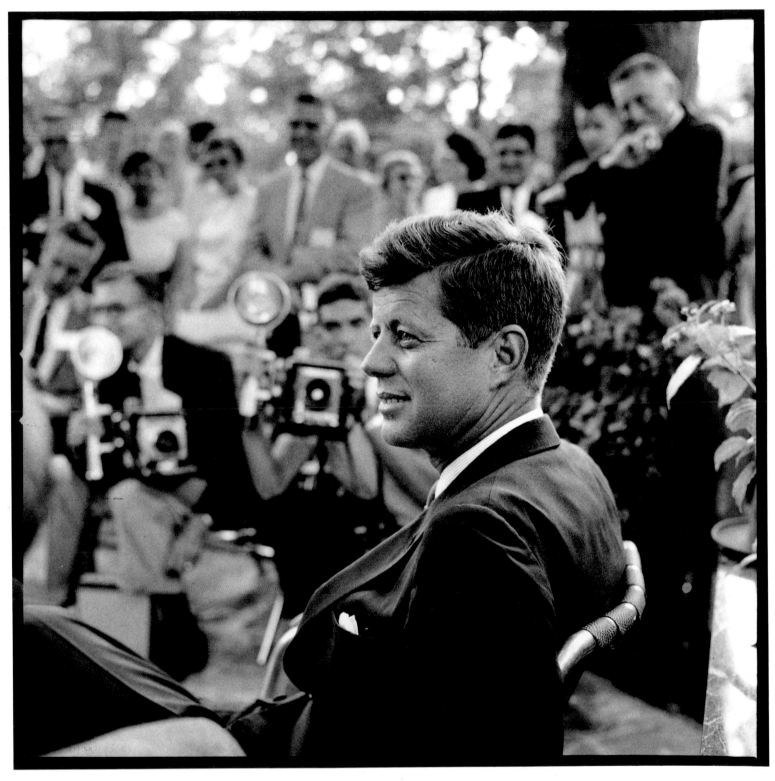

OMAHA, NEBRASKA. LATE SUMMER 1959

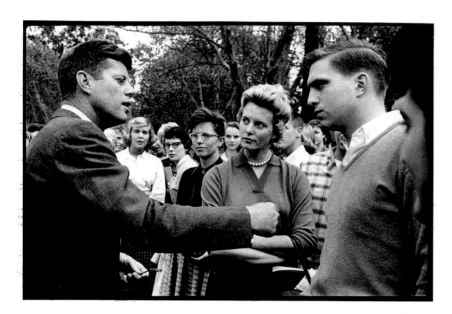

OAKLAND, CALIFORNIA. 1960

By the early spring of 1960 the occasional trips had become more frequent and went farther afield. Here, on a trip to California, Kennedy walked the campus of Mills College in Oakland (above), confronting students wherever he could find them, and a group of skeptical labor leaders at the Hilton Hotel in Los Angeles (right).

We were met at the airport by Joe Cerrell, later to become the leading political consultant in the state, and whisked to our hotel in a fleet of limousines. We quickly changed into black tie for a dinner that boasted most of California's Democratic political heavyweights as well as an ample contingent of Hollywood stars. Senator Kennedy was the keynote speaker. Frank Sinatra and his rat pack, Shirley MacLaine and a number of comedians, who roasted the Senator, entertained. The Senator gave back as good as he got! His biting wit, later to become so famous at his presidential press conferences, was already in evidence.

Kennedy hadn't declared his candidacy yet, but he was clearly a candidate, though only one of seven who were striving for the prize. And by this time a move to stop him had already begun, nourished by both the spunky ex-president Harry Truman — who openly championed Adlai Stevenson once again — and the more calculating majority leader of the U.S. Senate, Lyndon Johnson. But the next day, on a tour of California colleges, it became clear that this candidate was the leader no matter what the opposition. Teachers and students, men and women, young and old were absorbed, almost bewitched, by this charming, intelligent patrician New Englander whose wit and quotations of the classics kept them enthralled.

After we returned East I was asked for the first time to produce some of the work I had done. "At last, film in the camera" was the candidate's high praise.

In a recent survey American mothers were asked what their ambitions were for their sons. Seventy percent replied that they hoped he would become president of the United States, but only ten percent wanted them to be politicians. Which reminds me of the great Artemis, who said that he was not a politician and his other habits were good also.

John F. Kennedy, a statement used often in his campaign speeches

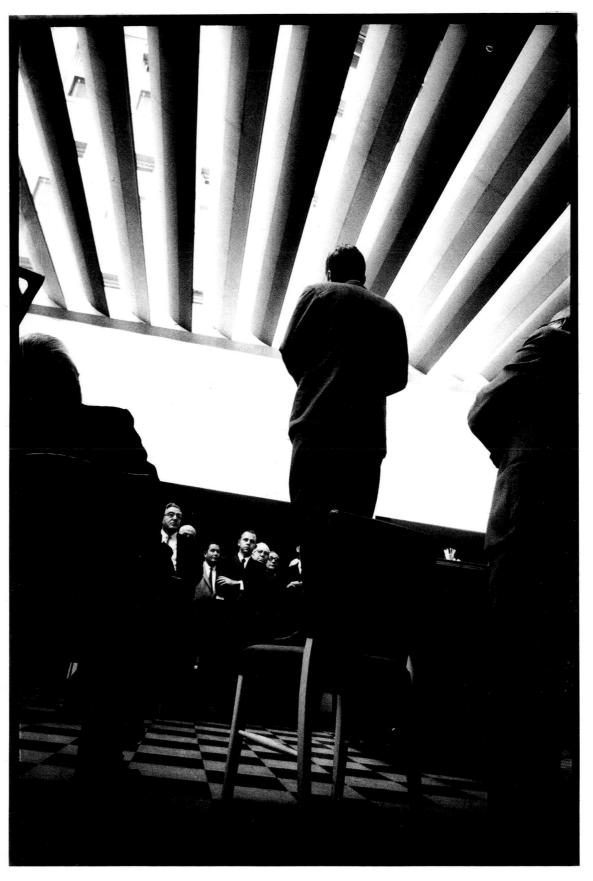

LOS ANGELES, CALIFORNIA. 1960

Mr. President, May 17, 1960, marked the end of an era — an era of illusion, the illusion that personal goodwill is a substitute for hard, carefully prepared bargaining on concrete issues, the illusion that good intentions and pious principles are a substitute for strong creative leadership.

For on May 17, 1960, the long-awaited, highly publicized summit conference collapsed. That collapse was the direct result of Soviet determination to destroy the talks. The insults and distortions of Mr. Khrushchev and the violence of his attacks shocked all Americans, and united the country in admiration for the dignity and self-control of President Eisenhower. Regardless of party, all of us deeply resented Russian abuse of this nation and its president, and all of us shared a common disappointment at the failure of the conference. Nevertheless, it is imperative that we, as a nation, rise above our resentment and frustration to a critical reexamination of the events in Paris and their meaning for America....

The harsh facts of the matter are that the effort to eliminate world tensions and end the cold war through a summit meeting...was doomed to failure long before the U-2 ever fell on Soviet soil. This effort was doomed to failure because we have failed for the past eight years to build the positions of long-term strength essential to successful negotiation. It was doomed because we were unprepared for the settlement of outstanding substantive issues....

Trunkloads of paper, I am told, were sent to Paris, but no new plans or positions were included.... Our allies and our own people had been misled into believing that there was some point to holding a summit conference....

But the truth of the matter is that we were not prepared....

If the 1960 campaign should degenerate into a contest of who can talk toughest to Khrushchev, or which party is the "party of war" or the "party of appeasement" or which candidate can tell the American voters what they want to hear, rather than what they need to hear, or who is soft on Communism, or who can be hardest on foreign aid, then, in my opinion, it makes very little difference who the winners are in July and in November; the American people and the whole free world will be the losers.

John F. Kennedy, "A Time of Decision," Congressional Record, June 14, 1960

A very serious John F. Kennedy getting ready to receive the press at a meeting in Omaha, Nebraska. What was most amazing about these often very impromptu press interviews was the candidate's broad knowledge and ability to answer all questions authoritatively. He was an avid reader. Having taken a speed-reading course some years before, he simply devoured pages and pages of articles and books, and retained the information accurately. It was astonishing. I remember one late night, arriving at our last stop of the day at about two in the morning, when a young local disc jockey-interviewer disparaged General de Gaulle. Kennedy, although having campaigned continuously from 7:00 A.M. to 2:00 A.M., disputed him vigorously by quoting from a recent De Gaulle biography not yet even in the bookstores. He probably had received an advance copy, but when had he read the book? In his campaign speeches he would often quote the Greek philosophers or the words of a great writer or poet for emphasis, often resulting in his having to spell out "Euripides" or "Aristotle" for his interviewers.

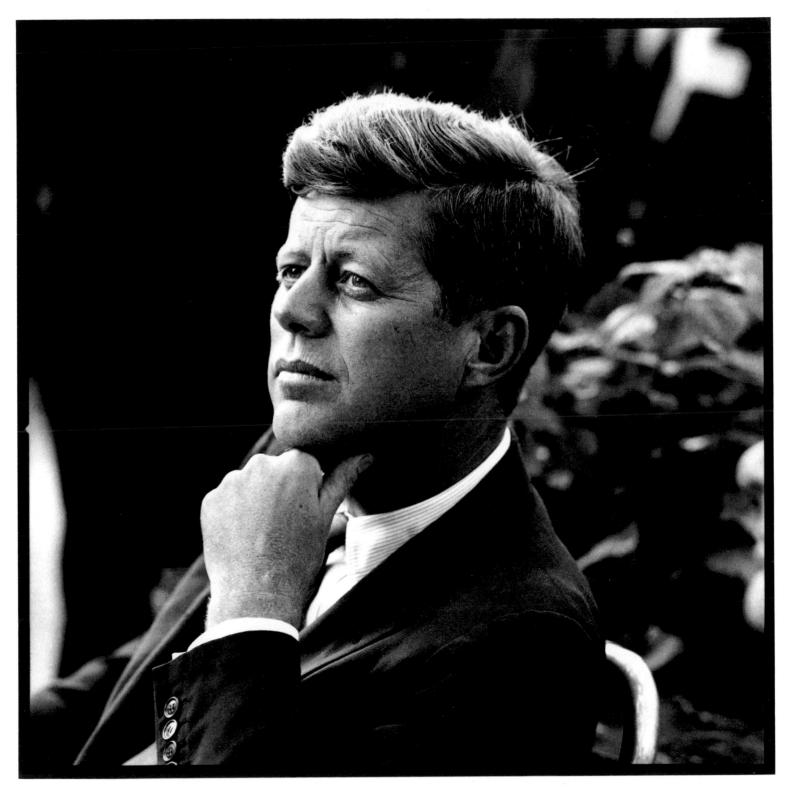

OMAHA, NEBRASKA. FALL 1959

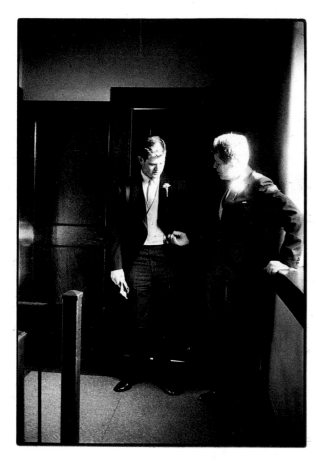

BRONXVILLE, NEW YORK. NOVEMBER 29, 1958

The picture above is of the bridegroom and best
man waiting for the ceremony to begin. Later, at
the Bronxville Country Club (right), the Senator
dances with the newest member of the Kennedy
family, Joan Bennett Kennedy.

Ambassador Joe Kennedy had asked me to photograph the
wedding of Teddy Kennedy and Joan Bennett, of Bronxville,
New York, on November 29, 1958. I had turned the offer down
on the grounds that I wasn't a wedding photographer. When
pressed further I explained to him that the wedding, tailor-made
for tabloid exploitation (they devoted endless pages to the
ceremony), was not a place where I could create the kind of
pictures he would expect from me. Presided over by Cardinal
Spellman of New York, with Senator Kennedy assuming the role
of best man and hundreds of well-known guests attending, the
atmosphere was expected to be more like that of a circus than that
of a holy ceremony. Every television station, as well as newsreel
producers, then still active, would have their lights set up, and
hundreds of reporters would cover the ceremony. I explained that
I needed my own natural light source, and the freedom of
movement in order to produce the kind of photographs he so
loved. He overrode my objections. I charged him a healthy fee,
which he agreed to.

The wedding ceremony turned into exactly what I had predicted. I
did my best, but was unable to overcome the constant changes of
bright lights. Even after the ceremony a clamoring mob of news
photographers kept demanding group shots of the bride and groom
and other combinations of relatives, leaving everyone exhausted.
Only at the private party later was I able to work well again.

I made contacts and prints and sent them to the Ambassador,
together with my bill. He wrote back to say that the pictures
weren't what he had expected and therefore I should lower my
bill. I wrote back to remind him of my earlier objections and my
reasons for initially refusing the offer. "Therefore," I said, "I
shouldn't have to lower my bill." He called and said I was perfectly
correct and I received a check in full. I learned a great deal about
this man, whose reputation was near mythical, in this interchange.
I especially learned to trust him. I could understand better what
that reputation was grounded in.

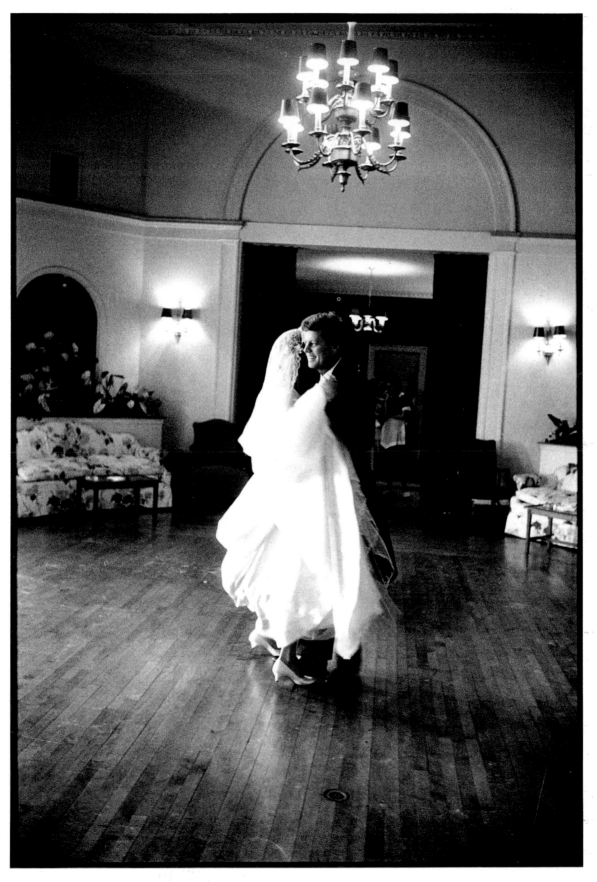

BRONXVILLE, NEW YORK. NOVEMBER 29, 1958

In some towns it was difficult to find anybody who was willing to shake hands, and most of the people who did talk to Kennedy were schoolchildren too young to vote.

Kenneth O'Donnell, White House appointments secretary, talking about the early campaign

Any man who goes into a primary isn't fit to be president. You'd have to be crazy to go into a primary. A primary, now, is worse than the torture on the rack. It's all right to enter a primary by accident, or because you don't know any better, but by forethought?...

Hubert H. Humphrey, West Virginia, 1960

It was curiously shoestring, when you look back, compared with what the big campaigns became or what the presidency became, you know — sometimes there would be just three of us in the car driving down to the next town in West Virginia.

William Walton, artist and friend of JFK

In the early days of the campaign it was difficult for Kennedy to find anyone willing to listen to his message to "Get the country moving again." Here, on a Sunday morning after mass, across the street from the Let 'Er Buck Motel, where they had spent the night, Senator Kennedy, Jackie, and Steve Smith sit having breakfast in a diner, totally ignored by the rest of the patrons. Six months later, that neglect would turn out to have been a luxury: They would be swamped by people trying to touch them.

OREGON. LATE FALL 1959

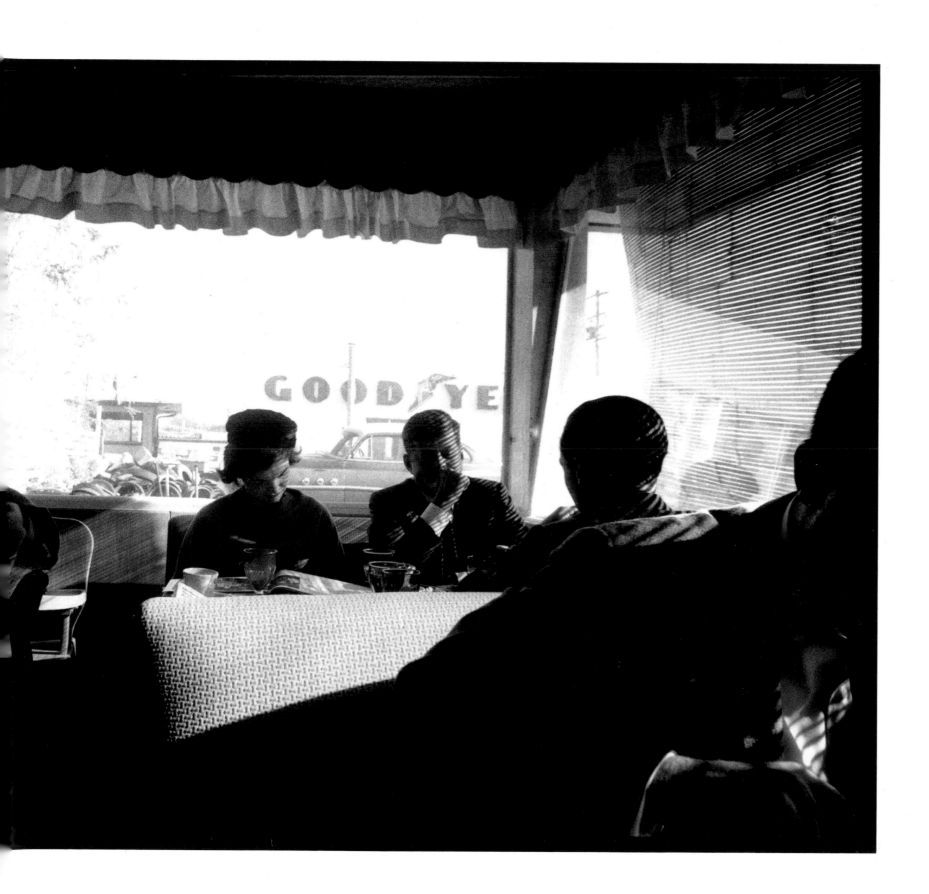

Senator Smathers has been one of my most valuable counselors at crucial moments — in '52 when I was thinking of running for the U.S. Senate, I went to Senator Smathers and said, "George, what do you think?" "Don't do it... it's a bad year." So I defeated Henry Cabot Lodge by 70,737. In '56 I said, "George, so you think I should run for vice president?" Smathers replied, "You have a good chance"— I ran and lost. In '60 I was wondering about entering the West Virginia primary. Smathers said, "That state you can't possibly carry," and actually the only time I really got nervous in Los Angeles was just before the balloting when George said, "It looks pretty good for you."

John F. Kennedy, Democratic fund-raising dinner in Miami, honoring George A. Smathers, March 11, 1962

Jack Kennedy was intelligent, definitely knew what was going on — he knew the game, the players, the odds, the whole nine yards.

Affable and friendly: He liked people — all of them: rich and poor, educated and illiterate, young and old, Democrats and Republicans.

Strong leader: While he appeared in his early political life as only average, he quickly began to learn and demonstrate leadership qualities that, by the time of his passing, had made him the...respected leader of the world's democracies.

He was a wonderful and close friend of mine.

George A. Smathers, in a letter to the author, November 1992

By the early months of 1960 Kennedy was deeply involved in the primaries. He'd predicted that he would enter and win all of them. He did. But it was a hard slog. It involved having to write his name in blood in a Kiwanis register, wearing funny hats he then immediately got rid of, and tossing babies in the air, which he wasn't very good at. But it more often involved waiting quietly and unobtrusively on the sidelines, while other candidates for the same or lesser offices finished their pitch, until it was his turn to speak. It couldn't have been easy for this patrician to endure this. But I never heard him complain.

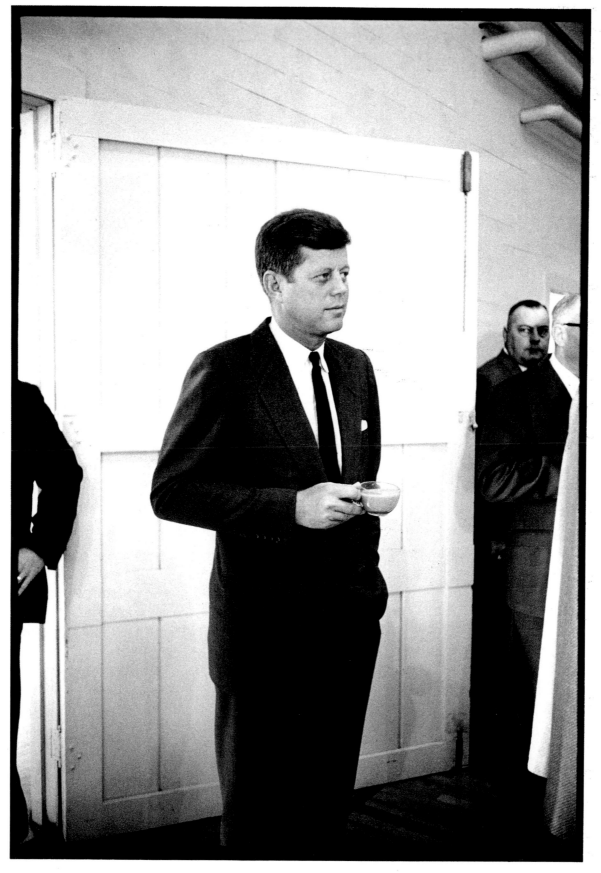

WISCONSIN. SPRING 1960

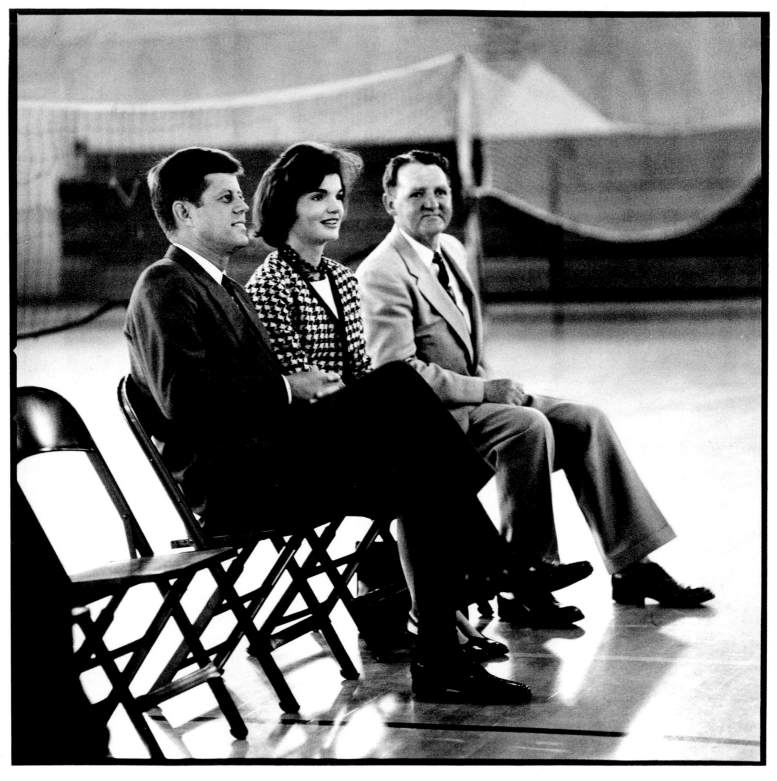

CALIFORNIA. FALL 1959

You shake hundreds of hands in the afternoon and hundreds more at night. You get so tired you catch yourself laughing and crying at the same time. But you pace yourself and you get through it. You just look at it as something you have to do. You knew it would come and you knew it was worth it.

Jacqueline Kennedy, interview with the author for *Jacqueline Kennedy: First Lady*, March 1961

Winston Churchill once said that democracy is the worst form of government except for all the other systems that have been tried. It is the most difficult. It requires more of you — discipline, character, self-restraint, and willingness to serve the public interest…and unless in this free country of ours we are able to demonstrate that we are able to make this society work and progress, unless we can hope that from you we are going to get back all of the talents which society has helped develop in you, then, quite obviously, all the hopes of all of us that freedom will not only endure but prevail…will be disappointed.

John F. Kennedy, National Convention of Catholic Youth Organizations, November 15, 1963

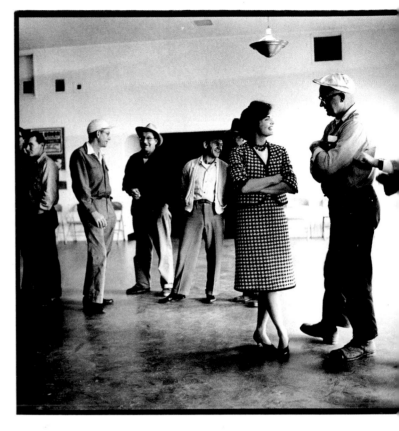

COOS BAY, OREGON. 1959

▲
While the Senator addressed an almost empty union hall of fairly hostile longshoremen in Coos Bay, Oregon, Jackie chats with one of the men. Even here, among blue-collar workers normally given to whistling when confronted by a pretty woman, hardly anyone paid attention to her.

◄
On yet another trip to California in the fall of 1959 Kennedy addressed students at a high school auditorium, where few were old enough to vote. Here, Jackie and the Senator sit with the principal, waiting to address the audience.

I first met John Kennedy in 1950 or 1951, when he was campaigning for the Senate. I have always felt very positive toward him — it was because I sensed the potential greatness in him that I did the biography. However, his idolaters…are still upset because I raised the question of how much basic commitment there was in him.

His personal political machine was the most effective, most efficient, most imaginative, most skillful personal political machine in the history of American politics. But it was a Kennedy organization, not a party organization, not a Democratic Party organization, not a liberal organization as such…once you make a commitment to a party, you link your personal organization and your personal activities with the great tradition in history and standing of a major political party. This is where sometimes you have to subordinate your own immediate personal organization and objectives to the tradition and broader purpose of the party.

I would argue, however, that if he ever had had to make a clear-cut choice between going down for what seemed the most effective in terms of his personal organization and what seemed appropriate in terms of what the Democratic Party had come to stand for, he would have forsaken ideology and party for practical, pragmatic, personal organization politics.

I think that Kennedy demonstrated that there are other ways besides party discipline of finding the basis for leadership. I still am doubtful about the method he found — of piecing together temporary alliances and coalitions. Picking up support, moving across party lines, appealing to Republicans, sometimes blurring national issues…The more you blur the great national issues and thus obscure the great national debating grounds…the more you blur the ideological and broader policy issues, the more you confuse the people….

The smoke-filled room, attended by city bosses and cigar-chomping "pols," is now a symbol of the past. But during the 1960 campaign, "bosses" were still enormously important and influential, and they had to be courted. Men such as Mayor Daley of Chicago, David Lawrence of Pennsylvania, and Carmine DeSapio or Adam Clayton Powell of New York, still controlled large chunks of votes, some real and some "fictional," but votes that would be counted come Election Day. Democrats and Republicans alike were guilty of bossism, though Democrats seemed to have the edge. Here, at a hastily called Chicago airport stopover, Kennedy addresses a group of politicians crowded into a small conference room.

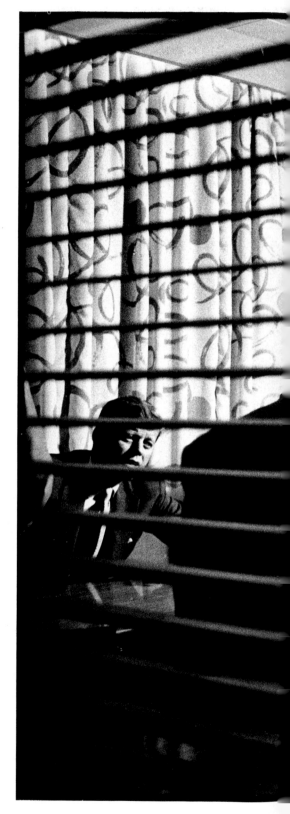

CHICAGO. SPRING 1960

36

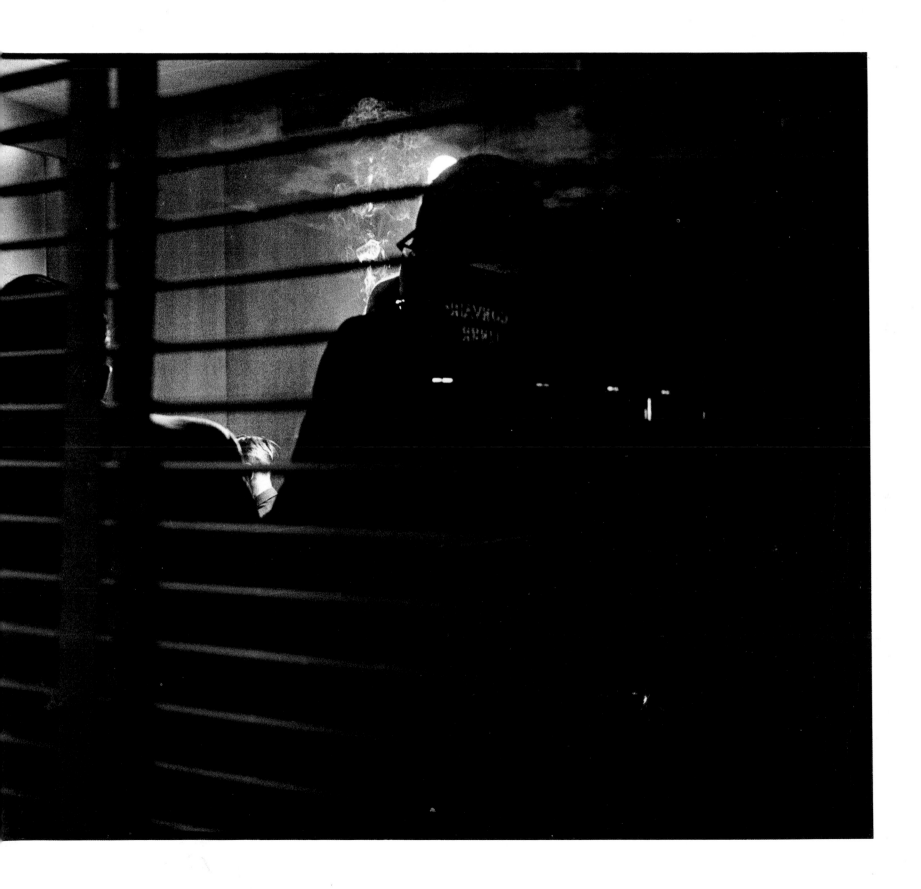

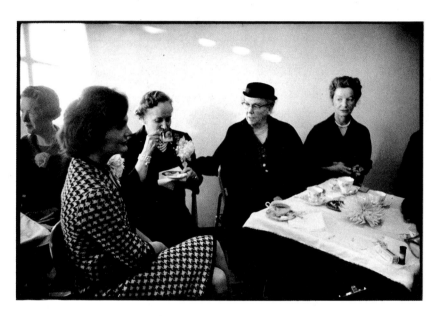

CALIFORNIA. 1960

At a small-town rally in California Jackie
Kennedy is being assessed by members of a local
Democratic women's club. Later, she waits with
her husband for a car to pick them up.

*I felt that JFK would never go all out on a political
gamble. I really doubt that he would have done
what his heroes in* Profiles in Courage *did. I don't
think he would have felt any one incident important
enough to justify putting all his political money
on it. This may be good presidential politics, as a
president has such a wide gambit to cover. Probably
he had commitment but of a different sort. I felt
that he could never throw himself into some cause
blindly; there would always be part of him sitting
back and watching with some detachment. His wit
reflected this lack of passion. Again, these may be
good qualities — it is better that a president does
not allow the heart to rule the head. God knows
he made enough of a commitment in the end.*

*So often you meet great men and you wonder
why are these people great, how have they got
where they are, they seem fumbling, slow. And
sometimes this impression is wrong. They look
slow, but there is a lot going on behind and there
is a certain wisdom that has accumulated over the
years that's hard to define or appreciate. But
Kennedy never struck me that way. I would say
there was a great mind there, a fine mind, just a
beautiful mechanism there. Whether there was a
great mind in the Churchillian kind of greatness,
who sticks to an issue through bad years and good,
who has almost a whole philosophical style, or the
kind of anguish and philosophical reflectiveness
that you find in Abe Lincoln, I think that is
another question.... I have nothing but admiration
for Kennedy's mind.*

James MacGregor Burns, December 19, 1964, from the *Oral
History Project*, John Fitzgerald Kennedy Library, Boston

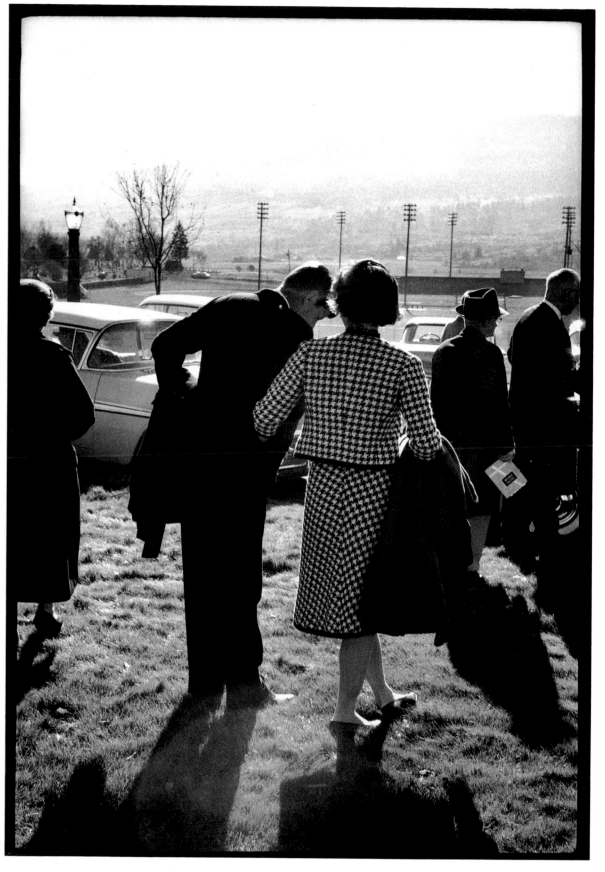

CALIFORNIA. 1960

The Kennedy strategy for winning his party's nomination was to enter every Democratic primary — New Hampshire, Indiana, Maryland, Nebraska, Wisconsin, West Virginia, and Oregon — and win them all. And he won them all convincingly, but in the beginning it seemed a near hopeless struggle. Once confronting an audience, however, he was very convincing; the trick was for the audience to show up. So the early campaign appearances took place in high school auditoriums, where few were old enough to vote, or were limited to endless coffees and teas in people's basements and living rooms. So the candidate would roam city streets and country lanes in search of votes and hands to shake. After all, few had ever heard of him.

We'd get up early, usually around six o'clock, and attend a local political breakfast or have our first "coffee." Then we would get into cars and visit supermarkets, the courthouse square, and Main Street. There, the Senator would wait for the stoplights, dash over to the waiting cars, and, sticking his hand through the windows, say, "I'm Jack Kennedy. I'm running in your primary. Please vote for me." And as we dashed from one small town to the next he would stop the car wherever more than a few people were gathered — "I'm Jack Kennedy…" — and he would climb on tractors to wave to school kids, sign his name in blood at a Kiwanis lunch, be photographed with local Indian chiefs. The things he would not do, except under severe duress, were wear funny hats…or kiss babies. It all seemed very hopeless, absurd, almost, and often bizarre. And I faithfully shadowed him and photographed every instant while convinced that this was a losing battle. I was discovering America in a way I had never experienced the country before, and that, not thoughts of the White House and glory, was what kept me going.

This photograph of JFK, taken in Coos Bay, Oregon, shortly after he addressed a group of tough, hostile longshoremen in their union hall, is my favorite image of the election campaign. The Senator had stood outside the hall, frowning and dejected. I'd tried to make light of the situation by saying, "Well, no fan mail to be expected from this meeting." Where he would normally respond with a quip himself he had simply stared at me, and let loose with a storm of words bemoaning the difficulty of reaching blue-collar workers. Now, a half hour later, he stared at the water in a dark mood, obviously preoccupied with his failure to reach the men. He very rarely reached this point of depression.

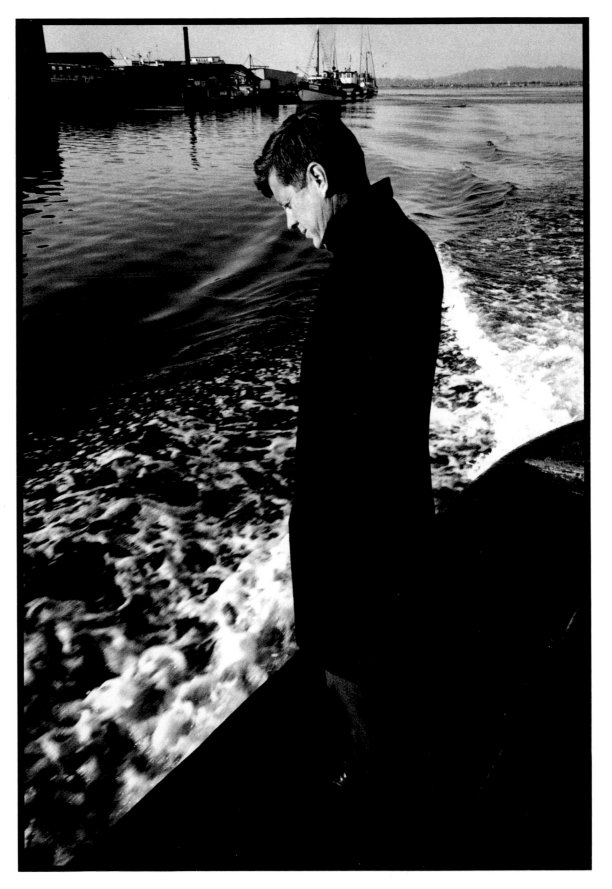

COOS BAY, OREGON. 1959

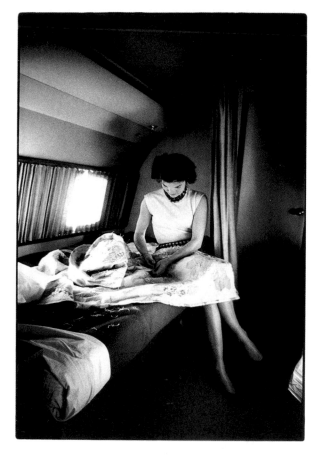

SEPTEMBER 1959

By September of 1959 Kennedy had his own plane, the *Caroline*. A comfortably appointed Convair, seating ten, with small sleeping quarters for the Senator, it became his home in the sky for the rest of the campaign. A stewardess served simple meals — clam chowder, sandwiches, and the occasional steak. Often he would read or work with one of his speech writers, one of whom was normally on board. Jackie, when she came along, would often do needlework or be engrossed in her own reading, such as Jack Kerouac's *On the Road*.

By now Kennedy had his own plane, christened the *Caroline* after his young daughter. It would become the political nerve center of the campaign. It would also scare the living daylights out of me because we would fly through any weather: blizzards and high winds, rain or snow. If told by the pilot that there was even a slim chance of getting to the next meeting, Kennedy would insist we take off. And he was absolutely fearless. As the little plane was thrown back and forth, and my heart was in my mouth, my knuckles white from grasping the seat, he would sit there calmly revising a speech or listening to the endless Irish jokes that Dave Powers, one of his aides, would recite. I was afraid of flying, one of those people who perceive changes in engine noises with terror, but by the end of the campaign I'd become a fatalist, no more fear of flying.

The first few primaries were won with relative ease. The audiences in general were sympathetic. Women especially warmed to him. There was one group, however, that Kennedy was simply unable to reach, and that was blue-collar labor, a critical segment of the Democrats' constituency. For one, they had their own candidate in Hubert Humphrey, but they also felt alienated by this elegant Bostonian who quoted Greek philosophers in his Boston-Harvard accent. I remember a particular day in Coos Bay, Oregon, where Kennedy addressed a group of extremely surly longshoremen. He pleaded with them to give him their confidence, while those who didn't simply walk out listened in stony silence. As we stood later in front of the hall I mentioned that he hadn't exactly warmed the cockles of their hearts and he replied in anger, "What am I supposed to do? Change myself? Talk down to them? Why don't they trust me?" And a few minutes later, on a boat where he met with union leaders and took a tour of

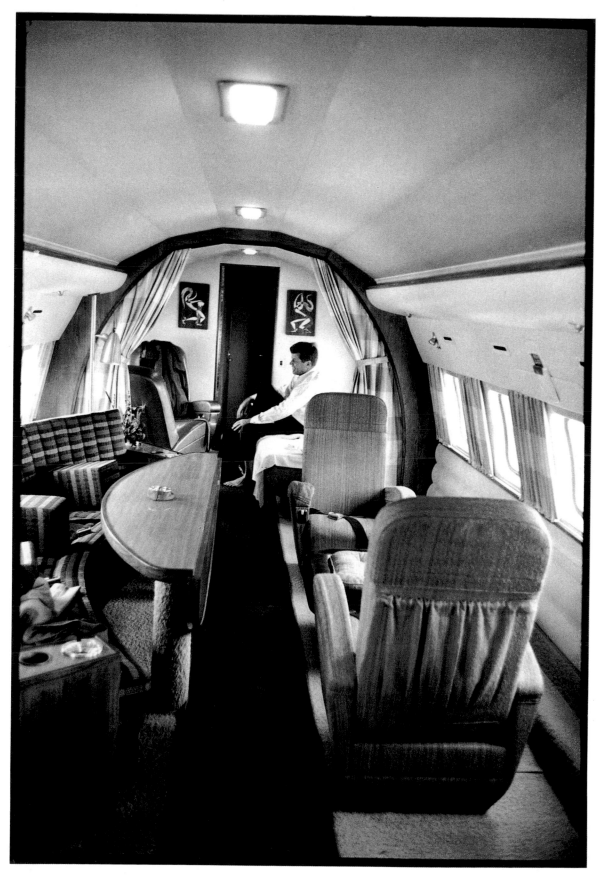

SEPTEMBER 1959

caught him in a strangely depressed mood, hands in pockets, staring down at the water. The picture has become famous, and it was a defining moment in Kennedy's approach to campaigning within the labor movement.

By the time we got to Wisconsin and Kennedy was the clear front-runner among the Democratic hopefuls, the issue of his Catholicism had raised its ugly head. Enough has been said about it, but it changed the campaign for me as well. I was suddenly confronted with a much more aggressive candidate, angry at times and sometimes strident. His fists would shoot out during a speech; his eyes, normally full of humor, would become hard. He won Wisconsin and thought the issue had been laid to rest, but in West Virginia, a state with a 5 percent Catholic population, poor, high in unemployment — and the next primary state — the issue started all over again, this time in dead earnest. Hubert Humphrey, a lifelong liberal who dreaded the label of bigot, suddenly found himself supported by the conservative Robert Byrd organization, by members of the Ku Klux Klan, and some other groups that could only be labeled the lunatic fringe. But although Humphrey dreaded it, he said little and did little to renounce that support. And where Kennedy's crowds had gotten larger and more lively, West Virginia proved the opposite. He had to start all over again. Few came to meetings, and few wanted to shake his hand. It was high political drama.

On April 10, a month before primary day, I drove to Parkersburg, West Virginia, to join the campaign. I had spent a week of rest photographing trapeze artists at the circus, an

The Kennedy plane often was turned into a campaign headquarters. Local politicians would come aboard at one stop and leave at the next, where a car would return them to their home base. Here, during the West Virginia primary, the candidate approaches Charleston and receives a last few words of advice. The small Cuban cigars JFK smoked, more a prop than a smoke, became something of a trademark. Rumor has it that before he ordered the embargo on Cuban trade as president, someone was sent out in a hurry to stock the humidors with enough cigars to last awhile.

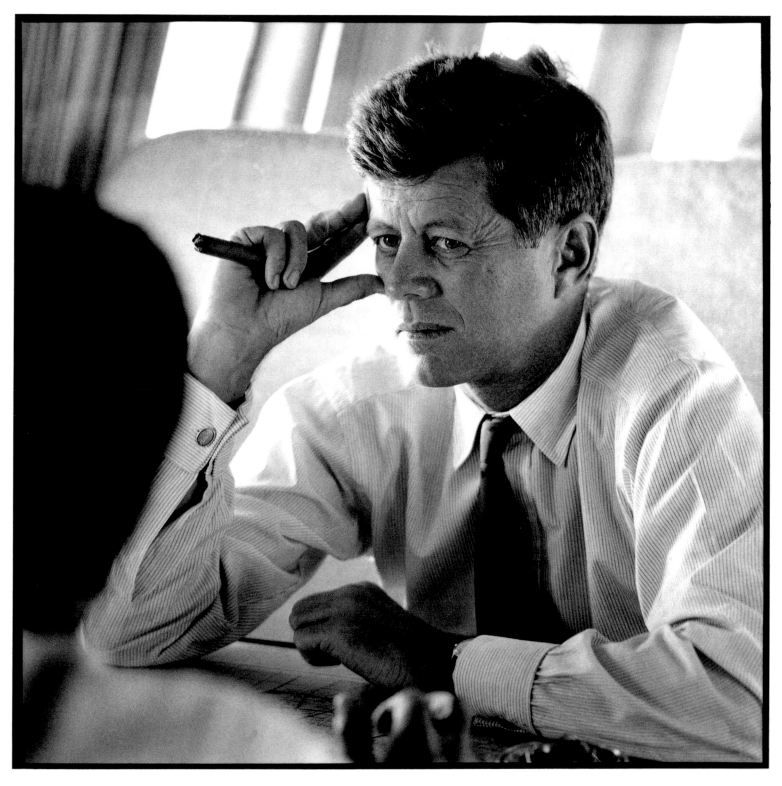

OVER WEST VIRGINIA. MARCH 1960

While Kennedy had won all the primaries he had entered up to date, and the crowds had gotten quite substantial, in West Virginia he had to prove himself all over again. In Wisconsin, the hotly contested previous primary, the Catholic issue had become important to the campaign. The *Milwaukee Journal* had divided election-night coverage into three columns — Democrat, Republican, and Catholic. Yet he had won that primary and thought the issue had been laid to rest. But in West Virginia, an impoverished state harboring a population suspicious of outsiders and largely ignorant of the religion, the Catholic issue had become the only issue, and the crowds had been reduced to a few people at each stop. Kennedy literally crossed streets to introduce himself to idle bystanders, leaned into cars waiting at red lights, and roamed the countryside in search of hands to shake.

▶

While traveling from Parkersburg to Charleston, West Virginia, Kennedy spotted this group of grade-school children with their teacher. He stopped the car and climbed on top of a tractor to address the group. It seemed a desperate search for votes, since there was only one to be had, the teacher's.

PARKERSBURG, WEST VIRGINIA. 1960

apt intermission. Taking the overnight train I reflected on the similarities between the political circus I was about to join again and the one requiring sawdust on the floor. I wasn't quite sure which was a better reflection of life, or what to expect next.

My first appointment was at the local Elks hall. By the time I got there, Kennedy had already finished his speech. He was mingling with the crowd of about two hundred, the biggest gathering of the day. The rest of the day seemed mired in catastrophe. Our film crew's truck burned up, and we constantly got lost or passed villages consisting of three houses.

I photographed men refusing to shake the candidate's hand. One particular incident stands out: "I'm Jack Kennedy. I'm running in the primary." "Who?" the man asked. "Jack Kennedy." "Oh," mumbled the character. Then, with an enormous drunken burp, he indicated the depth of his political support.

John L. Lewis, the lion of the miners labor movement, was dead set against the Kennedy candidacy, so we paid great attention to the miners. Everywhere we could find a few miners, Kennedy would pose with them, and it became my job to see to it that they all got copies. He would ask me weeks later whether I had sent the photographs. I hated his sharp memory, but the pictures got sent. And the Kennedy machine went into overtime. Every family member, every friend from college to the navy, was recruited to set up command posts. In the end Humphrey was overwhelmed by sheer organization. On one occasion his twelve-year-old son was passing out pamphlets and a television commentator asked how he was doing. "Not so good," replied young Humphrey on live television. "A lot of people don't want the stuff."

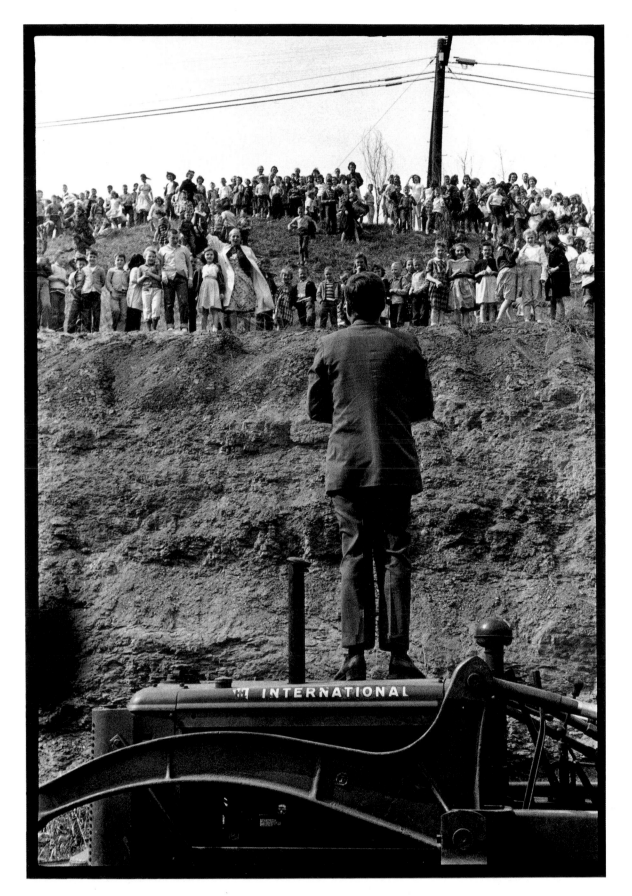

WEST VIRGINIA. 1960

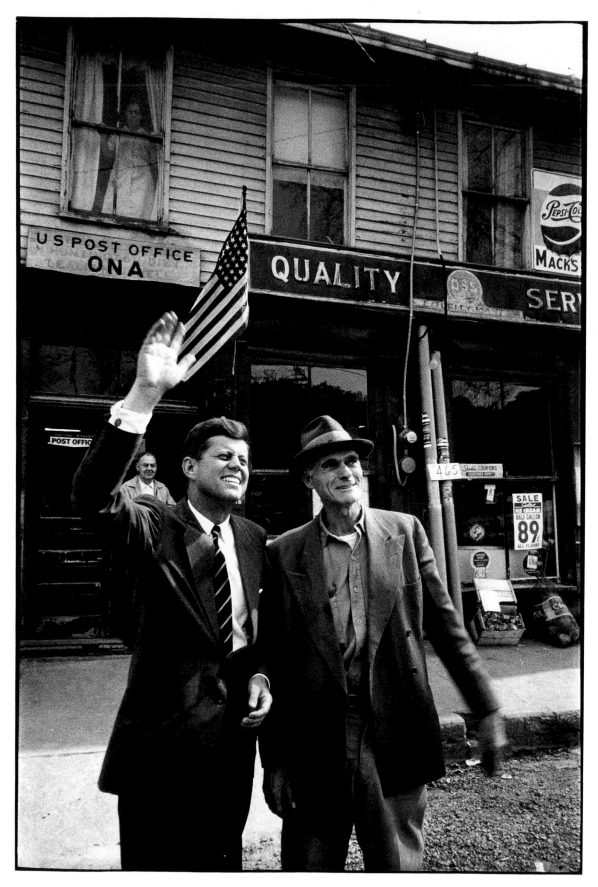

WEST VIRGINIA. 1960

So it is apparently necessary for me to state once again — not what kind of church I believe in, for that should be important only to me — but what kind of America I believe in....

I believe in an America where the separation of church and state is absolute — I believe in an America that is officially neither Catholic, Protestant, nor Jewish...and where religious liberty is so indivisible that an act against one church is treated as an act against all.

Finally I believe in an America where religious intolerance will someday end — where all men and all churches are treated as equal...where Catholics, Protestants, and Jews will refrain from those attitudes of disdain and division which have so often marred...the American ideal of brotherhood. That is the kind of America in which I believe....

I am not the Catholic candidate for president. I am the Democratic Party's candidate for president who happens to be a Catholic....

If the time should ever come when my office would require me to violate my conscience or violate the national interest, then I would resign the office...but I do not intend to apologize for these views nor do I intend to disavow either my views or my church in order to win this election.

If I should lose on the real issues, I shall return to my seat in the Senate, satisfied that I had tried my best and was fairly judged. But if this election is decided on the basis that 40 million Americans lost their chance of being elected president on the day they were baptized, then it is the whole nation that will be the loser.

John F. Kennedy, speech to the Ministerial Association, Houston, Texas, September 12, 1960

▶

Campaigning in Charleston, West Virginia, and in the countryside. Few seemed to care.

◀

While passing through Ona, West Virginia, Senator Kennedy stopped the car to meet the locals. Traveling in a separate vehicle, I had lost him minutes earlier, and the town was so small — three houses — that I had raced by it twice before spotting him and realizing that I was in the right place.

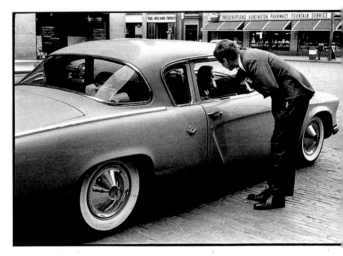

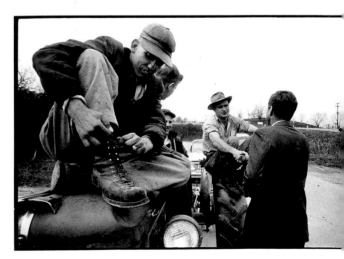

WEST VIRGINIA. 1960

49

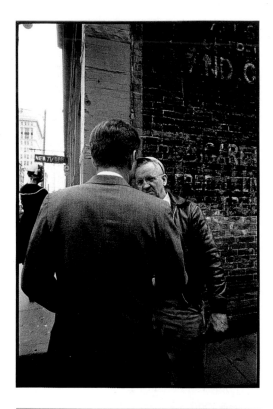

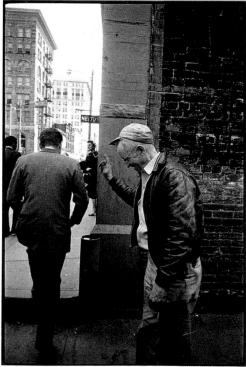

In the early days of the primary, Kennedy shook every hand, including that of this fuddled voter, standing on a city street corner. He had brought every relative, friend, and wartime comrade, anyone who would volunteer, into the campaign. Hubert Humphrey, his nominal opponent, had complained that he was a lone candidate running against a clutch of Kennedys nobody could tell apart. He had a point. When Bobby Kennedy appeared on *The Jack Paar Show*, a majority of viewers thought they'd watched the candidate. In the end, Kennedy won by a landslide, reversing the early figures, seventy/thirty, exactly. The Catholic issue had been laid to rest forever, and this small state finally gave Kennedy the credibility he needed to reach the pinnacle at the convention.

We Catholics believe that the first time you visit a Catholic church you could make three wishes, and I used to joke with Jack about it. We were in Anchorage, Alaska, and we had never been in this church, the Holy Family Church in Anchorage. We were walking down the aisle and I said, "Jack, don't forget the three wishes." And as he genuflected and looked down toward the altar, I heard him whisper, "New York, Pennsylvania, and Texas."

David F. Powers, special assistant to the President

You've got to appreciate the fact that I don't think any man in the history of American politics could have been more popular in his own locale than Kennedy was. He was the new look of the Irish, of everything that they had ever hoped for, a race that was downtrodden through the years....They had been second-class citizens for so many years — to see a fellow whose grandfather was born in the Old Country emerge as the president of the United States was just unbelievable.

Tip O'Neill, Speaker of the House

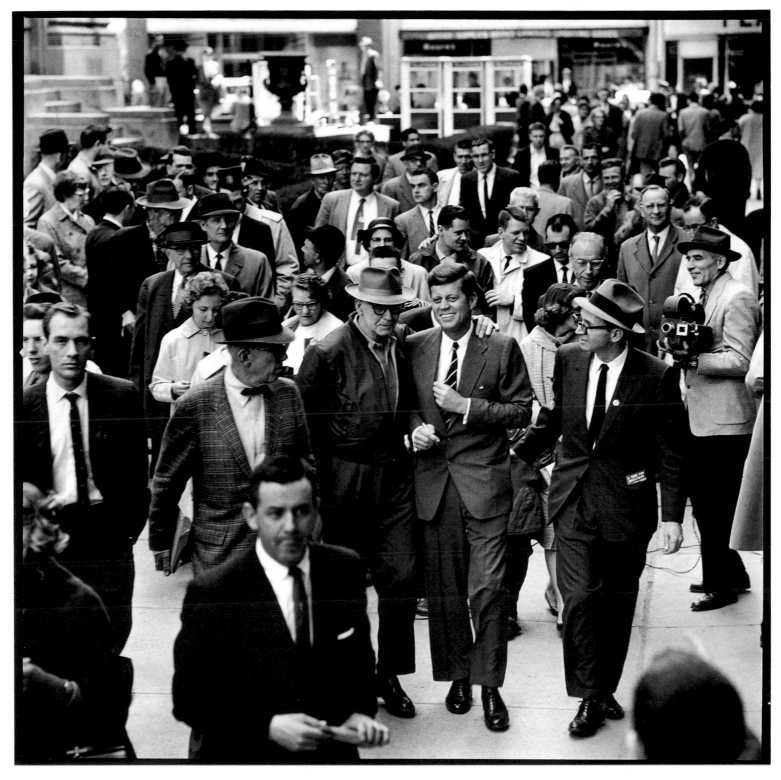

CHARLESTON, WEST VIRGINIA. APRIL 1960

Three days before the start of the Democratic Convention, I flew to Hyannis Port to take some color portraits of the candidate. Magazines, TV stations, and Kennedy headquarters in all fifty states were clamoring for them. I knew that it was nearly impossible to pin the Senator down for a quiet thirty minutes or so. I had to use a large format camera, black hood and all. And the task did prove nearly impossible. I first asked him to exchange ties with me, which he did reluctantly, though later he decided that he liked the tie and kept it. He fidgeted constantly, wanted to know what I thought of the current covers of *Time* and *Newsweek,* which both featured him. I told him to sit still because I had to focus.

"Why are we taking these pictures, Jacques?" he asked. "Because," I said, "there are a hundred million voters out there and you're running for president." "OK." And he sat still for a few minutes. Only one more time, later, in the White House, was I able to pin him down again for a formal sitting.

He told me to stay close to him when I got to the convention, a task easier said than done. The convention floor itself was a scene of sheer bedlam, resembling a war zone more than a political gathering. I was issued so many passes I didn't know which to display. But getting to the Senator's suite at the Biltmore Hotel, room 9333, proved nearly impossible. The corridor was packed with reporters speaking every conceivable language, there were favor seekers and groupies, some quite beautiful, as well as what seemed to be half of the L.A. police department. Fighting my way through I finally got to the door and pushed my way in, only to find that I was still three rooms away from the Senator's suite. The room was filled with Democratic office holders, governors and senators, state chairmen and millionaire donors, all hoping to get an audience with the leading candidate in this nomination process. I fought my way through the next two rooms until I finally found Steve Smith and Sarge Shriver, Eunice Kennedy's husband, the guardians of the candidate's door. They granted me safe passage into the Senator's suite. The problem was that Kennedy would duck out

The 1960 Christmas card. Jackie loved the picture of the two of them, but asked if I could replace Caroline's head with that of another picture from the sitting. I tried, but the available techniques in the early sixties did not allow it. We finally went with the original.

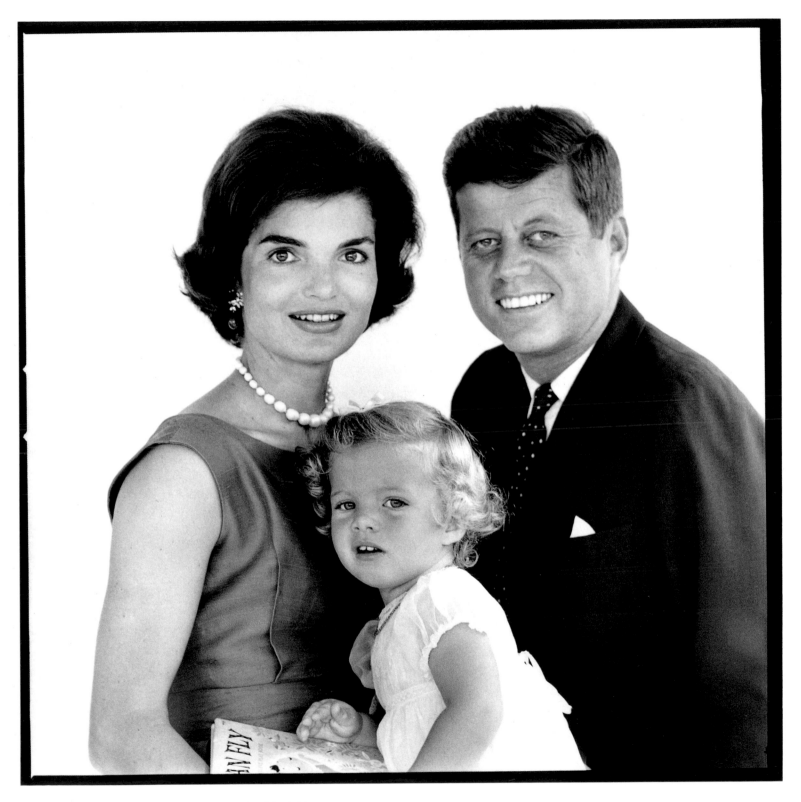

HYANNIS PORT, MASSACHUSETTS. AUGUST 1960

Room 8315 at the Biltmore Hotel in downtown Los Angeles was the nerve center of the Kennedy operation during the Democratic Convention in July of 1960. Bobby Kennedy, the campaign manager for his brother, had set up command posts and listening posts throughout the convention hall and at hotels where delegates were staying, and he had people working within every state delegation and every special interest group. His closest collaborators were his youngest brother, Teddy, and Steve Smith, his brother-in-law. It was a relentless and feverish effort. Kennedy had come to the convention with six hundred votes pledged to him on the first ballot, but he needed another 161 votes to bring him over the top. Although the candidate himself never entered the convention hall until the night of his victory, he tirelessly addressed every caucus and meeting of delegates he was physically able to. And Bobby's troops, coming to Los Angeles fresh from winning every primary war they had entered, were experienced political strategists by now. That experience was now being put to very good use.

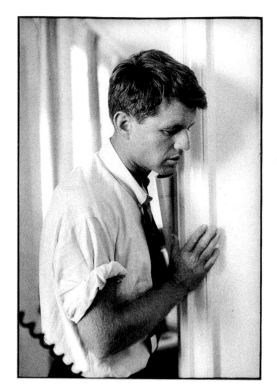

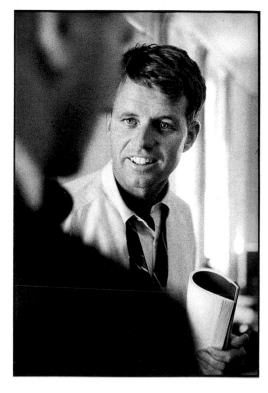 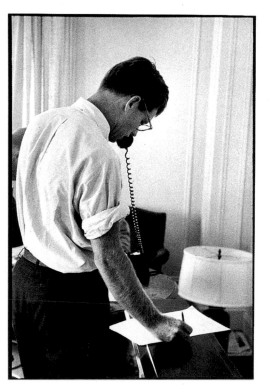

LOS ANGELES. JULY 1960

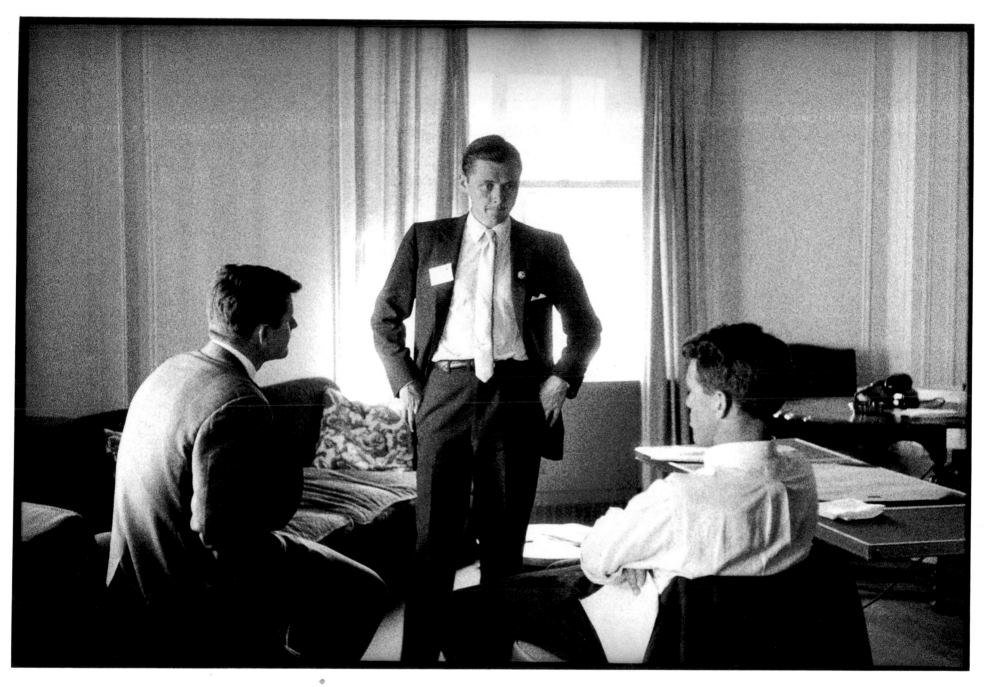

LOS ANGELES. JULY 1960

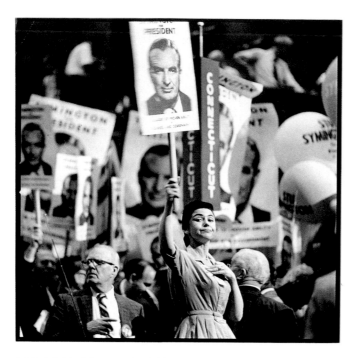

LOS ANGELES. JULY 1960

▲

All of the candidates had their moment in the sun and noisy demonstrations for various candidates punctured the days. But for most of them it was a peaceful last hurrah, except for Adlai Stevenson's demonstration, which jarred the mood of a generally good-natured convention. Lyndon Johnson was the only other candidate who had a real shot at the prize.

▶

Eunice Kennedy Shriver, Joan Kennedy, and Ethel Kennedy during the Kennedy demonstration. The poster image came from that first campaign trip I took to Omaha, Nebraska.

of the suite and ask me to follow him, but the minute he would step into the corridor he would be engulfed in a huge mass of human beings, all shoving and kicking and shouting. By the time we got to the elevator, I would have lost him. Most of the time I knew where he was going and I tried to get there by my own route, but at times I would lose him for hours and would simply return to the suite and wait. "Where were you when I needed you?" he would quip when he got back. I tried to explain, in vain.

I spent most of the nomination day on the convention floor, where a massive Kennedy command structure was in operation. Fifteen listening posts had been set up. Some forty men, many of them party leaders, had been assigned to specific state delegations. They had the names of each delegate and followed their moves closely. There were the usual demonstrations for rival candidates, all in the spirit of a kind of folk happening. But then an Adlai Stevenson demonstration interrupted the smooth proceedings. Following Senator Eugene McCarthy's nominating speech for Stevenson — "Do not reject this man…. Do not leave this prophet without honor in his own party…this favorite son of mine" — an ugly demonstration broke out. Stevenson, a confessed noncandidate, was staging his last hurrah with the help of some thousands of demonstrators smuggled into the hall. They poured on to the floor, screaming, squirming, hysterically snake dancing, and chanting, "We want Stevenson!" Tearing away state banners and pushing aside protesters objecting to the unruliness, they turned into a mob. The lights were turned off and McCarthy tried to calm them, but nothing could stop them. By my watch the demonstration lasted twenty-three minutes. It was a sad ending to the political career of a man I had voted for and admired. But then the convention settled down to nominate John F. Kennedy, while I stood anxiously on the floor next to Larry O'Brien, who later became White House congressional liaison, counting the votes.

The next morning I showed up early in Kennedy's suite. There was much telephone activity. And the Senator once again left, asking me to follow. I lost him and returned to the suite. He came back around 9:45 A.M. and at ten-fifteen Lyndon Johnson showed up. The three of us were alone in the room. There was some banter and then, to my complete surprise, Kennedy offered Johnson the vice-presidency. He accepted, aware that there would be a fight.

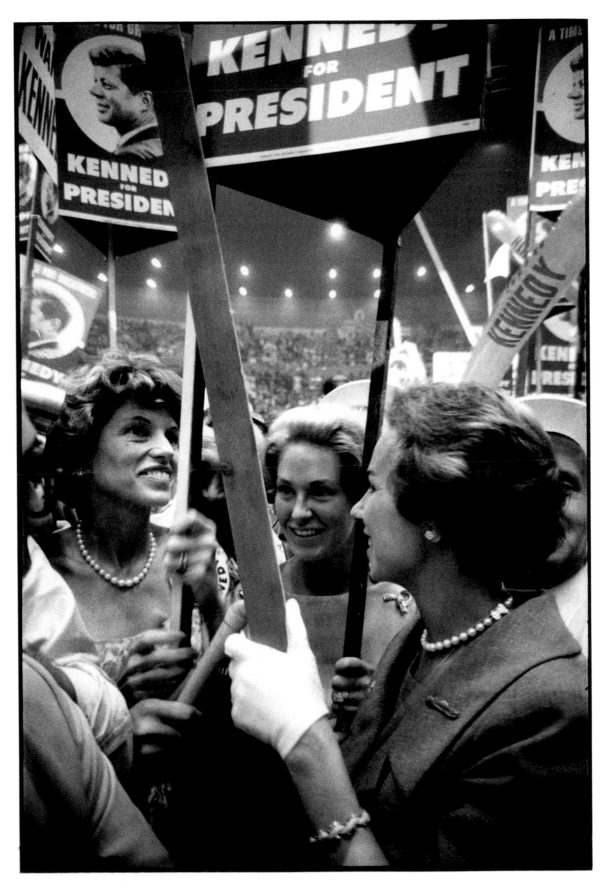

LOS ANGELES. JULY 1960

But he seemed very nervous, this cocksure, assertive, and often arrogant majority leader of the Senate. He realized that by accepting the Democratic nomination, he would lose his all-powerful position for a job that fellow Texan John Nance Garner, a colorful vice president under Franklin D. Roosevelt, had said "wasn't worth a pitcher of warm piss."

There was an open bar in Kennedy's suite, and Lyndon Johnson kept walking over to it, pouring himself generous portions of bourbon even at that early hour of the morning.

For the next few hours a stream of party leaders crowded the suite, some backing Kennedy's decision, but most totally against it. After all, his support had come from the liberal wing of the party and not from the conservatives who had backed Johnson all along. But by four-thirty in the afternoon, Kennedy and Johnson, this time joined by Bobby Kennedy, who had also been against the Johnson decision, sealed the agreement. I was there to photograph it all.

I was aware that I had just been present at a historic occasion. Yet I was still very naive and unsophisticated and only partially understood the momentous event I had just been a part of. I had not only been an eyewitness to a moment in history that would change the world forever, but I had actually photographed it. Within minutes the news was out, provoking unprecedented public anger and reaction among many Democrats. Kennedy was villified by the Stevenson wing of the party. Yet there had been no television, no pool camera, no press at all recording the events. Had I been aware of this I would have notified my major magazine clients around the world, because disbursing visual information was one of my assignments, and this one was certainly worth printing. And I wouldn't have been indiscreet in releasing the pictures, an issue I always had to consider. But Pierre Salinger, in charge of the press, was probably unaware that I was even there. And Bobby, who knew, had other things on his mind.

That night I had a dinner date with Norman Mailer, my New York neighbor. At the table were Peter Maas, a reporter for *Look* magazine, Clay Felker, editor of *New York* magazine, Shelley Winters, a Kennedy supporter, and several others. When the conversation turned to the Johnson nomination I casually mentioned that I had photographed it. The table came to a stunned silence and Maas and Felker bolted to the nearest telephone. *Look* magazine eventually ran the story with captions by JFK. Stage one of the odyssey had been completed, and the critical part was now beginning.

The morning after receiving his party's presidential nomination, an elated Senator Kennedy scans the newspapers. It had been a tough, and at times close, contest, bitterly dividing liberals and conservatives, big-city and Western delegates, and, because of the Stevenson demonstration, each faction within itself. Kennedy knew that he needed all factions, and a few nonideological Republicans to boot, to win the presidency. While he was going through the papers in his suite, the fight for the vice-presidency and the soul of the party was already under way in the adjoining rooms, where all the factional leaders were impatiently waiting to present their strong views to the party's standard-bearer. It was to be a fateful day.

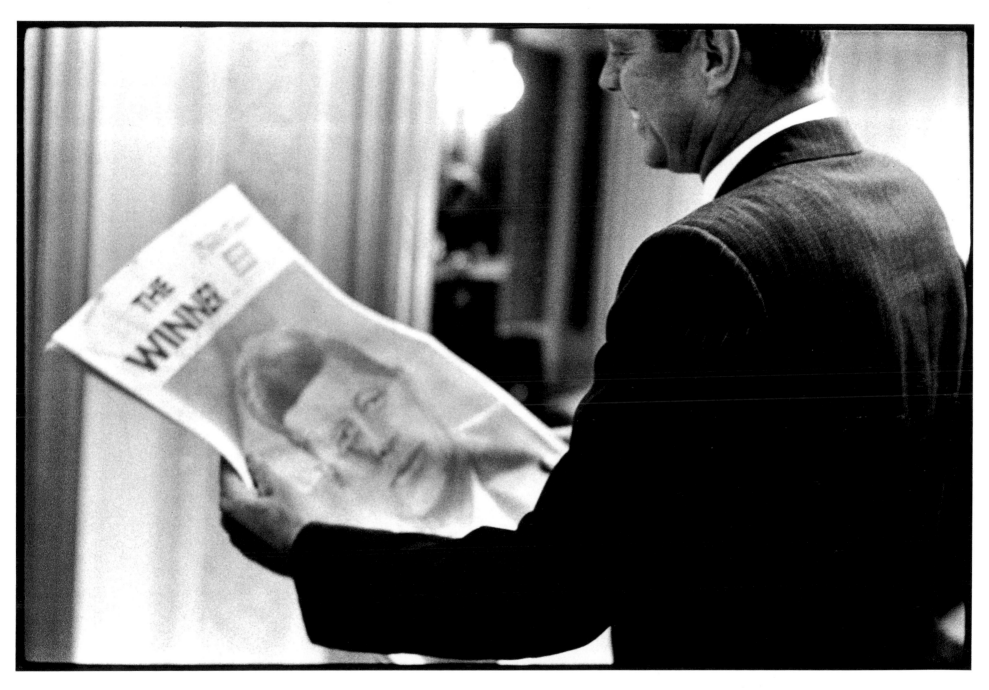

LOS ANGELES. JULY 1960

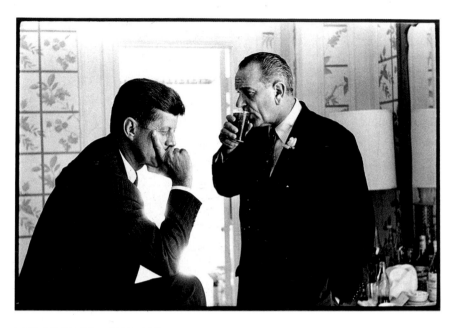

LOS ANGELES. JULY 1960

He [Jack] was really the one who formulated the strategy. There were day-to-day decisions once he set down the general guidelines, and these would be made by others, but he made the general decisions. He won all the primaries even though he had tremendous handicaps — number one, his religion; number two, his youth; and number three, lack of the kind of experience that Nixon or Lyndon Johnson had. During all of those primaries and then during the campaign after he got the nomination, Mrs. Kennedy was extremely important and made a major difference.

Robert Kennedy

◀

Kennedy captioned this picture himself in an article I subsequently published in *Look* magazine about the Johnson nomination: "10:15 A.M. I asked Lyndon Johnson if he were available for the vice-presidency. He told me that he was. He then suggested that I discuss the matter with various party leaders while he conferred with his own advisers."

▶

Kennedy again:. "4:30 P.M. After discussion with some of the party's leaders, it was agreed that Lyndon would be the strongest possible candidate for vice-president. I called him on the phone again, and he said, 'Jack, if you want me to run, I'll do it.' After I had talked to Lyndon I heard that certain other party leaders, including some in labor, were unhappy. I sent my brother Bobby down to Lyndon to tell him there might be a fight on the convention floor. He told Bobby, 'If Jack wants me for vice-president, I'm willing to make a fight for it.' I told Bobby that if Lyndon was ready to fight, so was I. I informed Clark Clifford, Senator Stuart Symington's adviser, of my decision. I also told Senator Henry Jackson of Washington, who had been under serious consideration. Then we made the announcement."

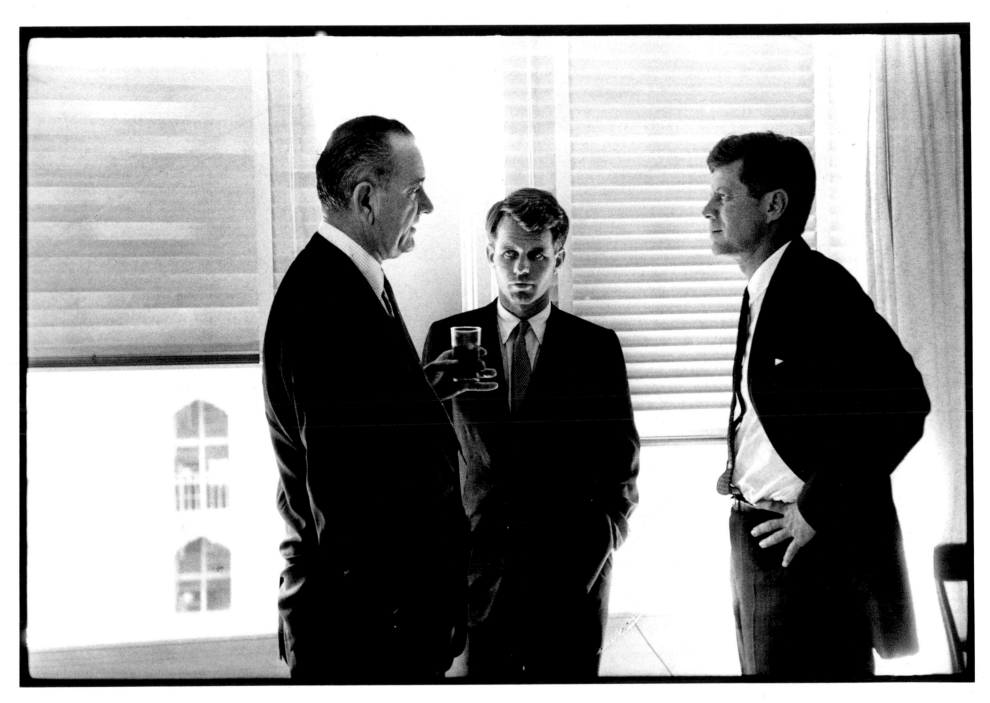

LOS ANGELES. JULY 1960

...The message came to the President that maybe Lyndon Johnson would be interested in it [the vice-presidency]. We couldn't believe that he would, but Jack decided that he'd go down and talk to him about it. To his great surprise, Lyndon Johnson indicated that he was interested. We made an assessment and started talking to various political leaders, and some of them were in favor of him, some of them were against it. Then we decided that it wasn't a good idea, and then we decided it was a good idea, and we argued back and forth and discussed it for most of the day. But finally the President decided, this is different than it's ever been printed, that I would go down...and see if I could talk him out of it. I would say to him that there was going to be a floor fight and it would be unpleasant, that he shouldn't do it, but he could have the head of the Democratic National Committee instead. So I went down and had that conversation, and he started to cry a little bit.

So I said, "Whatever you want to do we'll make the fight, but I wanted you to know there'd be a fight." So we put out the announcement. And so Lyndon Johnson became vice-president.

We changed and rechanged our minds probably seven times. The only people who were involved in the discussions were Jack and myself. Nobody else was involved in it.

Robert Kennedy

Kennedy again: "6:30 P.M. This had been a day to remember. It also had been a long and difficult one, which involved a number of decisions, many of them contested. But throughout this day — as through all the others before it — my brother had been constantly at my side, giving me his support and counsel. One campaign had ended. Another was now about to begin."

In actuality Bobby had argued vigorously against the Johnson nomination and he never really accepted it. But his loyalty remained with his brother and he defended the nomination to all his liberal friends. In the end Kennedy's decision was the right one in the short term. Lyndon won Texas for him, a crucial state, without which Kennedy would have lost the election. In the long run that decision doomed the country to a division not experienced since the Civil War.

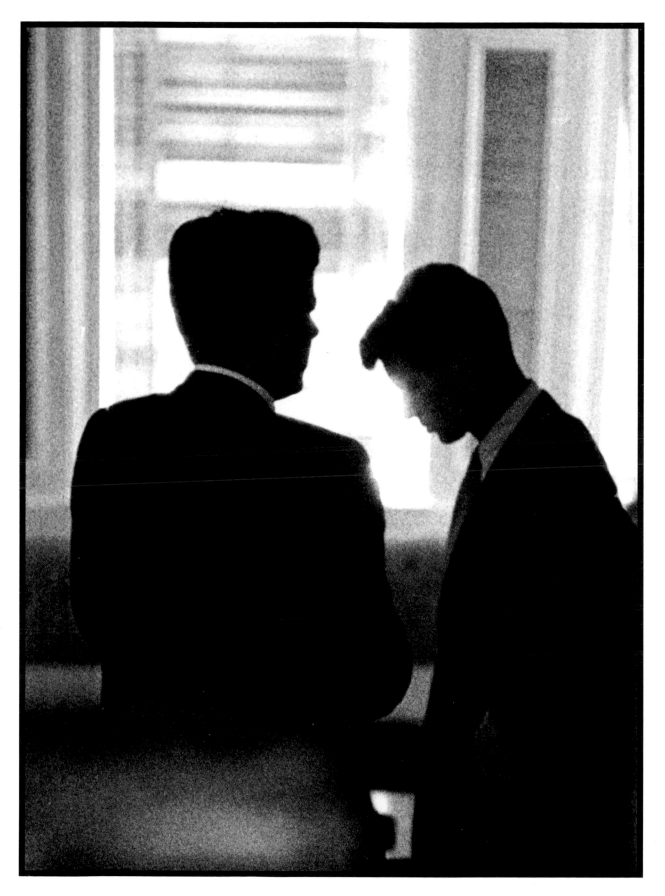

BILTMORE HOTEL, LOS ANGELES. JULY 14, 1960

...I think the American people expect more from us than cries of indignation and attack. The times are too grave, the challenge too urgent, the stakes too high to permit the customary passions of political debate. We are not here to curse the darkness, but to light a candle that can guide us....Today our concern must be with the future. For the world is changing. The old era is ending. The old ways will not do....The problems are not solved and the battles are not all won — and we stand today on the edge of a New Frontier — the frontier of the 1960s — a frontier of unknown opportunities and perils — a frontier of unfulfilled hopes and threats....

The New Frontier of which I speak is not a set of promises — it is a set of challenges. It sums up not what I intend to offer the American people, but what I intend to ask of them. It appeals to their pride, not their pocketbook — it holds out the promise of more sacrifice instead of more security....

Can a nation organized and governed such as ours endure? That is the real question. Have we the nerve and will? Can we carry through in an age where we will witness not only new breakthroughs in weapons of destruction — but also a race for mastery of the sky and the rain, the oceans and the tides, the far side of space and the inside of men's minds?...

It has been a long road...to this crowded convention city. Now begins another long journey....

Give me your hand, your voice, and your vote.

John F. Kennedy, presidential nomination acceptance speech, July 15, 1960

Kennedy's acceptance speech on Friday, July 15, at the Los Angeles Coliseum, normally the home of the Dodgers, was the equivalent of a Democratic love-in. The 100,000-capacity baseball stadium was packed. Kennedy was surrounded by his family except for Jackie, who was home in Hyannis Port, pregnant with John-John, and his father, who had decided to remain inconspicuous and watch the proceedings from the home of Henry Luce, the publisher and editor in chief of Time-Life. Every defeated candidate was present — Humphrey, Symington, Stevenson, Jackson, Johnson, and the patron saint of Democratic liberalism, Eleanor Roosevelt — all taking their turn proclaiming Democratic unity and all singing the praises of their young standard-bearer. It was quite a show. And I vividly remembered some earlier words uttered by these same men and women.

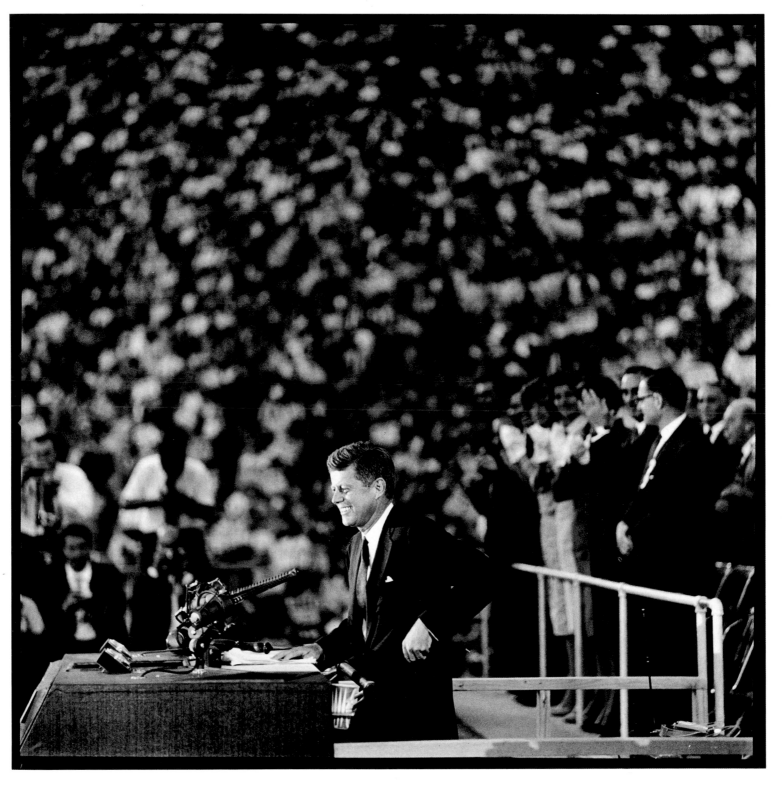

LOS ANGELES. JULY 1960

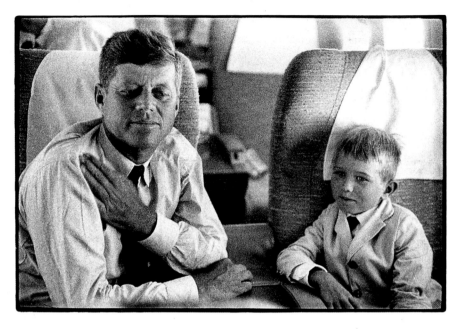

FLIGHT TO BOSTON. 1961

◄

The four-hour-fifty-eight-minute
flight back to Boston, for those of
us who had been invited on to
the "Kennedy Special," a chartered
commercial jet, was a continuous
party. Kennedy himself remained
in his seat most of the time,
chatting with Bobby's children.
He was leaving behind him two
long years of daily grinding
campaigning, many moments of
euphoria, and times of deep
disappointment. But the hour was
his and he was looking forward to
a short rest before facing his
Republican opponent, Richard
Nixon, who had been nominated
earlier at his convention.

►

On arrival in Boston, a crowd of
fifteen thousand was waiting for
us, the largest we had ever seen.
But we all knew as well that this
was Boston. How the rest of the
country would make its choice, no
one could even guess.

*I cannot assure you that the road ahead is an easy one —
because I know it will not be easy, and our journey will
require effort and sacrifice. But I believe that the people of
this state — and the people of all America — can again
begin its forward march. For I believe that we all share the
faith of a great son of North Carolina, Thomas Wolfe,
when he wrote: "I think the true discovery of America is
before us. I think the true fulfillment of our spirit, of our
people, of our mighty and immortal land, is yet to come."*

John F. Kennedy, campaigning in North Carolina, fall 1960

BOSTON, MASSACHUSETTS. 1961

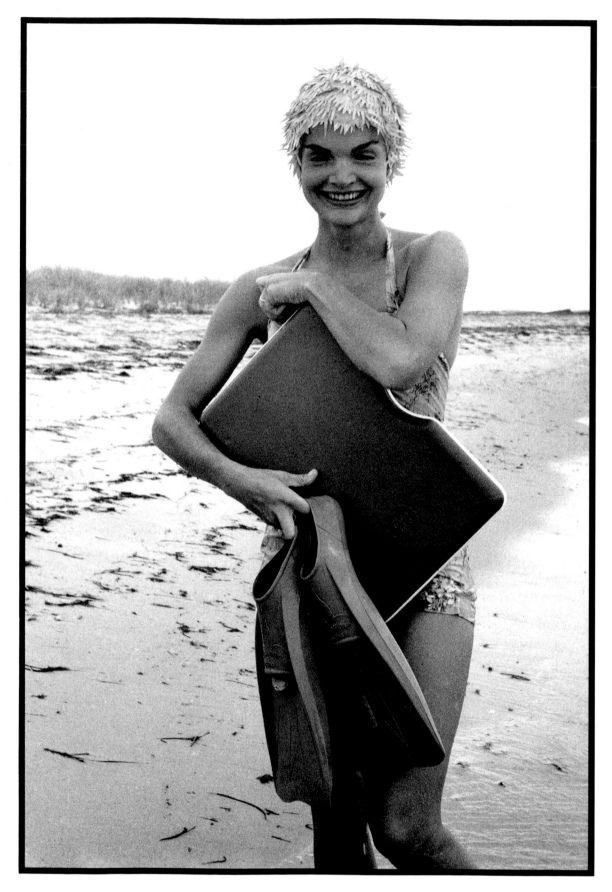

HYANNIS PORT, MASSACHUSETTS. AUGUST 1960

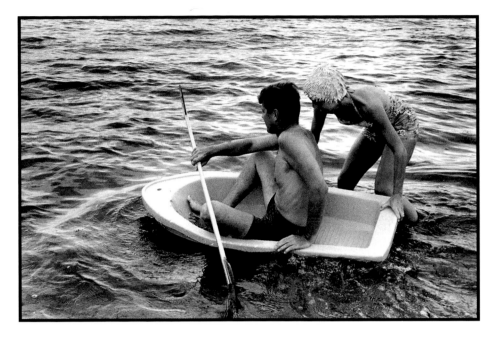

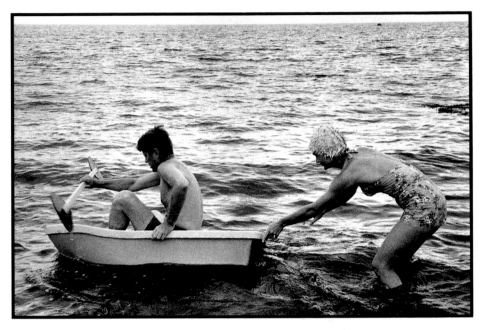

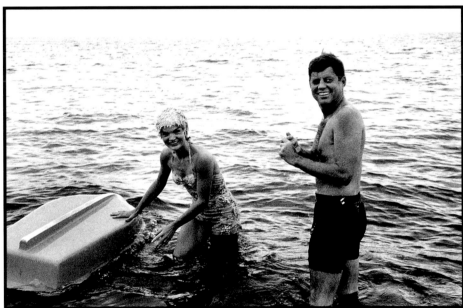

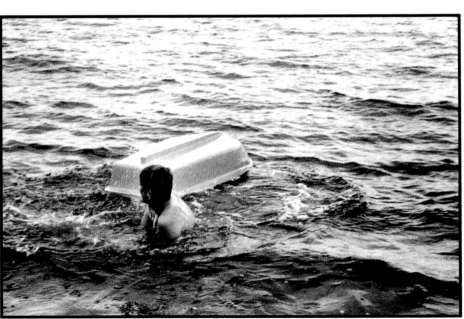

The year 1960 offered few moments of relaxation. Starting with the primaries, where Kennedy normally slogged through eighteen-hour days, many starting at the crack of dawn in the East and ending late at night in California, the young candidate, often in pain due to his bad back, wasn't given much rest. The convention, where he triumphed over seven other candidates, finally ended this most demanding phase of the campaign and he was able to spend two weeks in relative peace at his beloved Hyannis Port before diving into the general campaign against Richard Nixon. Here, on one of those weekends, Kennedy and Jackie enjoy a carefree romp in the sea with the aid of a boat more akin to a bathtub.

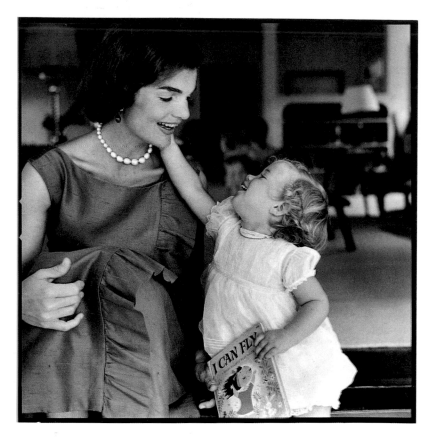

HYANNIS PORT, MASSACHUSETTS. AUGUST 1960

▲
Caroline and Jackie on the porch of their Hyannis Port house during the August lull between the convention and the start of the general election campaign.

▶
Between the end of the Democratic Convention and the beginning of the general election campaign on Labor Day, JFK enjoyed himself enormously. Here he relaxes with Jackie and Caroline, sitting on the stoop of his house in Hyannis Port after a day of golf and sailing. *I Can Fly* was Caroline's favorite book.

Why did Kennedy's death affect us so deeply? He obviously had enemies but he had many supporters. Some people literally worshiped him. To this day, in some ethnic communities, a picture of JFK hangs prominently next to that of Jesus Christ. I don't think it was so much what he accomplished but what he stood for that inspired such adoration.... I believe it was rather the perception of JFK and his family that affected people.

When the Kennedys moved into the White House, they became America's own Royal Family. Knowing that stories about royalty sell, the news media coined the term "Camelot," which enhanced that impression. Media-enhanced or not, however, I personally believe the most important thing the Kennedy era gave my generation was hope. As the President spoke with confidence about limitless opportunities, and Mrs. Kennedy gave encouraging speeches to Hispanics in fluent Spanish, America dared to hope. The Peace Corps seemed a great idea, that we might bring our knowledge and "can-do" attitude to other countries of the world. No matter that there was money to be made by American industry introducing its technology to Third World countries; most people didn't think of it that way. Strength was added to his image when Kennedy stood up successfully to Nikita Khrushchev during the Cuban Missile Crisis. Khrushchev "blinked" and the President earned his stripes.

Because a lot of people in my business are successful based more on publicity than talent, I am somewhat skeptical about media creations. However, in Kennedy's case, I think the image — part truth, part illusion — was a positive thing. It gave the nation a sense of hope in the post-Eisenhower years, a sense of energy, of a limitless future to do with whatever we desired. When Kennedy died, the image and dream died with him. Although successive presidents have accomplished more than Kennedy, they never captured the magic that surrounded him, unique to that particular time and that particular presidency.

Carole King, in a letter to the author, December 1992

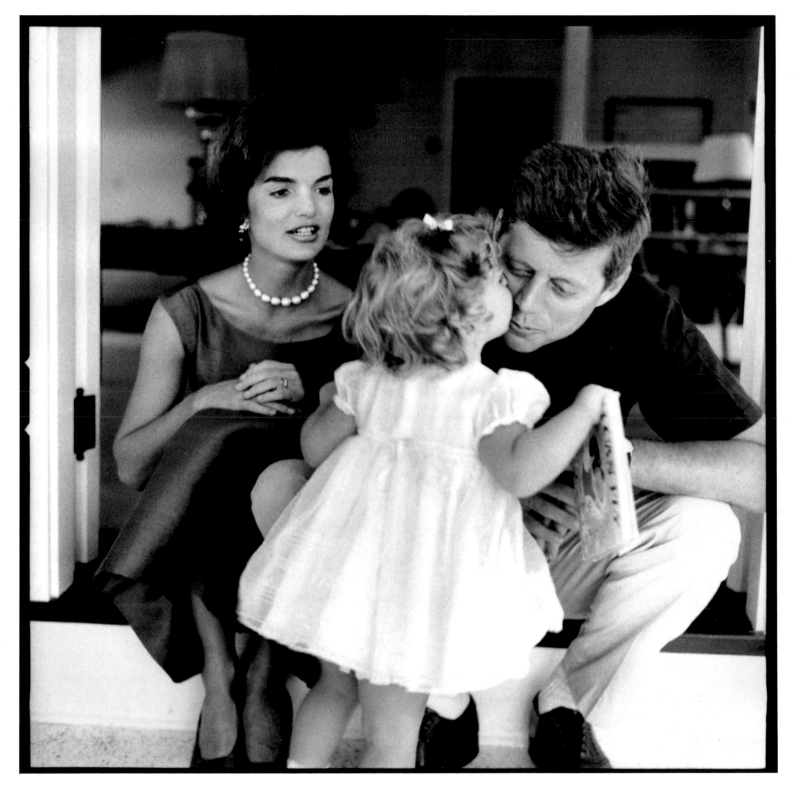

HYANNIS PORT, MASSACHUSETTS. AUGUST 1960

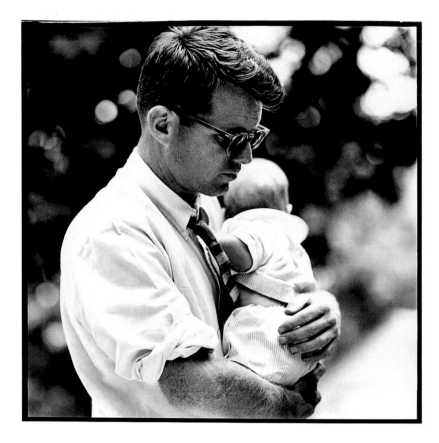

MCLEAN, VIRGINIA. 1961

▲

Bobby Kennedy holding his young son Michael in the garden of his home in McLean, Virginia. Bobby was then the attorney general.

►

Bobby with David in 1958. It is one of my favorite photographs and expresses very well how I felt about him.

I had first met Bobby Kennedy in 1956. Our friendship had led to the privilege of covering the Kennedy campaign and, later, the White House. From first meeting him I had admired his talent for fatherhood. Although a tireless worker at whatever job he was performing, as committee counsel, as campaign manager, and finally as attorney general, he always had time for his children. He would bound up the steps of his McLean, Virginia, home from a long day at work, and his tie would come off, the jacket would be removed, and, if it was summer, a football would be in his hands within seconds and a game would start. He would never tire of listening to his children's problems or woes or stories of achievement. He would caress and hug them, yet cheer them on to victory against whomever the Kennedys were playing. There was true love in Bobby. And his children responded to that love.

When he ran for president himself years later, his compassion for the underprivileged, especially the children of the poor, had become legendary. His visits to the Mexican grape-farm-worker communities in California or to Bedford-Stuyvesant in Brooklyn were punctuated by tales of his concern for the children. When he too was assassinated, the first thing I thought of was the children. How could they ever cope with the death of such a man, such a father, with the absence of such love? And of course they couldn't. David, seemingly his favorite from my observation, and a wonderful little boy, died of an overdose. It took many of his other ten children a very long time to come to grips with their loss, as it did for so many of us who knew him.

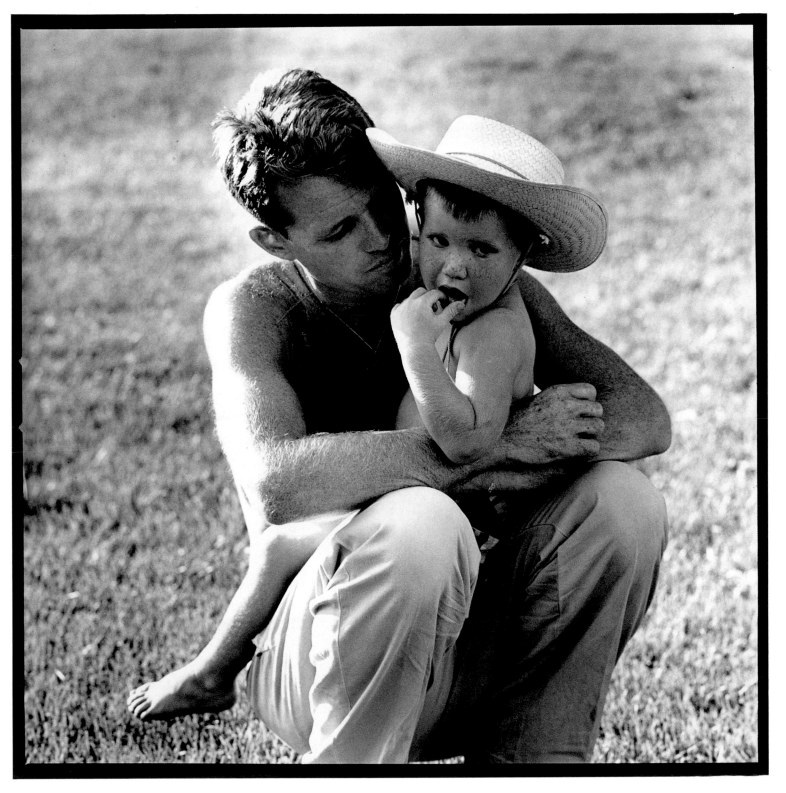

MCLEAN, VIRGINIA. 1958

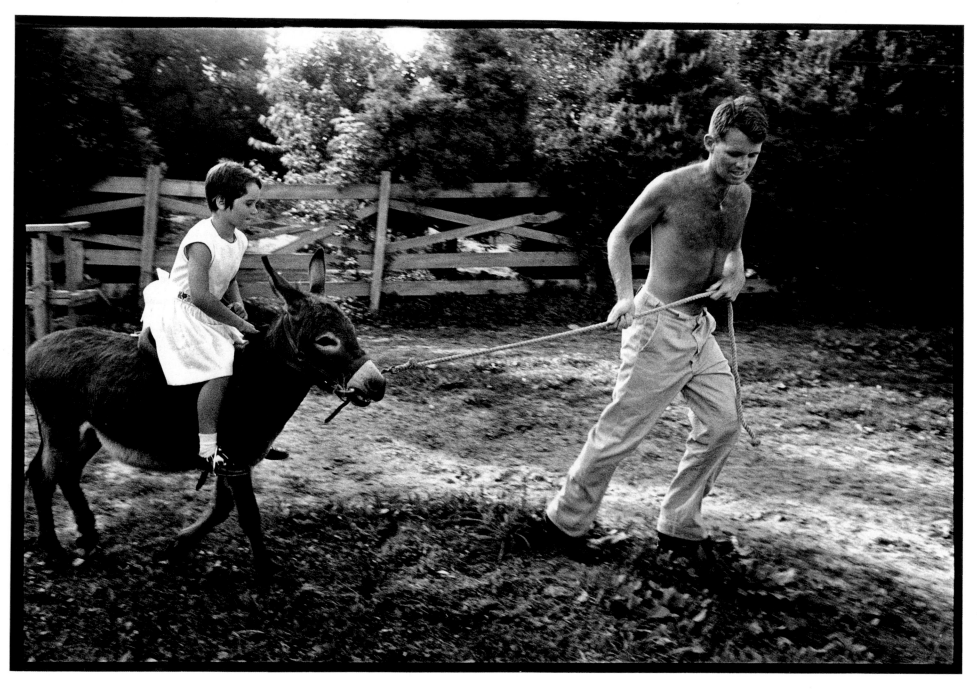

MCLEAN, VIRGINIA. 1958

I think he always saw like my father, always saw the bright side of things, and recognized the problems, but I think he really assessed what was happening, what he was doing over a period of years, even though he'd get upset with what the newspapers were writing, because he was a perfectionist.

He thought that a good deal more needed to be done domestically. The major issue was the question of civil rights.... In January he thought that we really had to begin to make a major effort to deal with the unemployment and the poor in the United States. He thought that was going to cost several billions of dollars each year, and that if he wanted to get the tax bill by, he couldn't then come in with a program which was going to cost billions of dollars.

I used to ask my brother each week about whether he liked the job. And he always answered he did.

Robert Kennedy

MCLEAN, VIRGINIA. 1956

◄

Bobby and his daughter Kathleen.

▲

The first time Bobby invited me to his house for dinner, in 1956, following the third surprise photographic session with this important young majority counsel of the McClellan Labor Management Committee, I walked straight into this pillow fight. Having watched him in action with a couple of labor crooks that afternoon on Capitol Hill, this was quite a surprising change of scene.

HAMTRAMCK, MICHIGAN. SEPTEMBER 1960

▲

At the height of the campaign we would often
encounter groups of men and women who would
watch silently, almost as though in reverence. Often
they represented minority groups — Russians, Poles,
Ukrainians. They would compare Kennedy with
Franklin Roosevelt, their hero, whenever one
engaged them in conversation. Many years later
these men and women would come to be known as
the Silent Majority.

▶

As the campaign built, so did the crowds.

The few weeks between the end of the convention and
the beginning of the general election campaign, which
would start on Labor Day, were probably the only care-
free period that the future president would be able to
enjoy for the rest of his life. It was a beautiful summer
and he spent the time in Hyannis Port by the sea, at
his summer home and close to his extended family. So
did I. There was much sailing, swimming, and touch
football, and playing with Caroline and her cousins.

All wasn't play, however. Endless delegations showed
up to pay their respects and present their case. I
remember Jackie coming down for breakfast one day,
looking for a peaceful place to enjoy her coffee. The
sitting room had been turned over to a minorities
meeting with Poles, Slovaks, and Hungarians, all
chatting away in their native language and shouting
into phones. An astonished Jackie turned to the
porch, where a group of Boston supporters, chewing
on huge cigars and enveloped in smoke, and their
wives waited for the candidate. Shaking hands all
around, she next went to the dining room, where the
candidate, deep in negotiations, frantically waved her
away. Finally she tried the kitchen, where Salinger
was conducting a press conference. Dumbfounded,
she went back upstairs.

For me the quiet interlude also presented me with my
first conflict. A good friend, Chuck Saxon, the editor
of *Modern Screen,* later to become a distinguished
cartoonist for *The New Yorker*, had offered to do a
twelve-page layout about John F. Kennedy and his
family. From time to time I had photographed movie
stars for Chuck: Marilyn Monroe, Tony Curtis and
Janet Leigh, Kim Novak, Tuesday Weld, and many
others. Now *Vogue* magazine wanted the same
pictures, but they wanted exclusivity. Jackie asked me
to give the pictures to *Vogue*. But I knew that *Vogue*'s
circulation was about a tenth of that of *Modern Screen*

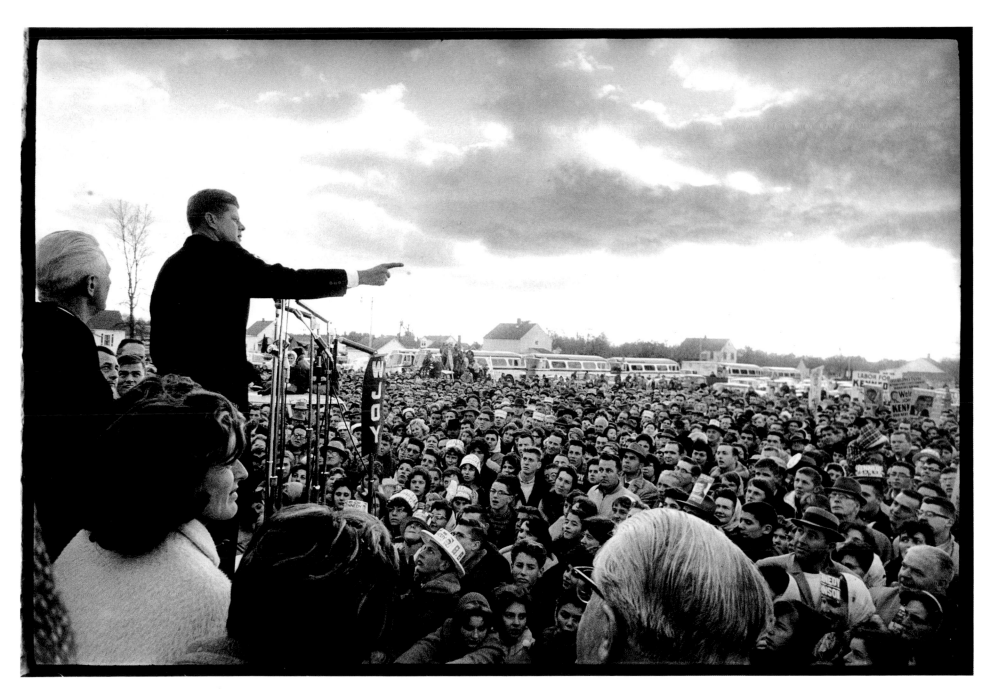

KANSAS. FALL 1960

MICHIGAN. FALL 1960

As the campaign neared its zenith and the prize to be decided upon by the American people on Election Day came nearer, Kennedy's campaign stance became more belligerent, his rhetoric more powerful, his gestures more purposeful. His finger would shoot out at the audience in making a point, and he showed anger, as well as his by then well-established sense of humor. The crowds were getting enormous, the audience more partisan — and at times unruly. They wanted to touch him, tore buttons off his coat, bloodied his hands. He reminded Nixon, who was running on his "experience" of having stood up to Khrushchev, faced the mob in Venezuela, and was present during the great decisions of the Eisenhower years, that he might have been present, but he hadn't made the decisions. And he was aided by Ike, who when asked by the press what decisions Nixon had made, replied, "Give me a week and I'll think of one."

and my job was broad disbursement. I also realized that *Vogue*'s readers, fur coats and all, would be more likely to be Nixon supporters. I was in a dilemma. So I took my case to the candidate, who without hesitation ordered me to send the pictures to *Modern Screen*. "Would you please explain your decision to Jackie, Senator?" I asked. "You explain it to Jackie. You tell her there isn't one vote for me among that bunch of rich b-----s." "Yes, Senator, thank you, Senator." I wished to God I hadn't asked.

Soon the campaign, with Richard Nixon as the opponent, started in earnest. By then I had been appointed the official photographer. One day while I was boarding the plane, someone had attached an OFFICIAL button to my lapel. I had not asked for the job, nor even discussed it. I was simply appointed. And my assignment had been clarified…somewhat. I was to feed TV stations, small dailies, and rural weeklies with pictures of the candidate and the campaign as frequently as possible. I was also to supply state chairmen and party organizations with photographs of the campaign. And finally, I was to work with the publications staff to supply special images, Kennedy with the elderly, with the young, with labor, with management, Kennedy and the minorities, etc. Most of these pamphlets were in English but some were in foreign languages, from Spanish to Chinese. A *New Frontier* internal paper was published at regular intervals. And then there were the buttons — J'AIME JACK and VIVA KENNEDY — and the fliers and the stickers, all carrying pictures of the candidate. And of course there were posters.

I would travel with Kennedy for two weeks, rush back to New York, develop and print what I had, and distribute the resulting images. Not once during the entire campaign did anyone, let alone the candidate, ask me what I was sending out or why I was choosing certain images.

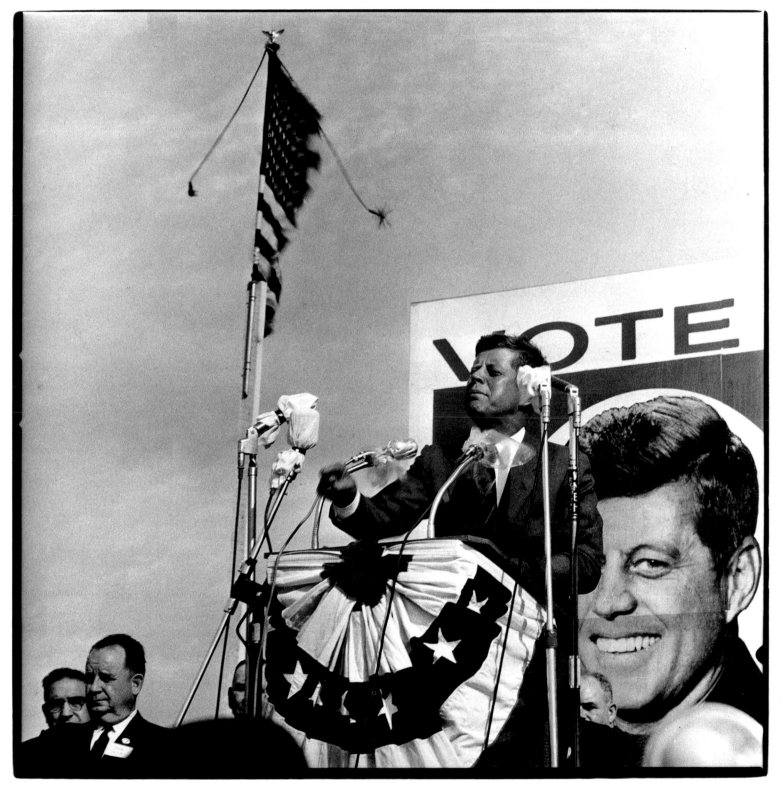

WISCONSIN. FALL 1960

The Nixon-Kennedy debates changed the entire campaign. Where, until that moment, the two campaigns had run neck to neck, with Kennedy still slightly the underdog, the debates altered that equation. Nixon, running on his record as a successful Communist-bashing vice president, who had stood up to the anti-American mobs in Venezuela and had faced Khrushchev down in the famous "kitchen debate," had belittled JFK as an inexperienced upstart. He had called Kennedy a callow youth applying for a man's job. Suddenly Kennedy, facing the television cameras and the questions on an equal basis, not only came across to the vast audience as the equal in statesmanship to Nixon, but he looked better, seemed more at ease, quicker on his feet. More important, the public perception of him changed; the playing field had been leveled. And his name and face became as well known as Nixon's.

On the night of the first debate, Monday, September 26, I had driven from New York to Boston to document the Kennedy Foundation, a charitable organization helping the mentally retarded, especially children. I had tuned in my car radio and therefore had missed the image of the confident, cool senator facing the sweating, tense, and haggard-looking vice president. And listening, there was no doubt in my mind that Kennedy was in control of that debate, and at least an equal. Of course, I was a partisan, but I didn't find it too difficult to dismiss those pundits who in the next day's newspapers either declared Nixon the winner or called it a draw. And the vast majority of people agreed with my judgment. Following the debates our crowds grew from large to spectacular, from 10,000 to 25,000 and from that number to 100,000 and more. It was beginning to be difficult to imagine how Kennedy could ever even come close to losing this election.

NEW YORK. SEPTEMBER 26, 1960

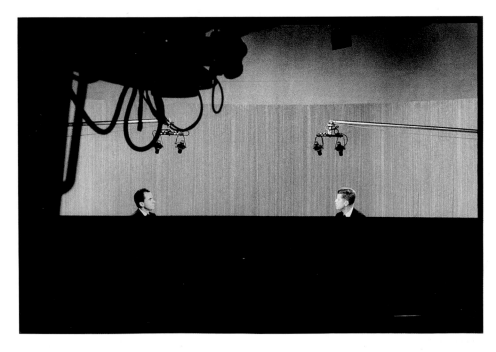

NEW YORK. SEPTEMBER 26, 1960

Top: Jackie Kennedy, now very pregnant, watches the fourth debate in New York with her sister, Lee Radziwill, in a private screening room built by ABC for the Kennedys' special guests. Left: The view from the screening room of JFK and Nixon during the debate. Right: Bobby joins Jackie during the debate.

NEW YORK. SEPTEMBER 26, 1960

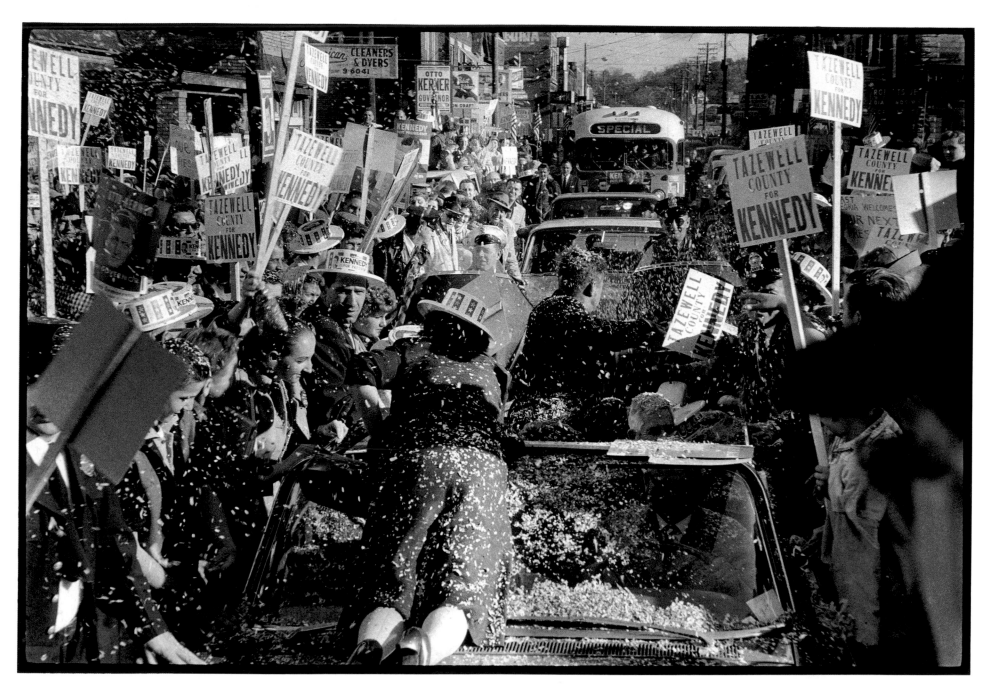

PEKIN, ILLINOIS. FALL 1960

It was also a time of little sleep and few decent meals. On a typical day we would leave our hotel at 7:00 A.M., hop across the country, making twenty stops, and arrive at our destination three hours late, often around 3:00 A.M. and long after the chicken dinner had shriveled. Wake-up time would be 6:00 A.M. And not all of it was breathtakingly exciting.

This was a typical day:

3 A.M. (C.D.T.) .
Arrive Lambert Airport, St. Louis

9:15 .
Democratic breakfast, Park Plaza Hotel

9:30 .
Depart Park Plaza Hotel

9:35 .
Arrive Crestwood Shopping Center/Rally

10:05 .
Depart Crestwood Shopping Center

10:50 .
Arrive Northland Shopping Center/Rally

11:20 .
Depart Northland Shopping Center for airport

12:00 P.M. .
Arrive Lambert Airport

12:20 (C.S.T.) .
Arrive Joplin Airport/Rally

1:05 .
Depart Joplin Airport for Wichita, Kansas

2:15 .
Arrive Wichita Airport. Motorcade to Lawrence Stadium

2:30 .
Arrive Lawrence Stadium

3:00 .
Depart Lawrence Stadium for Wichita Airport

3:30 .
Leave Wichita Airport

4:30 .
Arrive Richards–Gebaur Air Force Base, Grandview, Missouri.
Motorcade to Truman Shopping Center

4:45 .
Arrive Truman Shopping Center

5:15 .
Depart Truman Shopping Center

PITTSBURGH, PENNSYLVANIA. FALL 1960

◀
Toward the end of the campaign the crowds became uncontrollable. Here, in Pekin, Illinois, a veritable mob threw themselves onto Kennedy's open car, tearing the buttons off his coat and causing his hands to be sore at night from relentless pressing of the flesh.

▲
Kennedy's speeches had a curious effect on some in the audience, especially young women. Some young girls would stand and watch in silent rapture, then break into tears when Kennedy came anywhere near them. Others would howl and scream and kick their feet as soon as he smiled or asked for their help. At times the uproar was so great that he couldn't get his words or program across. "Touch him for me, Gladys," shouted one young girl, who couldn't reach Kennedy, to a friend who was more fortunate. And the crowds finally dispersed with fire in their bellies. Where Stevenson had left his audience murmuring, "Great speech," Kennedy had them marching out, registering voters and ready to do battle.

5:45 .
Arrive Muehlebach Hotel, Kansas City, Kansas. Rest and dinner.
A very special day.

8:00 .
Depart hotel for auditorium

8:30 .
Televised speech from auditorium

9:15 .
Depart auditorium for Kansas City, Missouri

9:30 .
Arrive fund-raising dinner, Shawnee Mission East High School

9:45 .
Depart fund-raising dinner for Richards-Gebaur Air Force Base

10:00 .
Arrive Richards-Gebaur Air Force Base

10:15 .
Leave for Green Bay, Wisconsin

12:45 A.M. .
Arrive Green Bay, Wisconsin

That was the schedule. We arrived in Green Bay ninety
minutes late, at 2:15 A.M., and reached our hotel at 3:00 A.M.
What energized me was the Senator's energy. He was fifteen
years older than I was, and in the mornings, when I would
stumble out of my room, he was up and about, looking
perfectly rested, giving interviews and signing autographs.

Meanwhile the crowds were getting denser and more
partisan all the time. And following the first debate with
Richard Nixon, they were getting huge. Two days before
election day, a crowd estimated at thirty two thousand waited
for us in a streaming rain in Waterford, Connecticut. We
had left Bridgeport, Connecticut in a motorcade at midnight,
with huge crowds lining the streets all along the way, and
we stopped constantly. By the time we reached Waterford,
at 3:00 A.M., we were hours late for the scheduled speech.
They had waited.

On the last day of the campaign, Kennedy returned to Boston, where a huge crowd of young people rushed at him. He was on his way to Hyannis Port. The campaign was over.

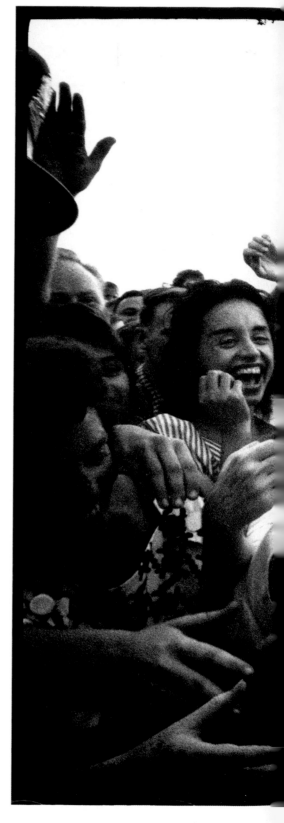

BOSTON. FALL 1960

84

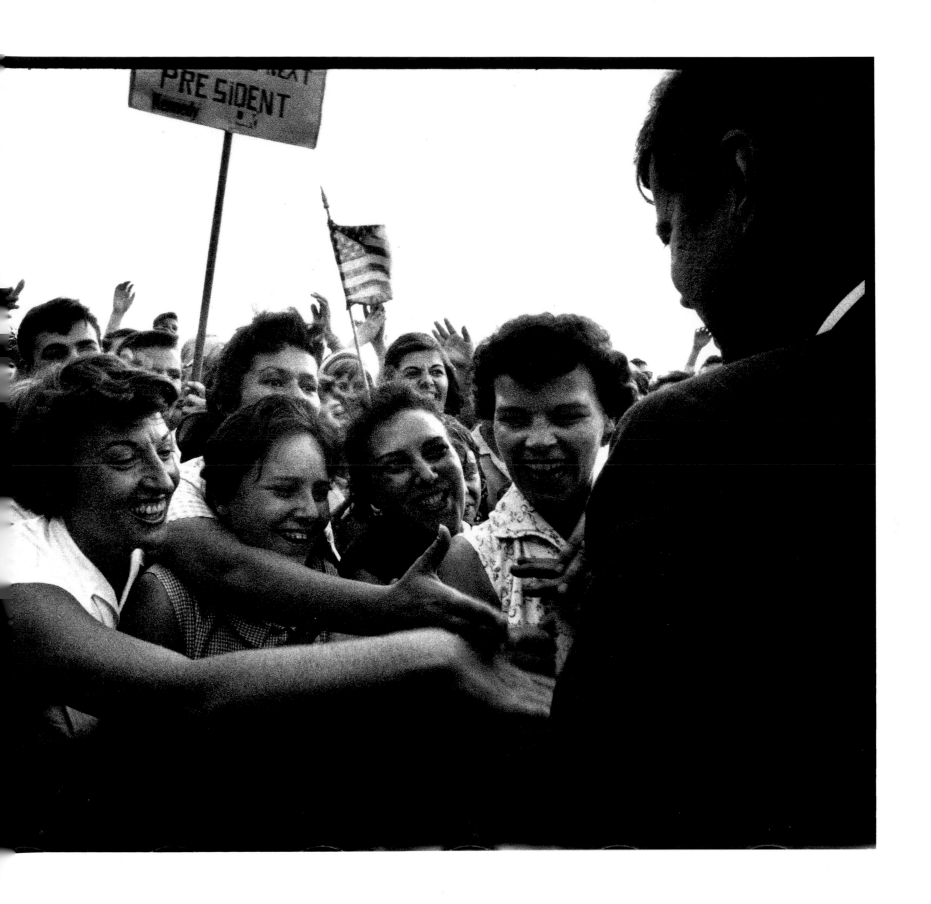

...Mr. Nixon, like the rest of us, has had his troubles with this campaign. At one point even The Wall Street Journal was criticizing his tactics. That is like the Osservatore Romano criticizing the Pope.

One of the inspiring notes in the last debate was struck by the Vice-President in his very moving warning to the candidates against the use of profanity by presidents and ex-presidents when they are on the stump. And I know after fourteen years in the Congress with the Vice-President that he was very sincere in his views about the use of profanity. But I am told that a prominent Republican said to him yesterday in Jacksonville, Florida, "Mr. Vice-President, that was a damn fine speech." And the Vice-President said, "I appreciate the compliment but not the language." And the Republican went on, "Yes, sir, I liked it so much that I contributed a thousand dollars to your campaign." And Mr. Nixon replied, "The hell, you say."

However, I would not want to give the impression that I am taking former President Truman's use of language lightly. I have sent him the following wire:

"Dear Mr. President: I have noted with interest your suggestion as to where those who vote for my opponent should go. While I understand and sympathize with your deep motivation, I think it is important that our side try to refrain from raising the religious issue."

John F. Kennedy, in response to ex-President Truman's comment that those who voted Republican could go to hell, Alfred E. Smith memorial dinner, October 1960

Jackie Kennedy on the porch of her summer house in Hyannis Port, Massachusetts, in August of 1960. The house is part of an enclosure known as the Kennedy compound. There are three houses on the property, JFK's, Robert Kennedy's, and the Big House, belonging to Ambassador Joseph Kennedy, Sr. The three houses are within yards of each other, and only a short walk from the beach overlooking Nantucket Sound. This is a very close-knit clan, and the children especially, of which there were many, were constantly in and out of one another's homes.

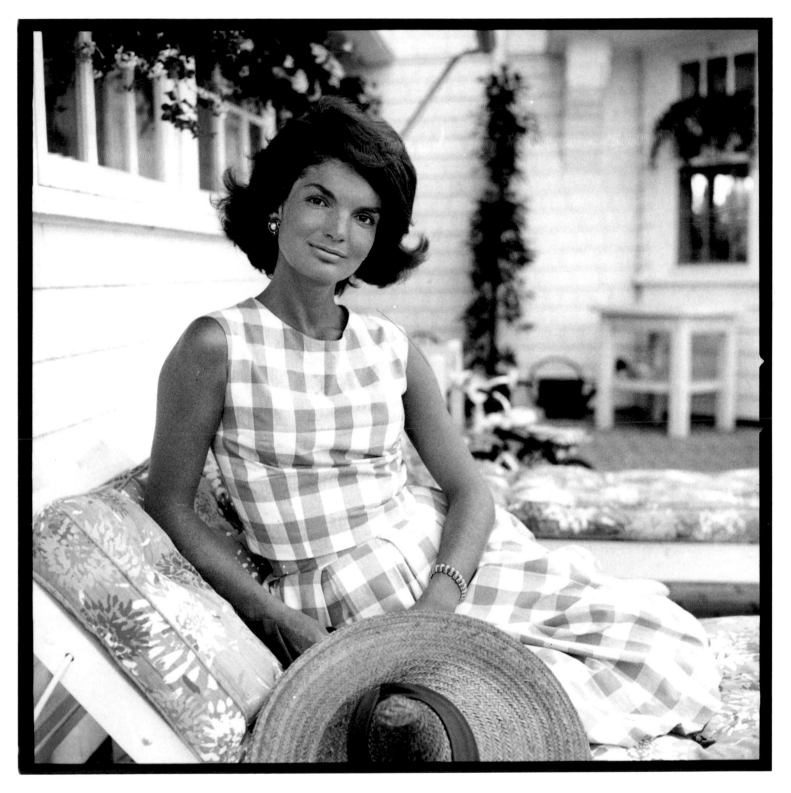

HYANNIS PORT, MASSACHUSETTS. AUGUST 1960

I was impressed by the peculiar attraction that he had for men and women. I remember in one crowd a woman screaming to another one, "Touch him for me."

Everywhere he went he liked to go down and mix with the crowds. Several times he did it and I was with him and actually feared for his safety. In fact, when he first came to St. Louis, the first meeting after he had become the nominee and started to campaign, he came up from Texas and the crowd was so great at the airport that they put him back on the plane. They were afraid he would be hurt. And all of us noticed this tremendous crowd appeal he had. Not excepting Franklin Roosevelt or anybody else that I have ever known.

Stuart Symington, senator from Missouri

HYANNIS PORT, MASSACHUSETTS. SEPTEMBER 1960

Jackie was a respectable amateur painter. Her style was reminiscent of primitive American art. When Kennedy came back from the convention victorious, she presented him with a painting. It shows him standing at the bow of a ship wearing a Napoleonic tunic. In another picture, painted as a gift for Joe Kennedy's birthday and signed "For Grandpa, Love, Jackie," it shows the Ambassador in a bright yellow shirt and shorts, looking out at Jackie coming toward him dressed in a red bathing suit and carrying snorkels, JFK behind her carrying golf clubs, Caroline running after her parents, and nurse Maud waving her arms and pushing a carriage, presumably occupied by John-John. The background depicts a very accurate picture of JFK's house and, of course, the sea. She painted mostly in watercolors. Here she is working, with Caroline at her side, upstairs in her makeshift studio.

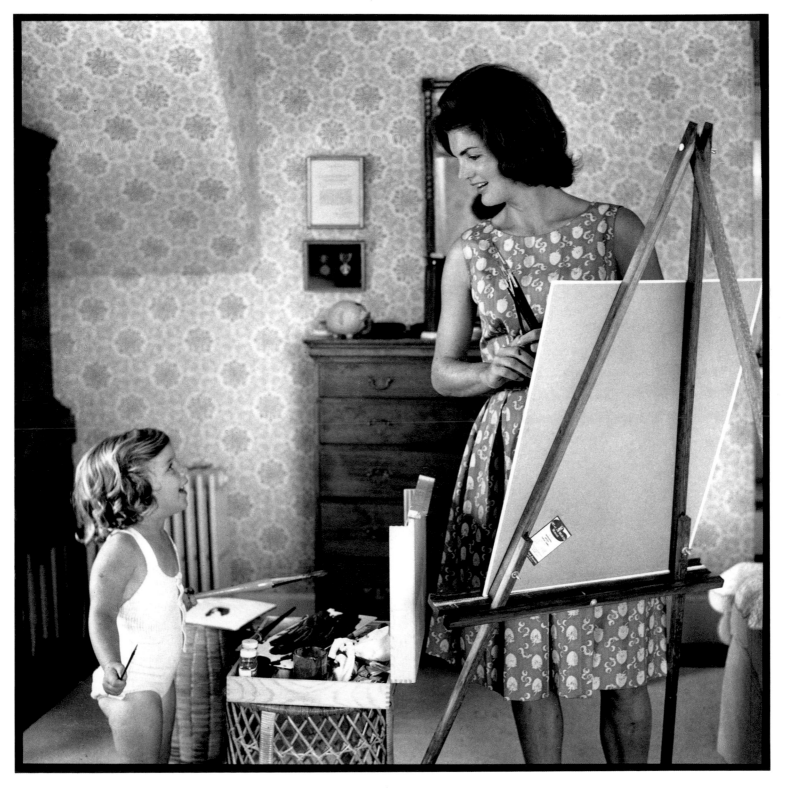

HYANNIS PORT, MASSACHUSETTS. SEPTEMBER 1960

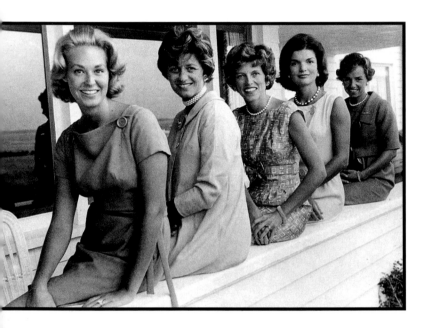

HYANNIS PORT, MASSACHUSETTS. AUGUST 1960

▲

Five Kennedy women — Joan, Jean
Kennedy Smith, Eunice Kennedy Shriver,
Jackie, and Ethel — on the porch of the
Big House.

▶

Ethel Kennedy reading to her children
at her house in Hyannis Port. There are
seven now; eventually there would be
eleven. From left, Bobby Jr., Joe,
David, Mary Kerry, Mary Courtney,
Kathleen, and Michael. The painting in
the background is of Bobby and David.

*They [the Mexicans] had all this tremendous respect
and admiration for John Kennedy. There were a lot
of reasons for it. He was young and he came across
really well. He was Catholic. Every time that he got
put down for being a Catholic this made points with
the Mexicans, who were all Catholic. But they
looked at him as sort of the minority person himself.
I don't know; maybe I'm wrong, but with Bobby it
was an entirely different thing.*

*With Senator Robert Kennedy, it was like he was
ours. We would never have dreamt of making a
demand on President Kennedy, the kind that we
wouldn't think twice of making on Senator
Kennedy. While the other would be liked, we
wouldn't touch him, although we respected him.
We liked him very — we loved him very much.
Our people...they'd be afraid to have Teddy
Kennedy run for president. Not that they don't
want him; they love him so much they don't want
to see him killed. It's more important for him to
live than for him to be president. This would be the
feeling of all of us. We already tried it with the
[union] membership and they say, "Oh God. No,
no. We don't want any more of that."*

Cesar Chavez, on Bobby Kennedy picking up the torch

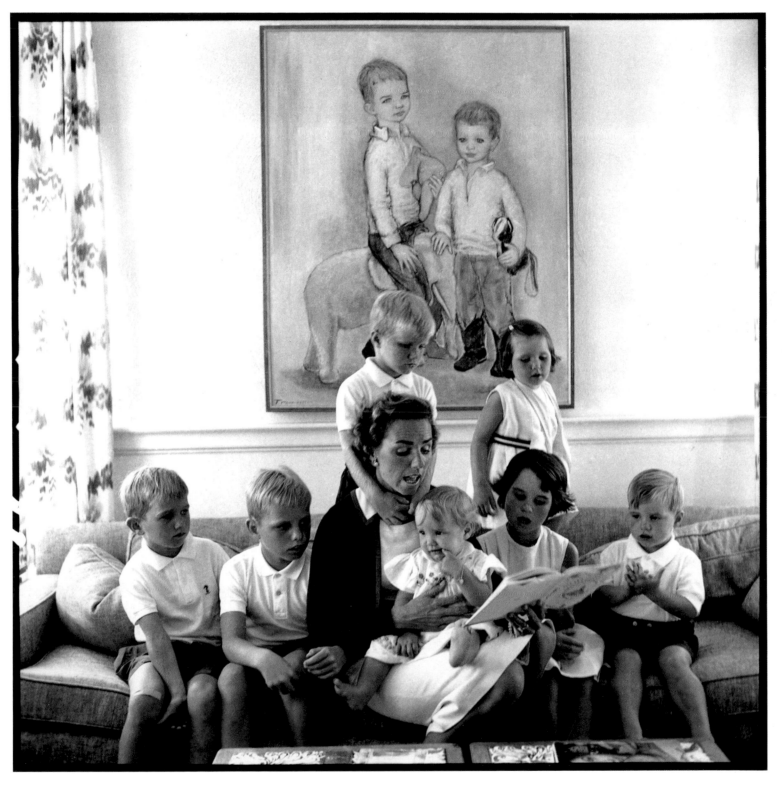

HYANNIS PORT, MASSACHUSETTS. SEPTEMBER 1960

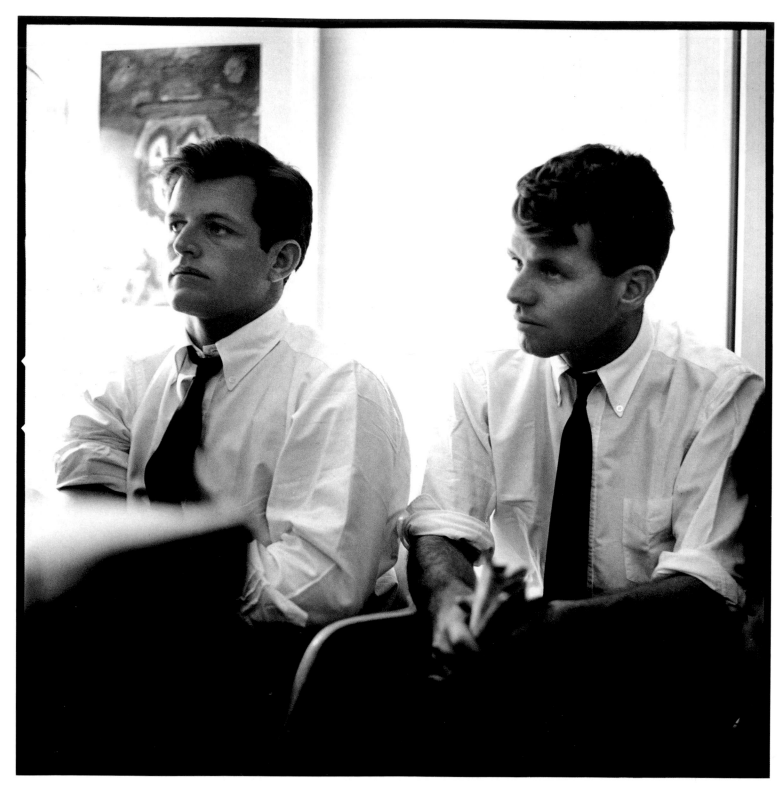

HYANNIS PORT, MASSACHUSETTS. NOVEMBER 1960

Tuesday, November 8, 1960, was Election Day, the day we had all awaited for so long. The polls had predicted a Kennedy landslide. We were certain that by early evening the results would be in and we could celebrate. Little did we know.

Most of the day was uneventful. I went to the voting booth with Bobby and Ethel Kennedy and took a picture of their legs sticking out from under the voting booth curtain. The few of us who were privileged to stay at the Kennedy compound, mostly staff and a few members of the press, were assigned our rooms. The rest of the press corps, some two thousand strong, shuffled around the Hyannis Port armory, where the anticipated victory announcement was to take place. Jack and Jackie came out at about noon and faced a small contingent of the press. I asked them to pose for me with Caroline on the lawn, which they did. For once there were no crowds. The ten-minute drive earlier with the candidate back from Hyannis Airport to his house had been very quiet. The public did not seem to pay attention. The silence was almost eerie. There was nothing to do but eat and drink and wait, lazily.

By six o'clock that evening Bobby Kennedy's house — the election night nerve center — began to show signs of life. The candidate's house, a typical white clapboard eight-room Cape Cod, was next door. And the Big House, Ambassador Kennedy's seaboard mansion with a magnificent view of Nantucket Sound, where they had all grown up, faced both. That was the setting in which we awaited the nation's verdict. Thirty direct phone lines had been set up on the sun porch, each in touch with a crucial election district. A command post had been installed on the second floor, now cleared of children's furniture. A

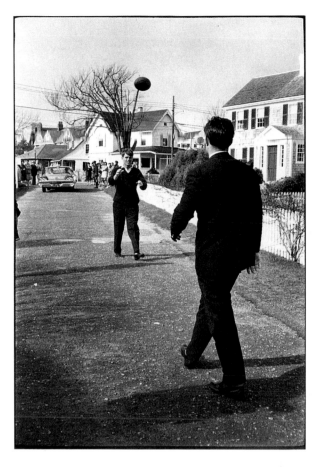

HYANNIS PORT, MASSACHUSETTS. NOVEMBER 1960

▲
Bobby and Teddy letting off steam and shedding tension by tossing a football around 7:00 A.M. on Wednesday morning.

◄
Election night, Tuesday, November 8, 1960. Bobby and Teddy Kennedy sit tensely frozen in front of a TV monitor at Bobby's house, the election night nerve center, their worried faces reflecting the terrible news coming over the airwaves. It is 4:00 A.M. and Kennedy's lead of 2,300,000 votes shortly after midnight had dissolved into a few hundred thousand and is still going down.

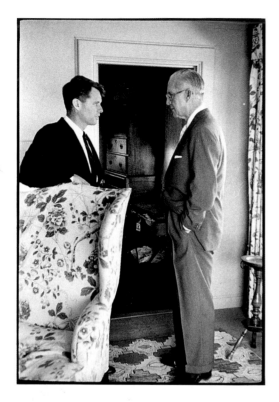

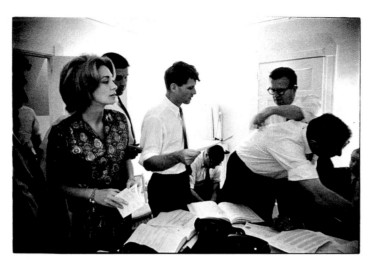

The pictures at left, taken about midnight, reflect the euphoria felt by all as Kennedy's lead was building. Bottom, far left, Bobby Kennedy frantically canvases each district via the telephone, and in the early morning, top left, he and his father discuss the possibility, though still remote, of a loss to Nixon. It is now Wednesday, and the race is extremely close.

▶

Wednesday, November 9, the day after Election Day, 7:30 A.M. No one, except the candidate, has slept all night. The election is still undecided and Kennedy's lead is still going down. The entire family, including Rose Kennedy and JFK's closest friend, Lem Billings, had taken a walk along the water and are coming back to watch and wait for the still-uncertain final result.

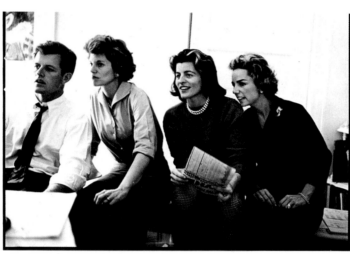

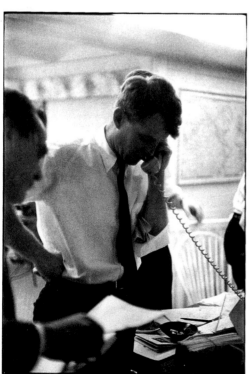

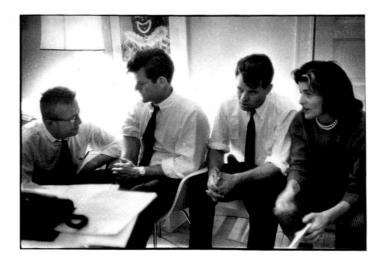

HYANNIS PORT, MASSACHUSETTS. NOVEMBER 1960

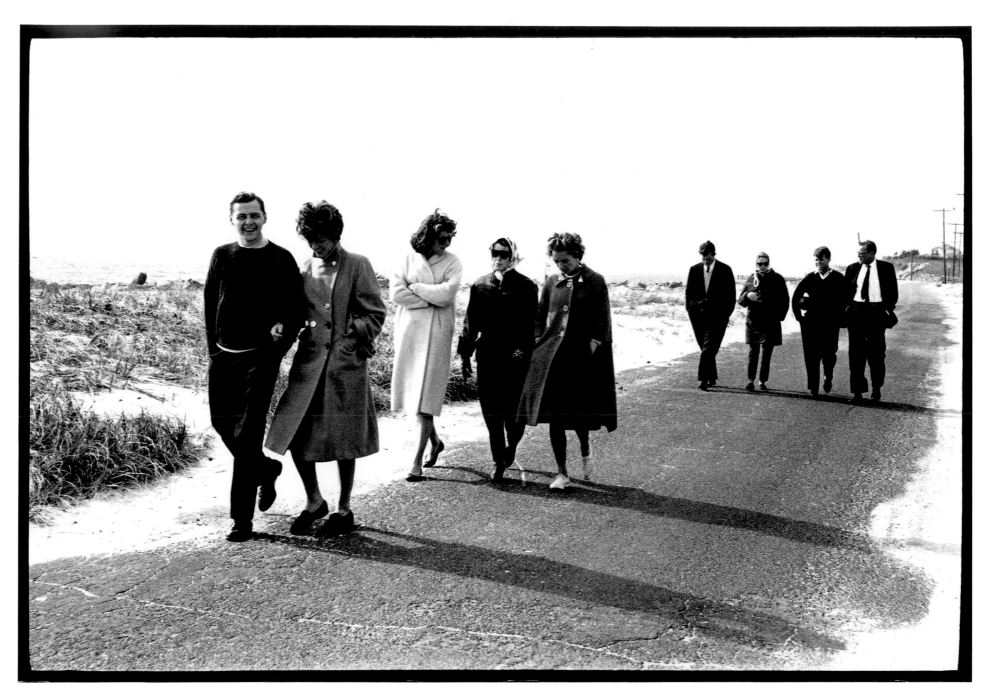

HYANNIS PORT, MASSACHUSETTS. NOVEMBER 1960

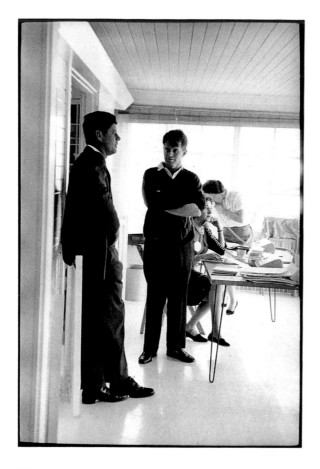

HYANNIS PORT, MASSACHUSETTS. NOVEMBER 1960

▲

By 8:30 A.M. JFK had come back to Bobby's house to discuss and speculate on the bad news.

▶

By 9:30 A.M. most of the family had drifted over to the Big House, to seek the counsel of Joe Kennedy. Here on the stairway, in deep and tense conversation, are Pat Kennedy Lawford, JFK, Joe Sr., Lem Billings, and Teddy, sitting.

ticker tape was clicking out results precinct by precinct. Television reported that Harts Location in New Hampshire, always the first to make the headlines, had voted and given eight votes to Kennedy and four to Nixon. Nixon had won in Kennedy, New York, and Kennedy in Nixon, New Jersey. Everyone was talking into telephones or watching TV.

The men and women presiding over this confusion were all veterans of the campaign: the Kennedy brothers and sisters, their husbands and wives, other relatives and friends, and friends of friends. The mood was jovial. By midnight our lead was over two million votes, but Nixon was refusing to concede. Kennedy came in at about that time, watched television briefly, and then went to bed. The rest of us stayed and got more and more nervous as our lead began to slip. The earlier mood of certain victory, the jovial bantering, subtly changed to grave concern: Was the impossible possible? My pictures that night record both emotions: the smiling, dead-sure family, and the glum brothers watching TV at four in the morning.

By 2:00 A.M., our lead down to less than a million, the NBC computer declared Nixon the winner but then changed its mind. After all, we were still in the lead. By 3:00 A.M. Nixon came down from his hotel room to speak to his supporters. Even the White House believed he would concede, and sent a congratulatory telegram to Kennedy. But Nixon didn't concede. He appeared, made a short speech, and went back upstairs. By 4:00 A.M., totally exhausted, I went to sleep on a cot in the maid's quarters, only to be woken up twice by false cries of "He has conceded. He has conceded."

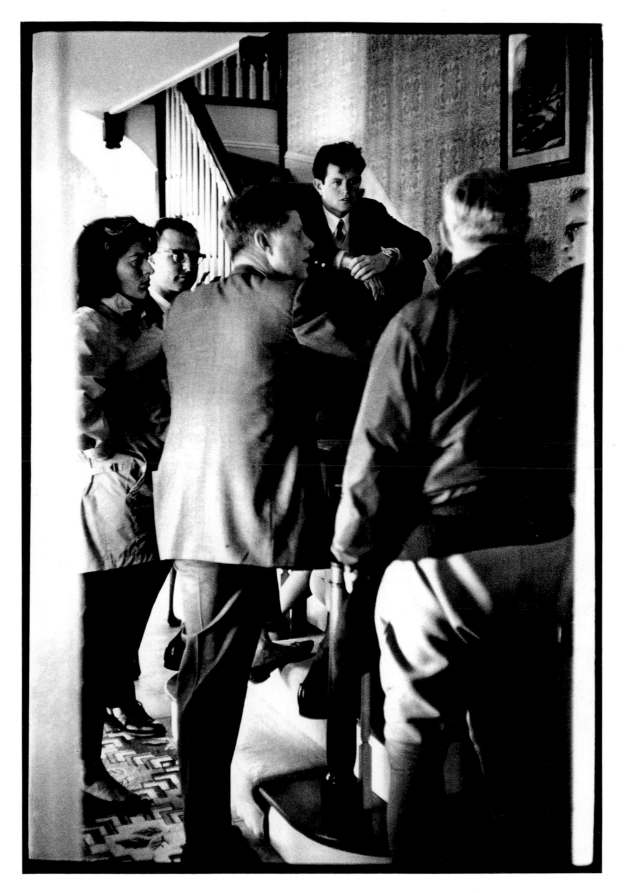

HYANNIS PORT, MASSACHUSETTS. NOVEMBER 1960

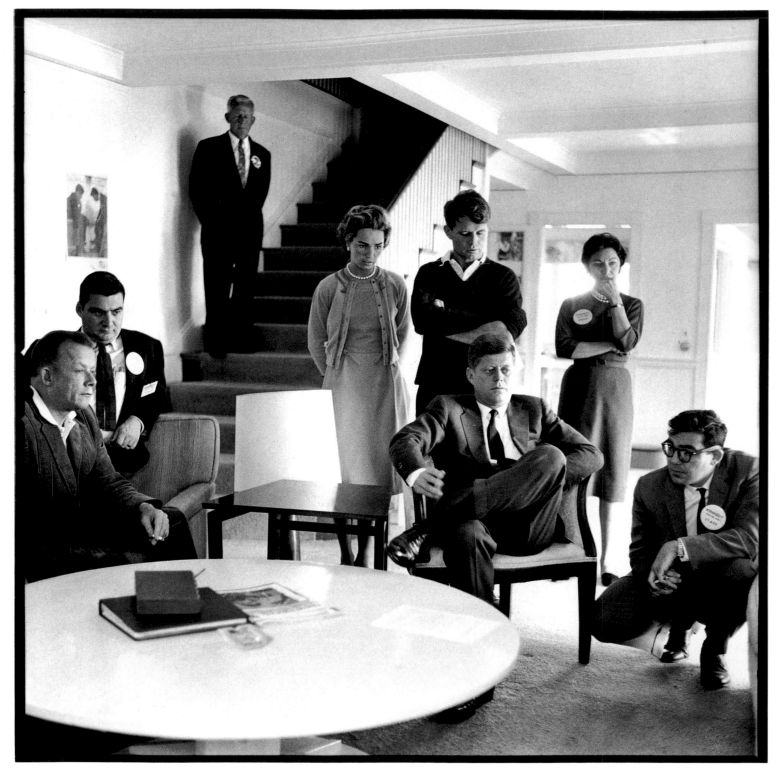

HYANNIS PORT, MASSACHUSETTS. NOVEMBER 1960

I was up at seven. Ethel was alone in the house. The maids were off and everyone had gone for a walk. It seemed that no one had gone to bed that night except the Senator and I. Ethel cooked a breakfast of bacon and eggs and then we joined the rest of the family during their walk.

By ten-thirty that morning, the day after Election Day, our lead was down to barely a hundred thousand votes, but the electoral count was in Kennedy's favor. He was only eleven votes short of the 269 required to win, and two big states, Illinois and Minnesota, had still not been decided. He was leading in both. Nevertheless a very troubled group of Kennedys and friends sat on the interior stairwell of the Big House discussing their apprehension. And when they later gathered in front of the television set in Bobby's living room, the tension was palpable. Kennedy, his eyes uncomprehending, the usual twinkle gone, kept twisting a pencil round and round, oblivious to all but the television drama unfolding.

By twelve-thirty-three it was all over. Illinois and Minnesota had decided for Kennedy. The Secret Service contingent had moved on to the property, and Nixon had conceded. And an elated family once more gathered in the sun room, all smiles and felicitations now. It was on to the armory to face the press.

But before that could happen I knew I had a job to do. I had asked over and over again to get a photograph of the entire family, brothers and sisters and married in-laws. It had been promised many times, but given the size of the family, someone was always missing. I knew this would be my only and last

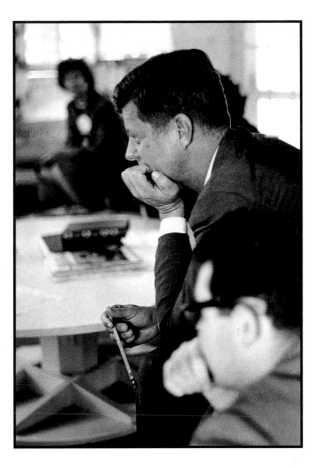

HYANNIS PORT, MASSACHUSETTS. NOVEMBER 1960

By 11:00 A.M. everyone was back in Bobby Kennedy's living room, glued to the television set. By now Kennedy's popular vote lead had been reduced to roughly 100,000, from two million only hours before. As the small group — JFK, Bobby, Ethel, Eunice Shriver, Pierre Salinger, a few friends and aides — who had been through this long struggle together grimly watched the results, waiting for the final push, Richard Nixon, back in his hotel in California, refused to concede. For nearly an hour, JFK sat riveted to the television, nervously clutching a pencil. Finally, at 12:33 P.M. — a day, a sleepless night, and an endless morning after casting their votes early the previous day — the long ordeal was over. Minnesota decided for him. He was now the President-elect. The relief in the air was manifest.

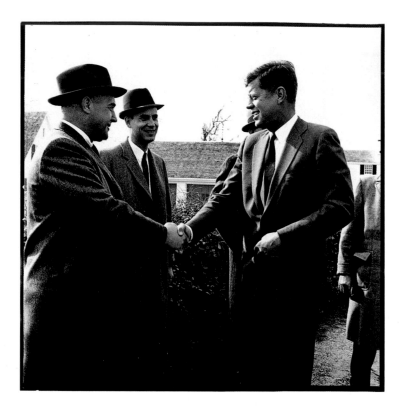

HYANNIS PORT, MASSACHUSETTS. NOVEMBER 1960

▲
JFK greets the Secret Service men assigned to guard him. Wearing fedoras, a symbol for both detectives and Mafia figures of the time, they had mysteriously appeared that Wednesday morning. And they were well briefed. They knew everyone by name and the function they served, where they could go and what they were expected to do: in my case, free access to photograph. I presume they had pictures, or at the least descriptions of everyone, though I never asked. But when I got my White House pass a few months later, the questions asked were few. They must have done their homework well in advance.

►
Shortly before going to the Hyannis Port armory I was able, with great difficulty, to assemble the entire family for a group picture. From left standing are: Ethel Skakel Kennedy, Stephen E. Smith, Jean Kennedy Smith, JFK, Robert F. Kennedy, Patricia Kennedy Lawford, Joan Bennett Kennedy, Peter Lawford. Sitting from left: Eunice Kennedy Shriver, Rose Fitzgerald Kennedy, Joseph P. Kennedy, Jacqueline Bouvier Kennedy, Edward Moore Kennedy, and Sargent Shriver.

chance to ever find the entire family in one house at the same time. Certainly, once Kennedy was in the White House, it would never happen again. So I appealed first to the President-elect, who said, "Okay, but you have to get everybody else together." But the mood was one of celebration, no one's mind was on photographs, everyone said "after", an after that I knew would never happen. Yet this was a unique, historic occasion and I could not let it slide by. So I appealed to the Ambassador, the patriarch Joe Kennedy, who appreciated history as much as his son Jack did. He agreed it would be the only chance and announced that a photograph was to be taken prior to the trip to the Armory. Yet as some members of the family gathered in the library, others drifted away, while still others had not yet arrived. I pleaded and cajoled, I explained the occasion, and finally all were assembled except Jackie Kennedy. She had gone for a long, solitary walk. The victory had been an overwhelming experience for her. She later described the wait between the closing of the polls and the moment of victory as "the longest night in history." President-elect Kennedy had gone down to the beach to bring her back. When Jackie, having changed clothes, finally arrived at the door, he went over and took her by the arm. The entire family rose and applauded.

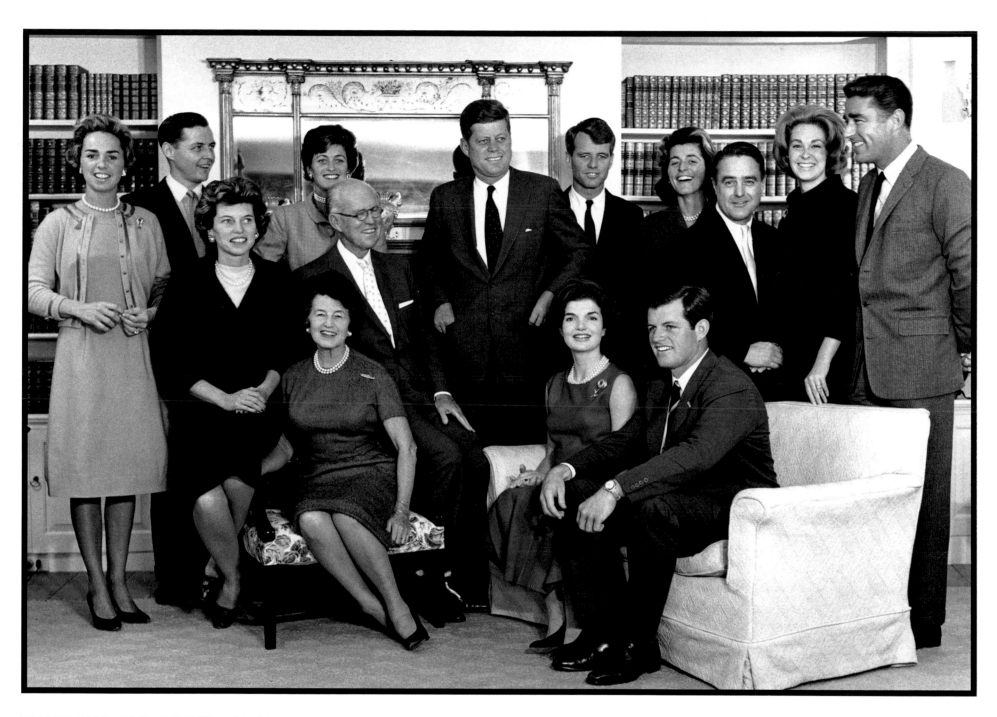

HYANNIS PORT, MASSACHUSETTS. NOVEMBER 1960

▶

Election Day 1960. On that lazy afternoon no tension had set in as of yet.

◀

Shortly after Minnesota awarded the victory to Kennedy, Illinois came in with a questionable margin, and before sitting for the family photograph President-elect John F. Kennedy took a long walk around the compound, piggy-backing Caroline most of the time. It was a walk of relief. A needed washing away of the strain. Jackie, in the meantime, overwhelmed by the sudden realization that she was now the First Lady of the land, had thrown a light coat over her shoulders and rushed out of the house. Although this had been two years in coming, although she herself had campaigned on her husband's behalf prior to her pregnancy, she seemed shaken. I caught a glimpse of her through a window as she rushed down to the sea.

Good morning, Mr. President.

Caroline Kennedy to her father on election morning

HYANNIS PORT, MASSACHUSETTS.
NOVEMBER 1960

On Thursday afternoon, January 19, 1961, a blizzard hit Washington, D.C., dumping eight inches of snow on the inaugural city. Traffic had come to a standstill. It was to be the coldest inauguration in living memory.

I had come to the capital three days in advance to pick up my passes and get guidance about the events. My despair had been instant. There was a pass for 14th Street and Pennsylvania Avenue, another for 16th Street and Pennsylvania Avenue, and a third to get from 14th Street to 16th Street. I would need roughly thirty-seven passes to cover my route. When asking for information I was handed a six-hundred-page document titled "Brief Notes on the Inaugural Parade." My official invitations to all the events had to be exchanged for tickets, and there were block-long lines of ticket holders trying to do just that. I finally received a staff badge marked "All Events, All Areas." I would be able to move freely at last.

That Thursday I had gone to the Washington armory to cover the rehearsal of the evening gala being directed by Frank Sinatra. Leonard Bernstein, Laurence Olivier, Ella Fitzgerald, Nat King Cole, Fredric March, Gene Kelly, Ethel Merman, and many others were participating in the show. I stayed for two hours and left to cover three other events. When I got outside the blizzard had started. By sheer luck I got a cab. I asked the driver to take me to the Mayflower Hotel. He was dubious, but he finally agreed. The ride normally takes twenty minutes. But after two hours in the cab, I grabbed another. That one stood still for forty-five minutes. I then took a bus. It moved five blocks in half an hour. It was a desperate situation. I saw my entire day slip by. When I arrived at the Mayflower four and a half hours later, the lobby had been transformed into a refugee camp. The celebrants were simply stranded. But having missed all other events I knew I couldn't miss the evening gala, and to get back there I had to leave right away. The event was black tie, but I couldn't get back to my hotel to change. I decided to take a chance and hitched a ride with Pierre

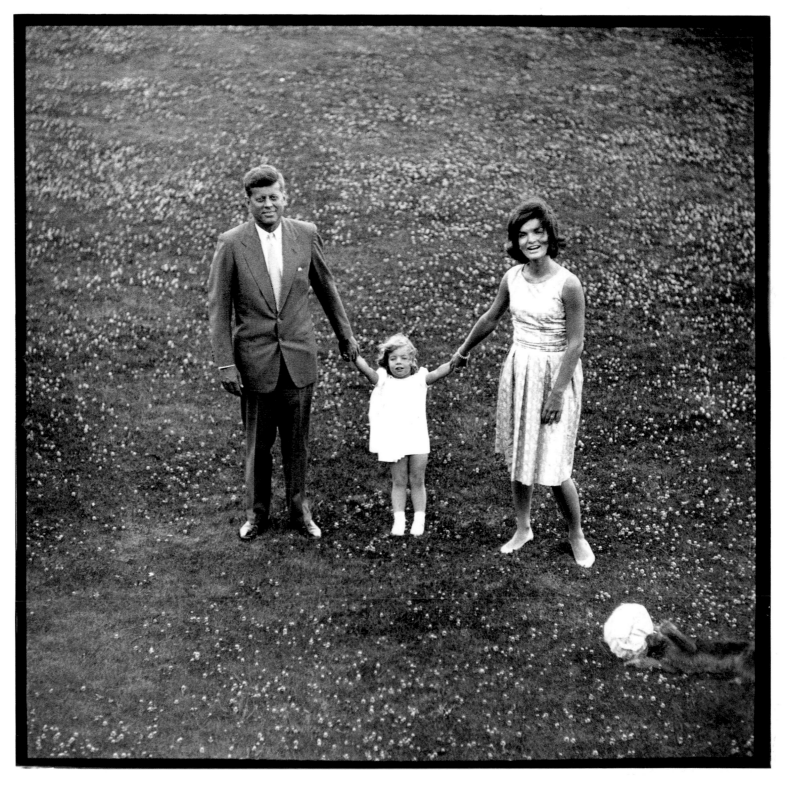

HYANNIS PORT, MASSACHUSETTS. NOVEMBER 1960

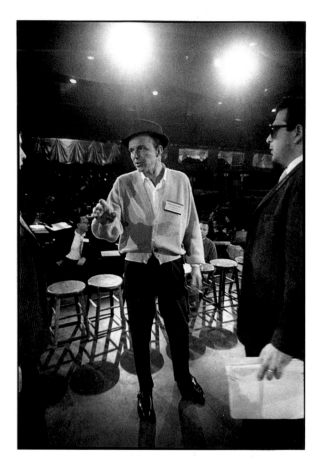

WASHINGTON, D.C. JANUARY 19, 1961

▲

Frank Sinatra, then a friend of the President-elect,
had volunteered and been granted the staging of the
Gala Spectacular. He had assembled a remarkable
group of star performers from the worlds of film,
the theater, and popular and classical music. In this
case "Spectacular" was not an exaggeration.

▶

President-elect John F. Kennedy addresses the
audience at the Gala Spectacular the night before
his swearing-in.

Salinger, who was staying at the Mayflower and had the use of
his brother's car. We made it back to the armory in an hour and
found we were much too early. The hall was empty. No one
had been able to get there. Finally, at 11:00 P.M. the President-
elect and Jackie Kennedy arrived wearing formal dress. I
covered the event from the presidential box, wearing a bow tie
and a sports jacket. I felt very odd, but nobody seemed to care.
After eight years out of office Democrats weren't concerned
about dress code. They were getting to know each other.

The Secret Service, sworn to defend the President-elect, now
got a chance to get to know him. Full of enthusiasm, he kept
bobbing up and down, jumping over aisle seats to greet friends,
and disappearing down the back stairs. I'd gotten used to all this
over the years and managed to stay with him most of the time.
But for the Service this was a new experience. They spent
much of the evening searching for him, rushing to ask me
whether I knew where he was. Kennedy, who hated restraint of
any kind, thought it was funny. I fell into bed at four-thirty and
was up at 6:00 A.M.

Next morning I showed up at 3307 N Street, the Georgetown
residence of the President-elect, to escort him to the White
House and stay with him throughout the day. The snow had
stopped, but it was bitterly cold, twenty-two degrees, with a
mean wind blowing. Shortly after eleven o'clock Sam Rayburn,
the Speaker of the House, and inauguration chairman Senator
John Sparkman arrived to take Senator and Mrs. Kennedy to
the White House, where they would pick up the incumbent
president and drive together to the swearing-in at the Capitol.
Kennedy walked out of the house in striped pants, carrying his
top hat. For the first time he entered a car carrying the
presidential seal.

"I've many promises to keep and many miles to go before I
sleep" had been the candidate's leitmotif throughout the

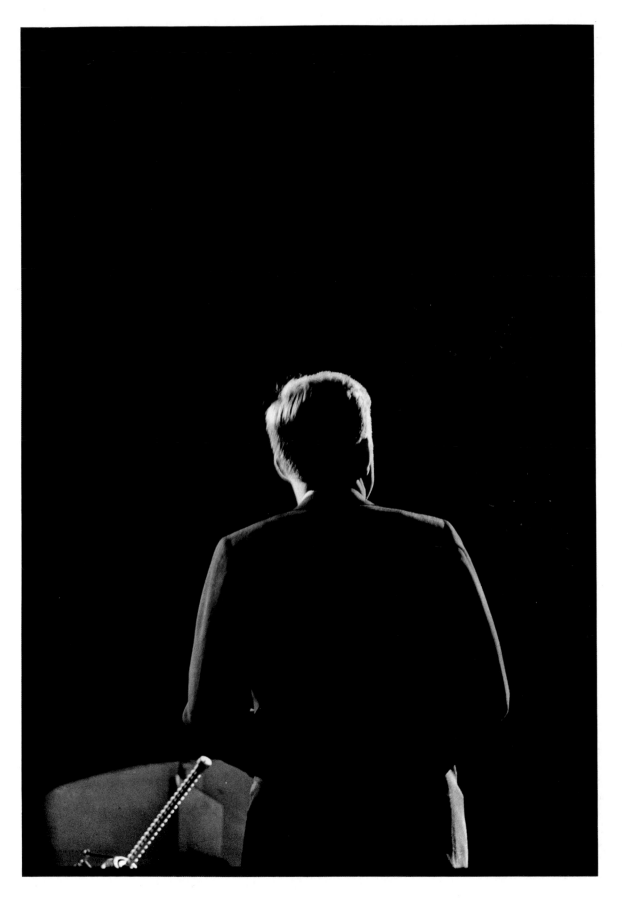

WASHINGTON, D.C. JANUARY 19, 1961

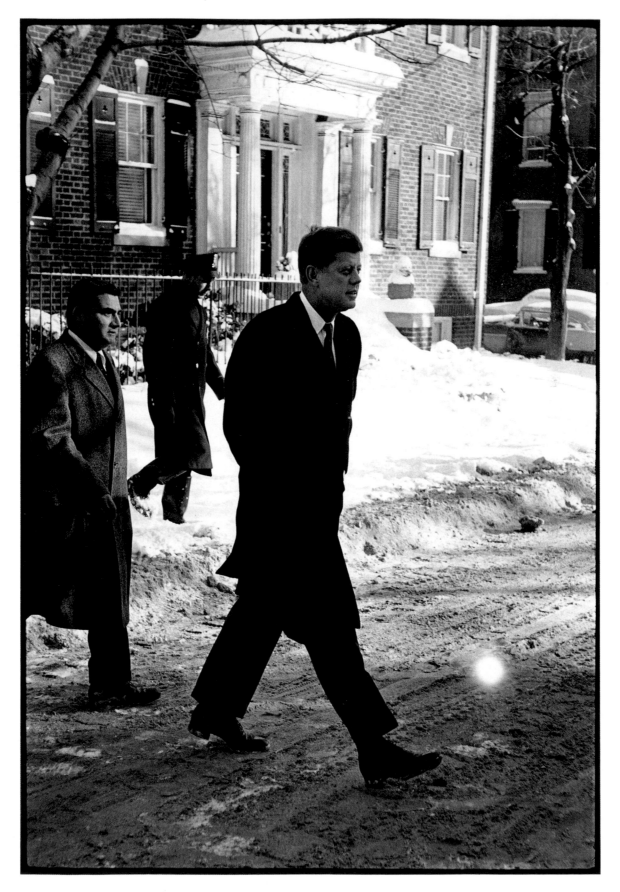

GEORGETOWN. JANUARY 20, 1961

campaign. He had recited these words hundreds, perhaps thousands of times. They came from a favorite poem by Robert Frost. Frost was to read his poem "The Gift Outright" during the swearing-in. The old man, now eighty-six years old, his snow-white hair waving in the wind and hands shaking from the cold, unfolded his papers to read a preface written for the occasion. But with the wind lashing his notes and with the strong sunlight stunning his eyes, he squinted but could not read his own words. Halfway through he gave up and recited the poem by heart. At the end the young president-to-be sprang to his feet and escorted Frost back to his seat. The contrast between the two men was uncanny. Here was this young, vigorous New Englander taking this wizened and old, yet still vigorous, New Englander by the arm, both very strong in spirit, admiring of each other. That moment, for me at least, was the highlight of the inauguration. Moments later Chief Justice Earl Warren administered the oath of office. John Fitzgerald Kennedy was now the president of the United States. The long journey was over and another was to begin. The words he quoted as often as those by Robert Frost, "A journey of a thousand miles begins with one step," would begin a new life.

Richard Nixon had watched the ceremony from the dais, as had President Eisenhower, who quietly disappeared following the ceremony. So had all the other contenders, from Lyndon Johnson, now vice president, to Stevenson, Humphrey, and Symington. Former President Harry Truman, too, who had done his best to prevent a Kennedy nomination, sat on the dais. For this twenty-nine-year-old Jewish emigrant from Nazi Germany, it was a remarkable transition.

The new president and his first lady rode up Pennsylvania Avenue in an open car despite the bitter cold, an eerie gesture in retrospect. I ran along with the car all the way to the White House while the new president commented from time to time on the fate of photographers. "You should have run for president instead of for photographer," he told me later. "It's more comfortable."

WASHINGTON, D.C. JANUARY 20, 1961

▲

The White House limousines, bearing JFK and President Eisenhower, Lyndon Johnson and Richard Nixon and their wives, enter the Capitol grounds for the swearing-in.

◄

On the morning of January 20, 1961, Kennedy left his Georgetown house early to attend mass. The snowstorm, a veritable blizzard, had subsided, but it was bitterly cold. Still, here he was, not wearing a hat nor gloves. During the campaign, a time when most men and women still wore hats, the American hat manufacturers had become extremely nervous about this charismatic figure who refused to wear one. Consequently, at nearly every stop, a representative would show up bearing the gift of a hat. The candidate each time politely registered his appreciation, and those of us with his hat size ended up with a great assortment of head gear. Obviously, even while he was President, that wouldn't change.

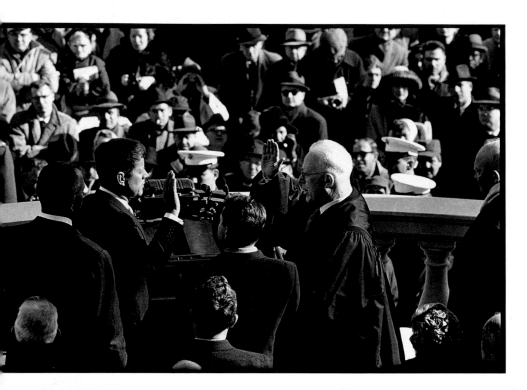

▲

January 20, 1961, 12:22 A.M.: Chief Justice Earl Warren swears in Senator John F. Kennedy as the thirty-fifth president of the United States. The President took the oath of office on the family Bible. Later Justice Warren would preside over the Warren Commission, appointed to determine the causes of JFK's assassination. The investigation would raise more questions than it solved, and satisfied no one, even to this day.

▶

The President and the First Lady return from the Capitol to their new home, the White House. They ride in an open car, he again not wearing a hat. This would become known as the Kennedy style. The open car evokes an eerie memory of Dallas nearly three years later.

Let the word go forth from this time and place, to friend and foe alike, that the torch has been passed to a new generation of Americans — born in this century, tempered by war, disciplined by a hard and bitter peace, proud of our ancient heritage....

Let every nation know, whether it wished us well or ill, that we shall pay any price, bear any burden, meet any hardship, support any friend, oppose any foe, to assure the survival and success of liberty....

To those people in the huts and villages of half the globe, struggling to break the bonds of mass misery, we pledge our best efforts to help them help themselves....

So let us begin anew — remembering on both sides that civility is not a sign of weakness, and sincerity is always subject to proof. Let us never negotiate out of fear. But let us never fear to negotiate....

All this will not be finished in the first one hundred days, nor will it be finished in the first one thousand days, nor in the life of this administration, nor even perhaps in our lifetime on this planet. But let us begin....

Now the trumpets summon us again — not as a call to bear arms, though arms we need — not as a call to battle, though embattled we are — but a call to bear the burden of a long twilight struggle, year in and year out, "rejoicing in hope, patient in tribulation" — a struggle against the common enemies of man: tyranny, poverty, disease, and war itself....

And so, my fellow Americans: Ask not what your country can do for you — ask what you can do for your country.

My fellow citizens of the world: Ask not what America will do for you, but what together we can do for the freedom of man.

John F. Kennedy, Inaugural Address, January 20, 1961

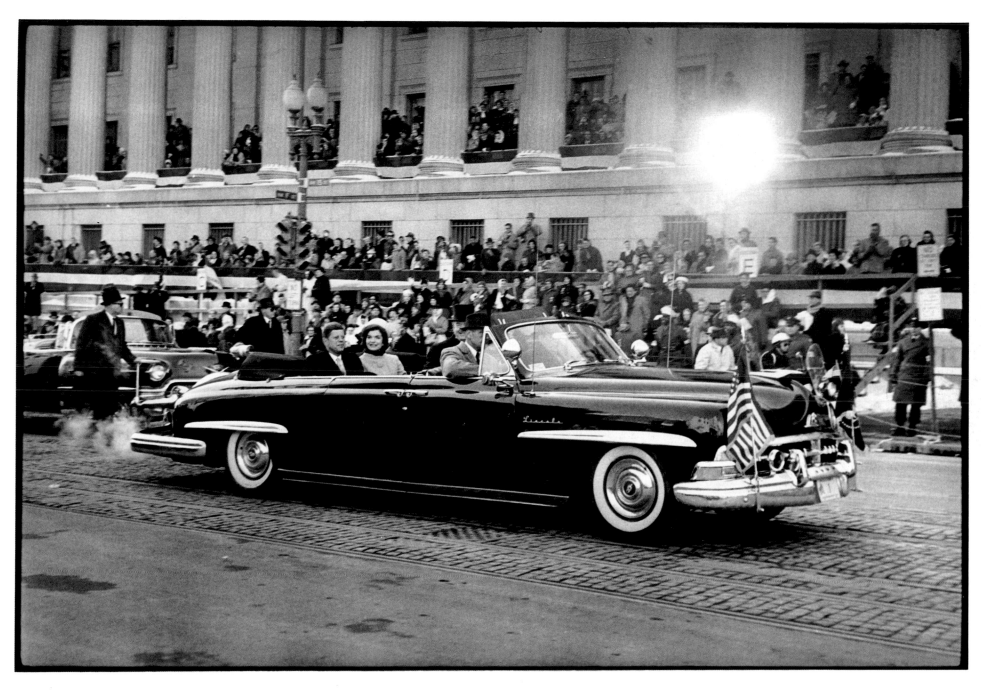

WASHINGTON, D.C. JANUARY 20, 1961

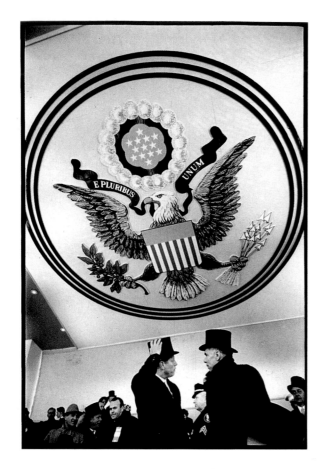

WASHINGTON, D.C. JANUARY 20, 1961

The Irish say very seriously they are descended from Irish kings. Probably in the old days there was a king every ten miles or so, and everyone gathered under each king's protection was related to him by ties of blood.

The old Irish legends tell of tall men, full of grace and dignity, brave, wise; generously giving of themselves for the good of all. These were the kings of Ireland.

They seemed only legends until we were given one of their sons for too brief a time. Now we know the legends are true. We can send down words telling of noble deeds that will become legends in their turn of a great and beloved leader, John Fitzgerald Kennedy, worthy son of kingly forebears.

Harry Golden, publisher of the *Carolina Israelite*

The President signed one of my pictures "At last, film in the camera." I might respond, "At last, a hat." The President on the inaugural stand watching the parade. He looked splendid and seemed to enjoy every moment of this freezing spectacle. He stayed until dark, responding with loud hoots when his PT-109 crew passed by.

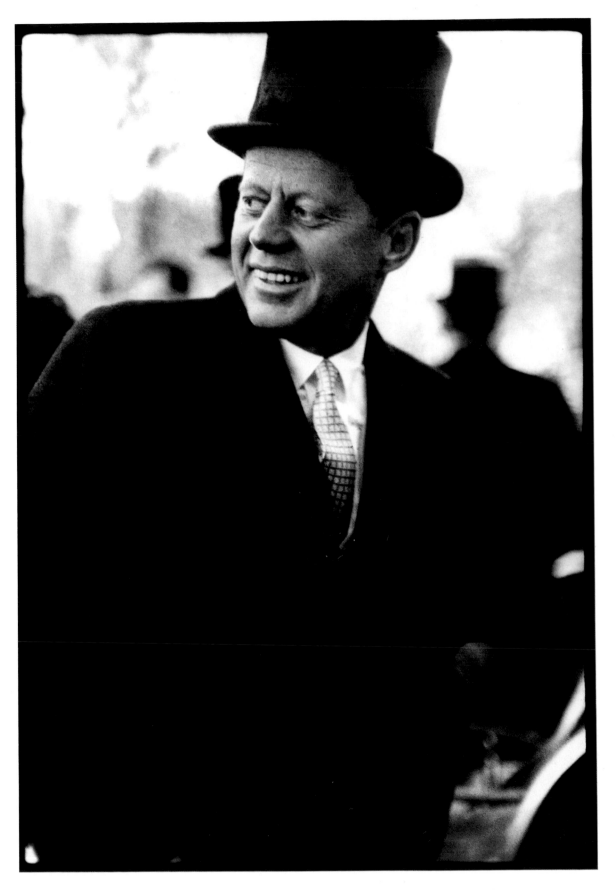

WASHINGTON, D.C. JANUARY 20, 1961

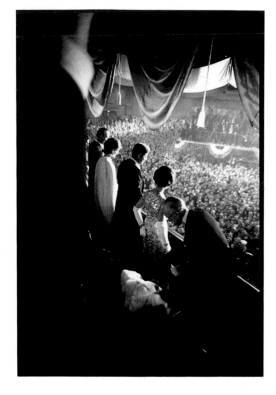

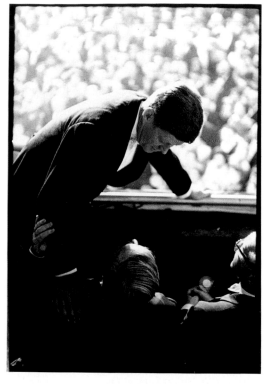

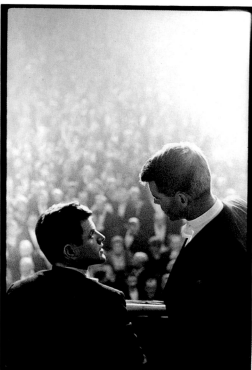

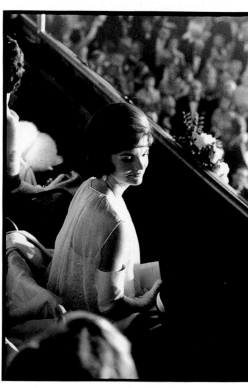

The inaugural ball at the armory on the evening of January 20 was the climax of the inaugural festivities. Actually there were several balls, and the President made the rounds to all of them, but this was the high point. The audience was a glittering assembly of who's who among Democrats in America. Political and financial potentates mixed freely with Hollywood stars and ordinary folks who had braved the political wars and won. The President was in his element. Restlessly moving around on the dais, shaking hands, and at times waving to the crowd and to certain people in the audience far down below him, he would also disappear from time to time. The Secret Service, still unaccustomed to the new president, desperately tried to follow him and from time to time would come by and ask me whether I had seen him. But I'd had the experience of losing him for years and I had to answer in the negative. The President, after finishing his rounds, turned up at a party at columnist Joe Alsop's house, where he stayed until after 3:30 A.M. At 8:52 A.M. he arrived at the Oval Office, ready for work.

I think this is an ideal way to spend an evening — you looking at us and we looking at you.

John F. Kennedy

WASHINGTON, D.C. JANUARY 20, 1961

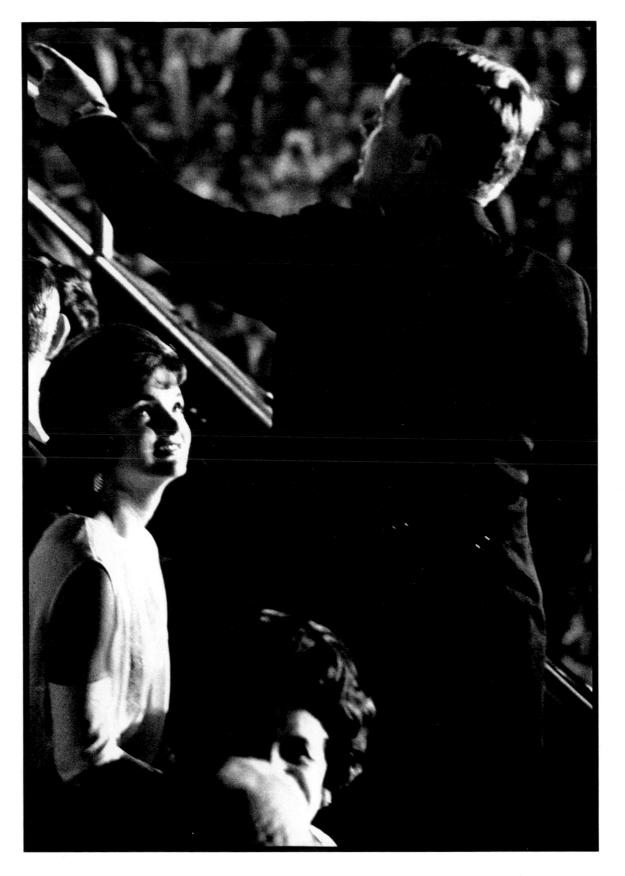

WASHINGTON, D.C. JANUARY 20, 1961

The White House is probably the most famous building in the world. Long ago it overshadowed the Houses of Parliament as the seat of modern democracy. To Americans, and those who wish to enter this country, the house itself evokes reverence, also bestowed to a degree on its occupants. For me to enter and be issued a White House pass was a near-spiritual experience. Still, reality intruded almost immediately.

The morning after the last inaugural ball and the new president's first day in office, I accompanied him to the Oval Office at exactly ten minutes to nine. He had called a staff meeting for nine o'clock. The room had been cleared of his predecessor's personal mementos. The walls were painted a putrid green interrupted by blank spaces where pictures had hung. The beautiful parquet floor was covered with little holes, cleat marks left by Eisenhower's golf shoes. The former president used to practice his swing there. JFK, as he was to be known henceforth, in his first act of office ordered the walls to be painted a warm off-white color. The office would later evolve into a very personal room replete with his pictures of sailing ships and volumes of the writings of Thomas Jefferson and his own books. He would find a desk in the White House basement, a gift from Queen Victoria to President Rutherford B. Hayes in 1878, made from the timber of the HMS *Resolute*.

As those closest to him professionally and in some instances personally assembled, one of the awkward problems was how to address this new president. To some he was Jack, to others, as he was to me, Senator. Most of the men in the room had been with JFK for many years, some since his congressional campaigns. But should Bobby address him as Mr. President? He did. Yet the form of address was only a

The President on his first day in office. As I looked at him that day I realized that he'd aged considerably during the little more than two years since I'd first met him. As his first official act, he will sign an executive order providing for more and better food to be distributed to needy families.

THE OVAL OFFICE. JANUARY 21, 1961

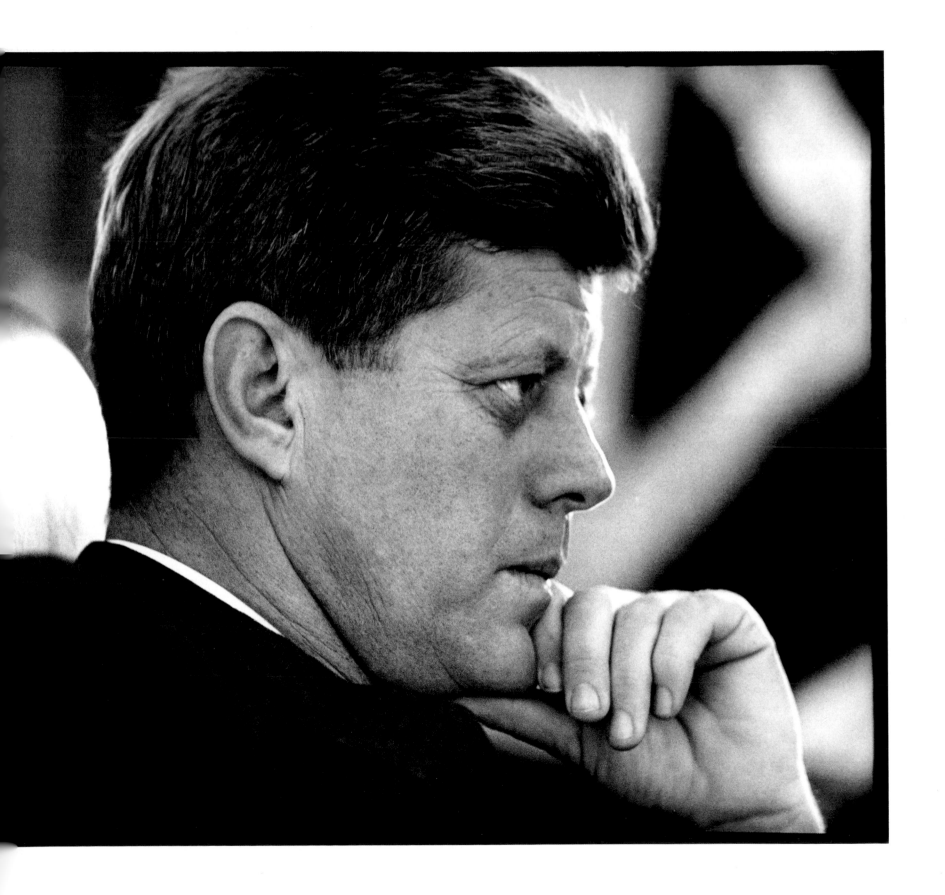

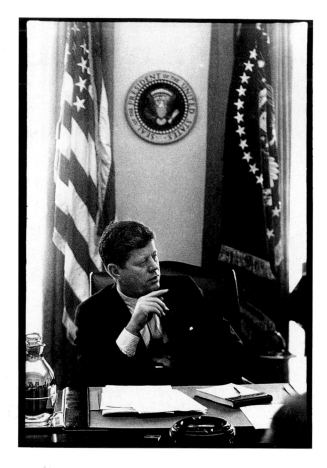

The President held his first cabinet meeting in the Cabinet Room of the White House. The room was located opposite the Oval Office, separated only by the office of the President's executive secretary, Evelyn Lincoln. At the cabinet table the vice-president's chair was across from the President; the secretary of state, not visible here, always sat to the President's right, and the secretary of the treasury, Douglas Dillon, always to his left. Also visible behind JFK are Fred Dutton, a special assistant; David Bell, director of the Bureau of the Budget; and Richard Goodwin, a speech writer and special assistant to the President.

symptom of the real problem. We had all been very free with him in discussion, in banter, in offering unsolicited advice and comments, even in exchanging ties, but now he was the president, and an invisible wall, created purely by the majesty of the office and not at all by him, who had really never changed, had been erected. Something had changed even from the night before.

The President had asked me to stick around to record his administration. "I'll make it worth your while," he had said. And again there were no instructions, no guidance on what he hoped I would accomplish or cover. "You've done fine so far. Just continue." Over the coming months he would occasionally make a special request, some of which got me into trouble with the First Lady, because they invariably involved pictures of Caroline, whom Jackie did not want photographed. "Just don't tell her," he would say. "But Mr. President, she'll see the photographs in the magazine." "Don't worry, we'll work it out." I was caught in the middle and I knew it, but he was the president, and I did what he asked of me. Otherwise I had to look at this vast administration and make my own decisions. I was given carte blanche to roam the White House and the other centers of government.

One of the first occasions I wanted to cover was a joint chiefs of staff meeting scheduled for the Cabinet Room, across from the Oval Office. The President was to meet his military commanders for the first time. I asked him and he said, "Just wait five minutes. Then come in, but don't knock." I did as I was told, and the moment I entered I realized that the President had not told the commanders that I was coming. General Lemnitzer, who was addressing the President and facing him and the door, stopped dead in mid-sentence. The President waited a moment and said, "Well, General?" Lemnitzer, pointing his chin toward the door, was still speechless. "Go on, General," said the President, and during the entire twenty minutes I was in that room, slowly moving around the

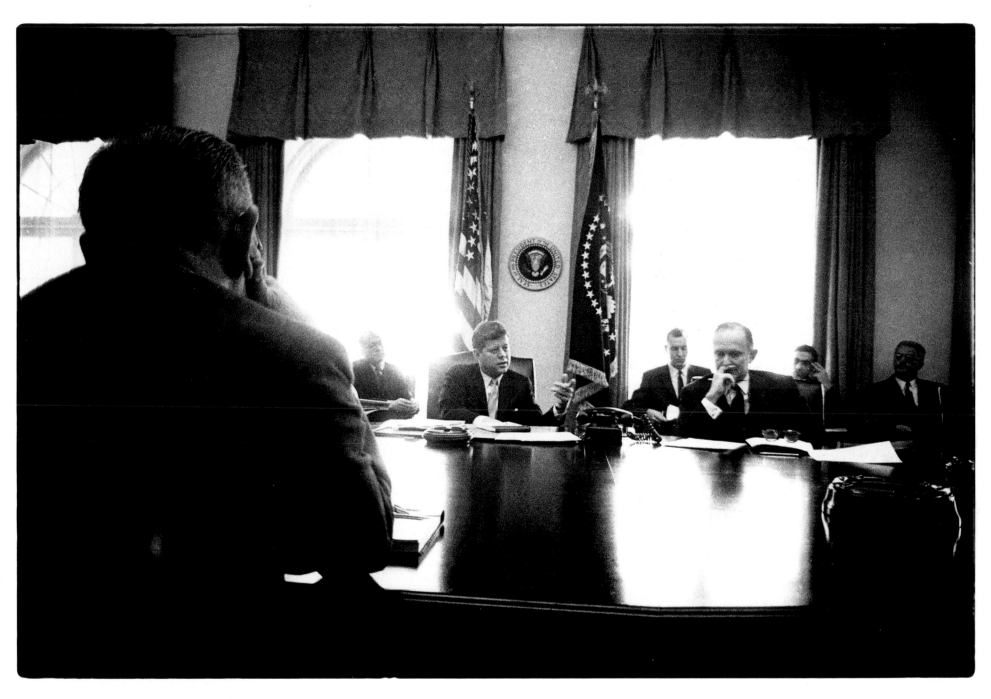

THE CABINET ROOM. JANUARY 26, 1961

table with my camera clicking away, the President never acknowledged my presence. I had seen a different side of this man I thought I knew so well — the tough Commander in Chief who made no excuses. Later, I told him that he really should have told them that I was coming. "Why?" he said with a grin. The point was made.

Later in the month I came to the Oval Office asking him to sign a copy of a book just published about my campaign experience. To my surprise he had read it. "Let me show you my favorite picture," he said, and he pointed to an early photograph of Jackie, himself, and a couple of staff members arriving at Portland Airport. Only three supporters had come to greet him. "Nobody remembers that today," he said, stabbing his finger at the page. He then asked, "Is this my page?" appropriating a full page left blank for his as well as several other inscriptions. Presidential prerogative, I figured.

As I turned to leave he asked, "Do I really owe you five dollars, Jacques?" As Senator, he rarely carried cash and had little judgment in dispensing tips. Standing next to him at these occasions had always meant you had to dig into your pocket. At one point a tip was due a bellboy. Kennedy asked me whether I had a dollar. I had a five-dollar bill, which Kennedy duly turned over to the young man. Of course I never got it back. I had mentioned this in the book, and when asked now I said, "You certainly do, Mr. President." "Very funny," he said. I never collected.

I often worked with the President alone at night in the Oval Office. He would dictate into a now obsolete Dictaphone and make telephone calls. Impatient, he would rarely go through the White House switchboard but dial his own numbers instead. I myself was often the recipient of these phone calls,

On January 25, 1961, the President met his joint chiefs for the first time. The meeting took place in the Cabinet Room. From left are seen: General Thomas White, Air Force; Admiral Arleigh Burke, Navy; General George Decker, Army; and General Lyman Lemnitzer, joint chief of staff, facing the President. The joint chiefs had appointed a commission to study what might be done to unseat President Fidel Castro. They had produced a White Paper for the President, outlining six approaches for his consideration, though their enthusiasm for the invasion plan was not strong.

THE CABINET ROOM. JANUARY 25, 1961

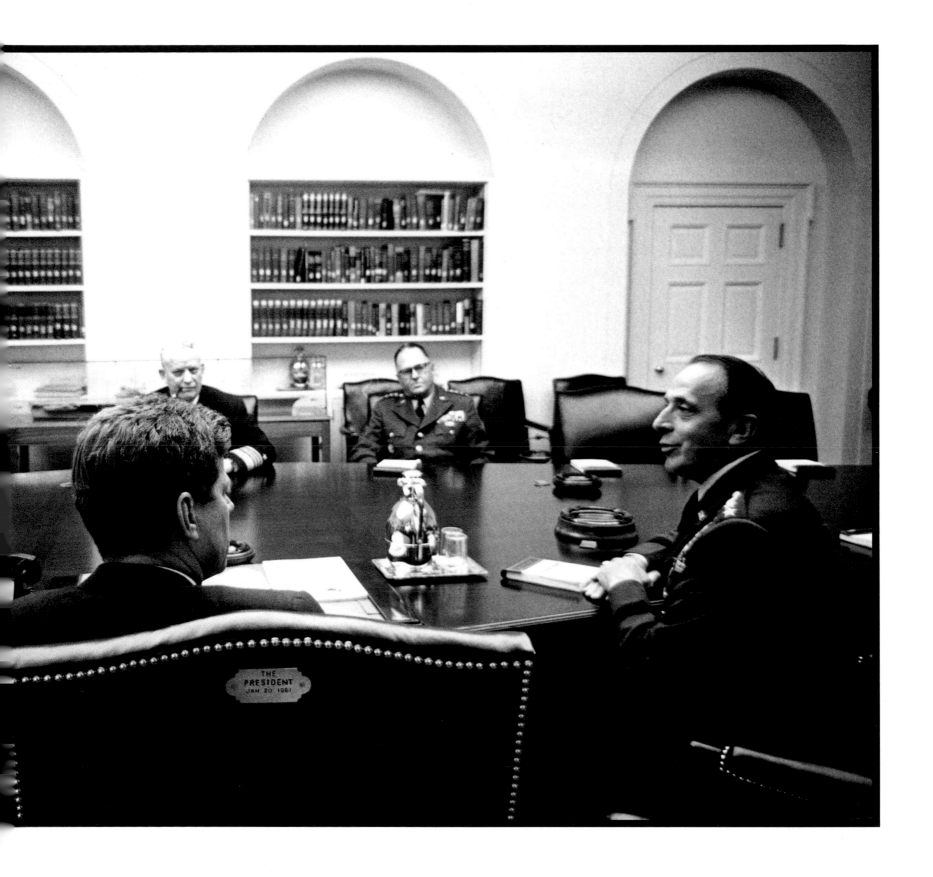

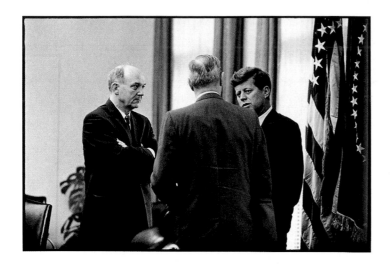

THE CABINET ROOM. APRIL 12, 1961

▲

President Kennedy in discussion with Secretary of State Dean Rusk and the mastermind behind the Bay of Pigs operation, CIA Deputy Director for Plans Richard Bissell. The invasion of Cuba was an unmitigated disaster. It was perhaps the first real defeat this forty-three-year-old president had ever faced in his life. He was only three months into his presidency. The operation had started a year before he took office. He had been briefed by the CIA, and President Eisenhower, though dubious of the operation, had nevertheless urged his successor to bring it to a successful conclusion. Kennedy, weary of the whole operation, and worried about its potential length, and world opinion, cancelled all American troop participation, making it a strictly Cuban-exile affair, thereby dooming the entire plan. In the end, the sheer momentum of the buildup was too much, and on April 17, 1961, he gave the go-ahead. He took full responsibility for the disaster. "There is an old saying that victory has a hundred fathers and defeat is an orphan. I am the responsible officer of the government," he said. The American people forgave him.

▶

A high-level meeting about Cuba, shortly before the invasion, is about to start. From left: General Chester Clifton, the President's military aide; National Security Adviser McGeorge Bundy, partly hidden; Secretary of Defense Robert McNamara; Joint Chief of Staff General Lemnitzer; CIA Director Allen Dulles; Richard Bissell; and Walt Whitman Rostow, Deputy National Security Adviser.

and it was startling to pick up the phone and have the President on the line saying, "Jacques!!! It's the President," rather than have the operator calling to tell you that the President is on the line. That moment of preparation helps, especially when he would call because he was angry about something — for instance, a picture *The New York Times Magazine* ran on its cover showing him with his glasses on his head. The picture had been used frequently without comment or incident. Why it had suddenly become non grata I never found out. All I could do that day back in my New York studio was stumble over my words. The incident would soon be forgotten. He simply had to get it off his chest.

One particular night he wanted to reach Ralph McGill, the distinguished editor of the *Atlanta Constitution*. As usual he dialed, and got McGill's young daughter on the phone. He asked to speak to her "daddy," who wasn't in. But the ensuing conversation between the world's most powerful political figure and the five-year-old was hilarious, he explaining that he was the president of the United States and wanted to speak to her daddy, she not quite understanding what "president" meant and insisting he call back. Finally a startled Mrs. McGill came to the phone, stuttering and apologizing.

In the ensuing months I attended most meetings within and outside of the White House and I spent time with each of the leading staff members. I then enlarged my work to cover the cabinet departments and officers, state to defense, and, of course, the attorney general's office, where Bobby remained "Bobby." In between there were parties and weekends in McLean and Hyannis Port. In the end I had amassed some forty thousand negatives, the most complete record of any administration in American history.

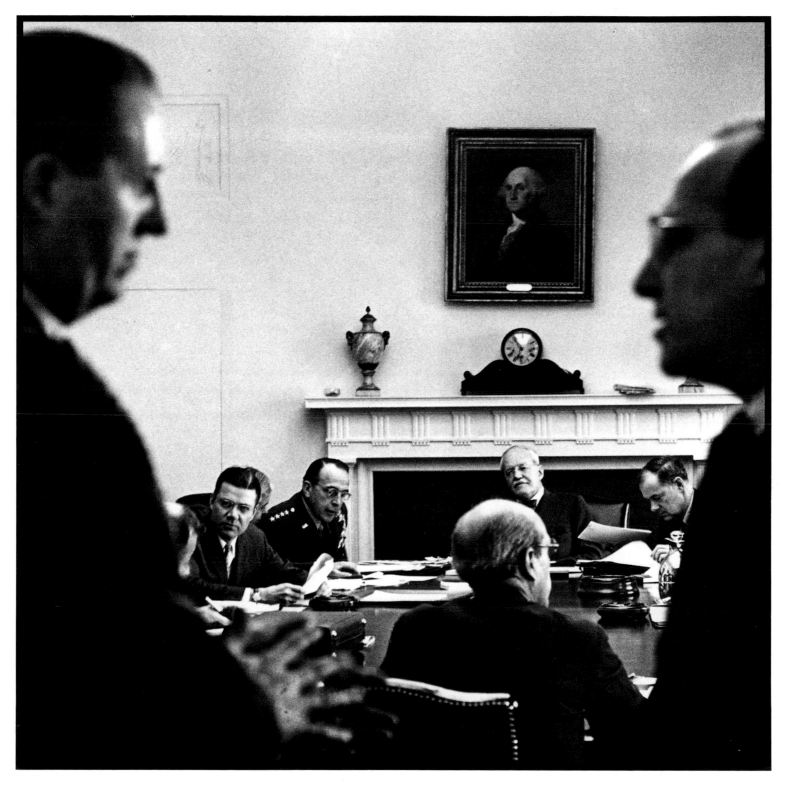

THE CABINET ROOM. JANUARY 26, 1961

We had to establish an effective deterrent to American interference in the Caribbean. But what? The logical answer was missiles....

I found myself in the difficult position of having to decide on a course of action which would answer the American threat but would avoid war. Any fool can start a war, [but] even the wisest of men are helpless to stop it — especially if it is a nuclear war....

My thinking went like this: if we installed the missiles secretly and if the United States discovered the missiles...after they were poised and ready to strike, the Americans would think twice before trying to liquidate our installations.... I knew that the United States could knock out some of our installations, but not all of them. If a quarter or even a tenth of our missiles survived — even if only one or two big ones were left — we could still hit New York....

The Americans had no direct information about what we were delivering, [but] it was not long before they concluded on the basis of reconnaissance photographs that we were installing missiles....

The Americans became frightened, and we stepped up our shipments. We had delivered almost everything by the time the crisis reached the boiling point...we had installed enough missiles already to destroy New York, Chicago, and other industrial cities, not to mention a little village like Washington. I don't think America had ever faced such a real threat of destruction as at that moment....

I spent one of the most dangerous nights at the Council of Ministers...in the Kremlin. I slept on a couch in my office — and I kept my clothes on...I remember those days vividly....

While we conducted some of this exchange through official diplomatic channels, the more confidential letters were relayed to us through the President's brother.... In our negotiations with the Americans during the crisis, they had, on the whole, been open and candid with us, especially Robert Kennedy.

Nikita Khrushchev

The President in the Oval Office. He's browsing through the day's newspapers or reading documents. But the stance is typical. He's in pain. Every once in a while he would have to get up out of his chair and lean heavily on a table or other surface. The position would ease his recurring back pain.

THE OVAL OFFICE. MAY 1961

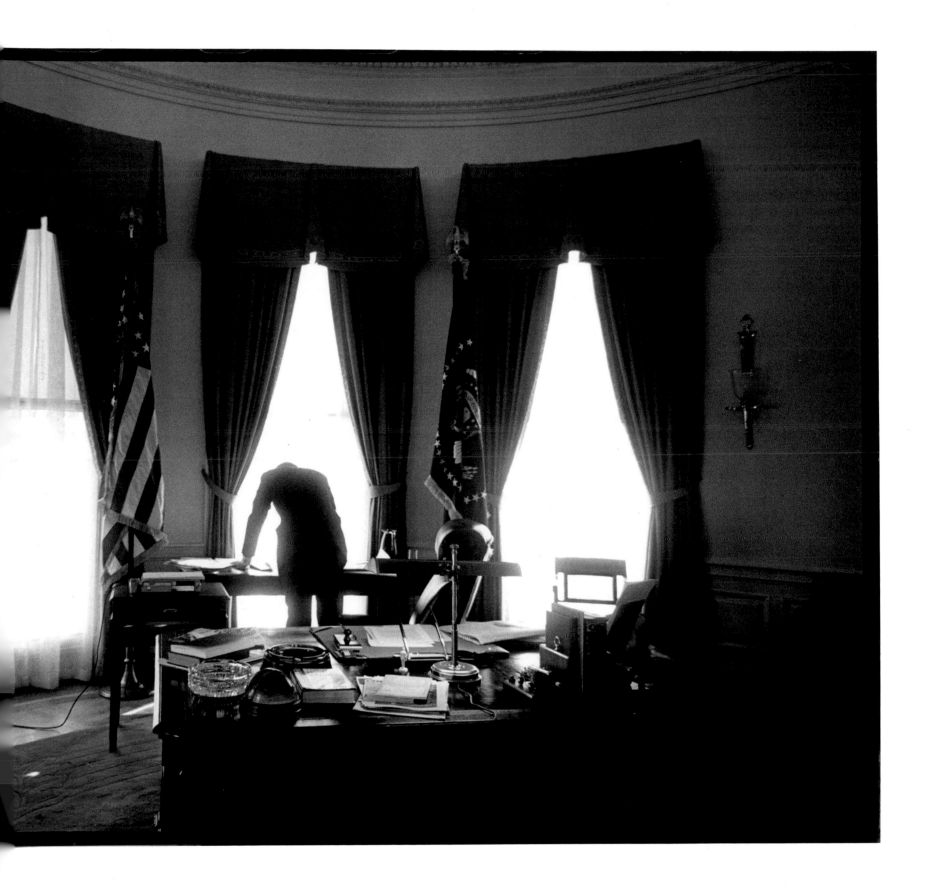

The dominant feeling at the meeting was stunned surprise. No one had expected or anticipated that the Russians would deploy surface-to-surface ballistic missiles in Cuba....

I told Ambassador Dobrynin of President Kennedy's deep concern about what was happening. He told me I should not be concerned, for he was instructed by Chairman Nikita Khrushchev to assure President Kennedy that there would be no...offensive weapons placed in Cuba.... I could assure the President that Khrushchev would do nothing to disrupt the relationship of our two countries, he liked President Kennedy and did not wish to embarrass him....

Now...we realized that it had all been lies, one gigantic fabric of lies.... Neither side wanted war over Cuba, but it was possible that either side could take steps that for reasons of "security" or "pride" or "face" — would require a response by the other side, which...would bring about a counter-response and eventually an escalation into armed conflict.... We were not going to misjudge, or miscalculate, or challenge the other side needlessly, or push our adversaries into a course of action that was not intended....

I think these few minutes were the time of gravest concern for the President. Was the world on the brink of a holocaust? Was it our error? A mistake? Was there something further that should have been done? Or not done? His hand went up to his face and covered his mouth. He opened and closed his fist. His face seemed drawn, his eyes pained, almost gray. We stared at each other across the table. For a few fleeting seconds, it was almost as though no one else was there and he was no longer the President.

Inexplicably, I thought of when he was ill and almost died; when he lost his child; when we learned that our oldest brother had been killed; of personal times of strain and hurt...."Isn't there some way we can avoid having our first exchange with a Russian submarine?" "No...there is no alternative," said McNamara.

The minutes in the Cabinet Room ticked slowly by...then it was 10:25 — a messenger brought in a note...."Mr. President, we have a preliminary report which seems to indicate that some of the Russian ships have stopped dead in the water."

Robert Kennedy

This picture clearly defines the relationship between the two brothers. The adoring younger brother, unquestionably loyal, and the President, slightly bowed here, again in pain.

I call upon Chairman Khrushchev to halt and eliminate this clandestine, reckless, and provocative threat to world peace and to stable relations between our two nations. I call upon him further to abandon this course of world domination, and to join in an historic effort to end the perilous arms race and to transform the history of man....

We have no wish to war with the Soviet Union — for we are a peaceful people who desire to live in peace with all other peoples....

The path we have chosen for the present is full of hazards, as all paths are — but it is the one most consistent with our character and courage as a nation. The cost of freedom is always high — but Americans have always paid it. And one path we shall never choose, and that is the path of surrender or submission.

Our goal is not the victory of might, but the vindication of rights — not peace at the expense of freedom, but both peace and freedom....

John F. Kennedy, from a radio and television broadcast, October 27, 1962

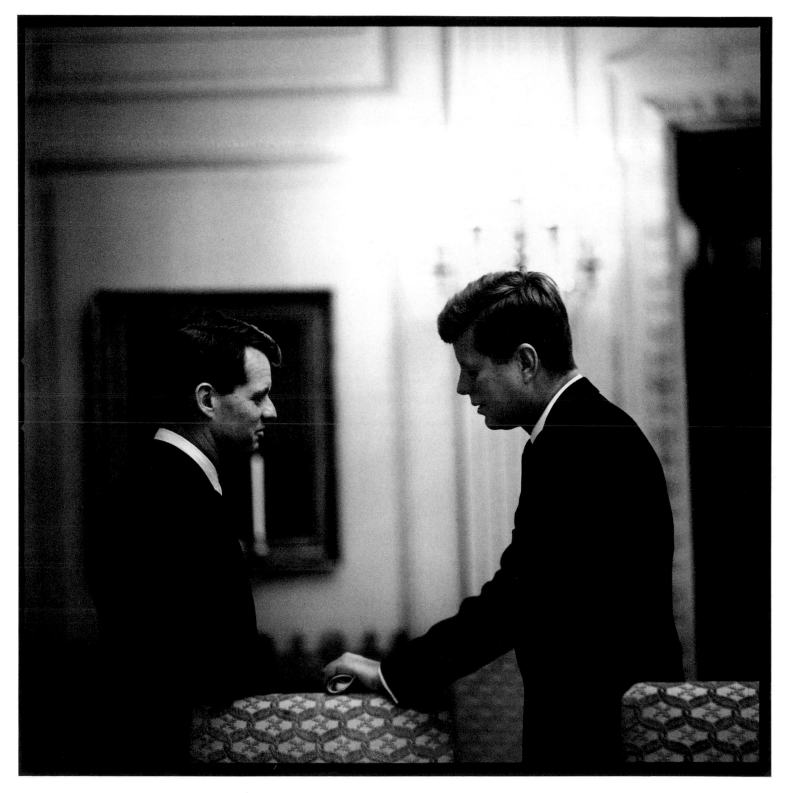

THE OVAL OFFICE. MAY 1961

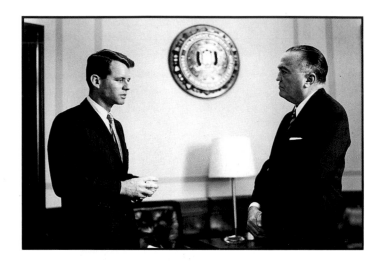

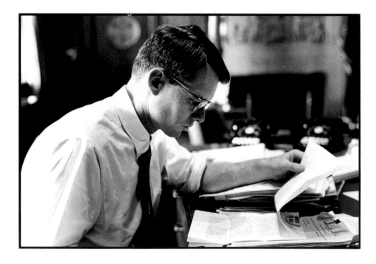

The attorney general's office is the most forbidding in all of Washington. The size of a small football field, lined with dark, gloomy wood-paneled walls and an immensely high ceiling, the room feels almost threatening. But within days vivid colored drawings by Bobby Kennedy's children transformed the walls, and a stuffed tiger had taken the place of honor in a heavy leather armchair. Often meetings were held standing around the desk while a football was being tossed back and forth between the conferees. And while Bobby's normal work hours topped twelve a day, he sat at his desk in shirtsleeves, ate his lunch at his desk, and was joined by his own and other people's children on a regular basis. Somehow, this very serious edifice to high purpose had been converted to the human condition.

The appointment of Robert F. Kennedy as the attorney general caused howls of righteousness from Republicans and Democrats alike. "Nepotism" was the guide word, but the reasons for the resistance lay elsewhere. Southerners were fearful of this pro-civil rights activist who not only was the President's brother but also was known as a tough, uncompromising operator. He had earned that reputation in his work as majority counsel for the McClellan Committee, where he mercilessly confronted the likes of Jimmy Hoffa, Dave Beck, and various Mafia figures, and also as the campaign manager for his brother. Some called him unfit for the office. After all, he was not a celebrated lawyer nor a renowned district attorney. But what frightened the naysayers most was the close relationship between the two brothers. Bobby himself didn't want the job. He felt he had devoted enough time to his brother; he loved him, but he'd done his job. He wanted a career of his own, maybe run for office himself, perhaps teach. But the President insisted. He needed someone he could trust in his inner circle, someone who would dare tell him the truth. He also had no intimates in the cabinet. And he knew that the domestic battles of his administration, especially the looming civil rights confrontation, wouldn't be fought at Commerce or Interior or Labor, but they would be decided at Justice. Bobby finally accepted. And it turned out to be an inspired appointment. Bobby became one of the finest attorney generals in modern times. His critics relented. Some became vocal supporters. And, backed by a brilliant staff, often disagreeing with accepted wisdom, his advice in all areas of government became a crucial and moderating influence, especially during the Cuban Missile Crisis.

J. Edgar Hoover, the director of the FBI, loathed the Attorney General, nominally his boss. And the feeling was mutual. Bobby felt that the director had expended entirely too much effort on Communist witch hunts and ignored crimes committed against civil rights and black power activists by accusing them to be leftists, all at the expense of fighting general and organized crime. He also felt that the director had become a law unto himself. He wanted to change that, and Hoover knew it.

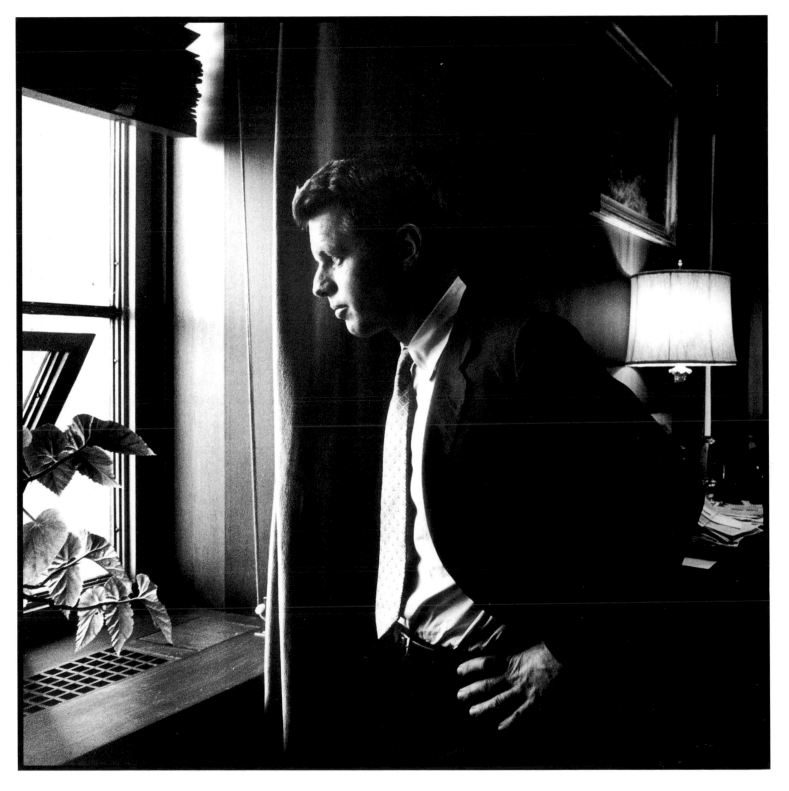

ATTORNEY GENERAL'S OFFICE. NOVEMBER 1961

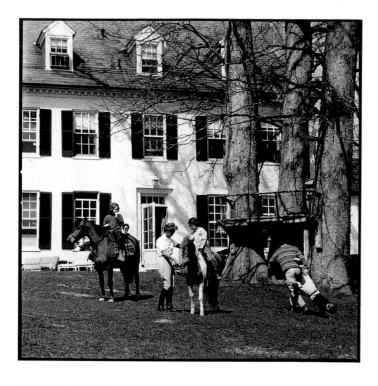

MCLEAN, VIRGINIA. MARCH 1961

▲

Bobby and Ethel's house in McLean, Virginia, always was a maelstrom of activity. Not only were their own children rushing about, but their friends' and neighbors' children also would join the fray on a regular basis. Here, on a weekend, Ethel is tightening the reins on Kathleen's horse so she can go riding with a friend, and Bobby Sr. is pulling Bobby Jr. in some unexplained new game.

▶

On Monday morning, after a long weekend, Bobby is ready to go to his office at Justice. Some of the children, because they are on vacation, will go with him. Due to the solemnity of the forthcoming occasion they salute the flag prior to leaving.

"Damn it, Bobby, comb your hair," and then, "Don't smile too much or they'll think we are happy about the appointment."

John F. Kennedy to his brother before announcing the appointment of attorney general

I remember Bobby's extreme reluctance to be a member of the cabinet. Yes, and I remember Jack's tremendous power of persuasion — I think one of the hardest things he really had to do was to overcome Bobby's reluctance.

Ethel Kennedy

I came to this department ten years ago as an assistant attorney making $4,200 a year. But I had an ability and integrity, an interest in my work. I stayed late hours, my brother became president, and now I am attorney general… those qualifications are not necessarily listed in their order of importance.

Robert Kennedy to Justice Department employees

When Jack was elected and was forming his cabinet, Bobby came to see me. Jack wanted him to be attorney general, and Bobby wondered what he should do. Up to then he had no real important bridge to cross…so he had quite a decision to make: whether to continue to sit in the shadow of his brother. Would he be criticized? Would it be harmful to his brother? Would he make a good attorney general? Would it help or hurt his future? These are the kinds of things he talked about…. He made, I thought, a very outstanding attorney general.

William O. Douglas, Supreme Court Justice

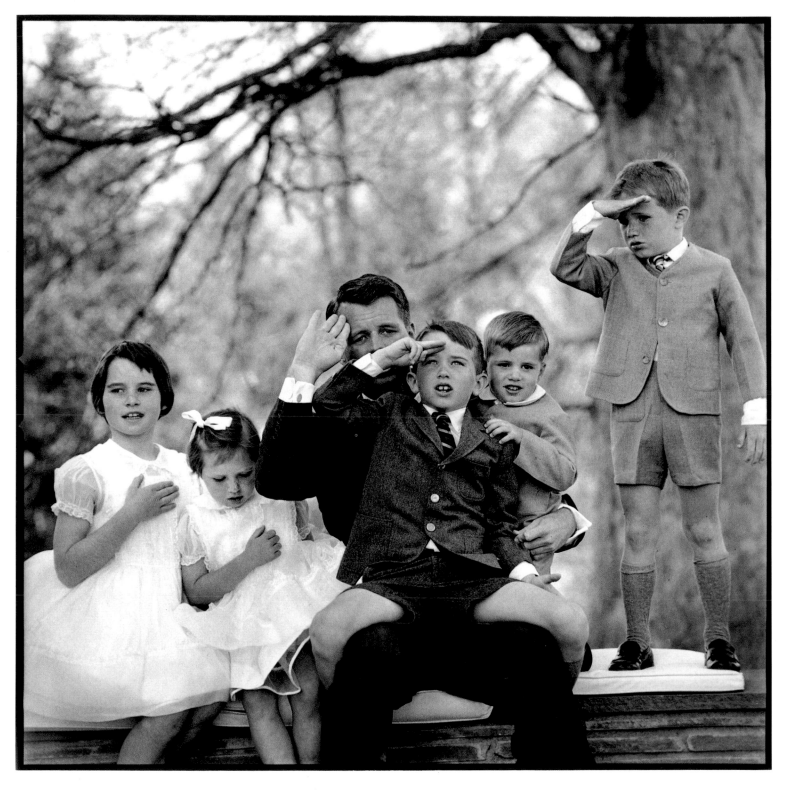

MCLEAN, VIRGINIA. MARCH 1961

*To many, his worst civil rights offense was his decision in
1963 to authorize J. Edgar Hoover to place a federal tap
on the phone of civil rights leader Martin Luther King.*

BBC commentary, from the BBC television program *Reputations: Robert
Kennedy*

*The problem was that it now appears to be outrageous.
But it did not at the time [when] a very secret Communist
member very high up in the Communist Party was
influencing Dr. King, and those were the grounds that Mr.
Hoover gave for doing it; he circulated that information
widely in the government and it was rightly or wrongly
Mr. Kennedy's judgment that the best way of disproving
any influence of that kind was to allow him to put on the
tap and not have all those other facts leak out and destroy
Dr. King by innuendo.*

Nicholas Katzenbach, Deputy Attorney General, from *Reputations:
Robert Kennedy*

*I think his attempt to bring the FBI under control and to
have a greater emphasis on white-collar crime and organized
crime was positive. And on the other hand he supported the
appointment of some miserable racist to the Federal Appeals
court in the South and he was occasionally insensitive to
civil liberties.*

Jack Newfield, journalist, from *Reputations: Robert Kennedy*

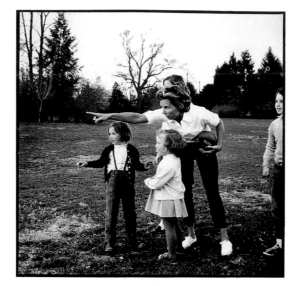

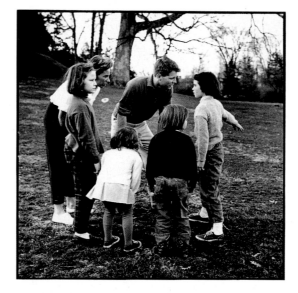

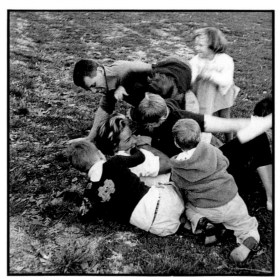

MCLEAN, VIRGINIA. MARCH 1961

◄
There were always enough kids,
and adults, around to start a
Kennedy versus Visitors football
game. It was a very fierce and
very competitive exercise.

►
Ethel in hot pursuit of Bobby,
who has the ball. The fact that
Kennedys were playing against
Kennedys this time did not
diminish the enthusiasm or the
competitive spirit.

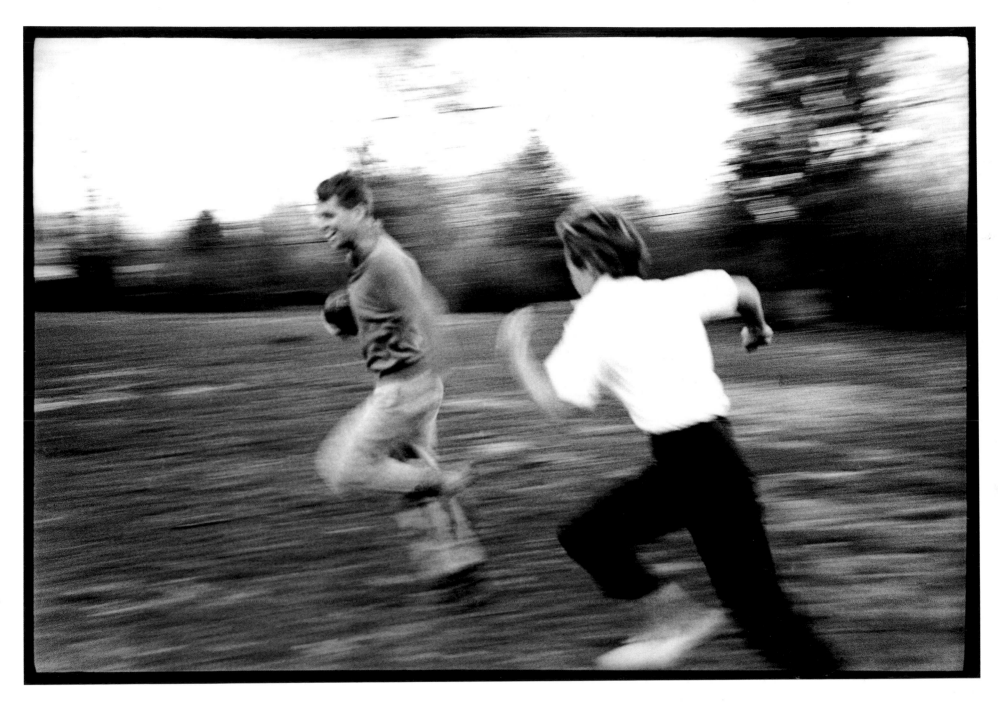

MCLEAN, VIRGINIA. MARCH 1961

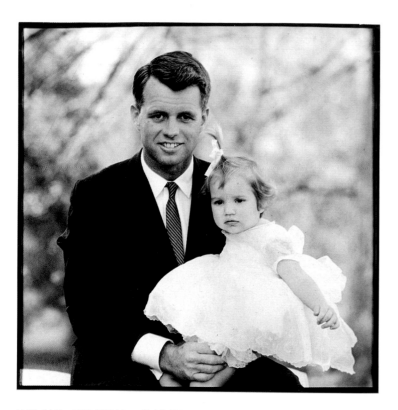

MCLEAN, VIRGINIA. MARCH 1961

▲

The Attorney General with Mary Kerry
at his home in McLean, Virginia.

▶

This photograph, one of my favorites
of Bobby and his family, was taken
after a formal Christmas card shoot
was completed.

The annual Robert Kennedy Family Christmas Card production was one of high photographic achievement as far as Ethel was concerned. She would start calling me in June, asking what the theme was going to be this year. I would point out that it was early summer and that I wasn't in the Christmas mood yet, but I would think about it. By July Ethel was back on the phone. And by August there was no way out.

The theme had to be nailed down. We had many. One year it was a group picture, but as the group got larger every year, we switched to an individual concert pullout concept. One year each child, wearing pajamas, was in prayer. One year each carried a candle. But the most memorable one was when each child was leading a favorite animal, from a horse for the oldest to geese for the youngest. I will never forget the session when we were trying to photograph Michael being followed by a clutch of geese. Neither young Michael nor the geese were terribly cooperative. Here was the renowned photographer frantically trying to capture the scene, while the Attorney General of the United States, his wife, and various other distinguished visitors were trying to keep a bunch of very confused and very noisy geese marching in unison behind a little boy. It took hours. The card was finally produced to everyone's satisfaction.

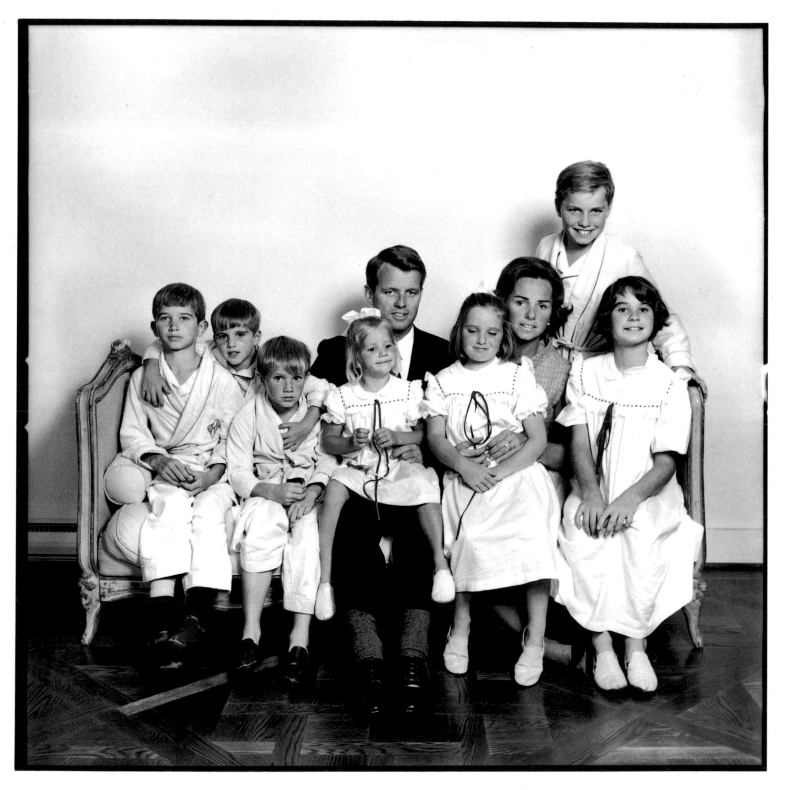

MCLEAN, VIRGINIA. MARCH 1961

During the freedom rides, I had a number of meetings with various civil rights groups, and I said that it wasn't as dramatic, and perhaps there wasn't going to be as much publicity about it…going down and registering people to vote, but I thought that's where they should go, and that's what they should do. I had some conversations with Martin Luther King along those lines. I think that they rather resented it. That's not what they wanted to do, and that's not where they were going to focus their attention.

The Bay of Pigs was the best thing that happened to the administration because if it hadn't been for the Bay of Pigs, we would have sent troops into Laos because the military wanted to send them in, and President Kennedy, based on the Bay of Pigs, started asking questions that were not asked at the Bay of Pigs, making them go back. For instance, one time they wanted to send troops into two airports in Laos, and we could land troops, and it would make a major difference — take over this part of the area.

So the President said, "Well, how many troops?"

And they said they could land a thousand troops a day.

So then he said, "How many troops do the Pathet-Lao have?"

They said that they have five thousand.

So he said, "Now, what kind of an airport is that?"

And it turned out that the airports could be used only during the day. So he said, "Well, what happens if the Pathet-Lao allow you to land troops for two days at both airports and then they bomb the airports? Then what are you going to do?"

Well, they said, they really hadn't thought about that.

Robert Kennedy

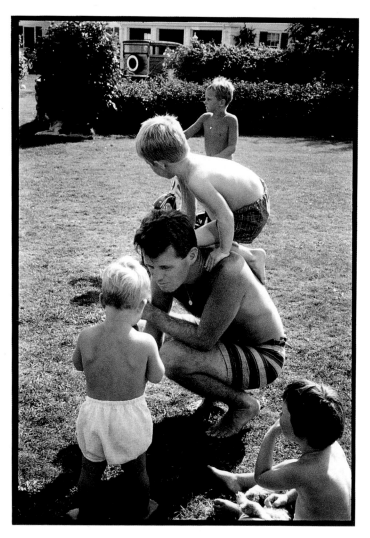

In the summer the family would move to Bobby's house in Hyannis Port, where the activities changed from football and horses to sailing and swimming, but basically very little else changed. Above: Bobby piggy-backing Michael, with Mary Courtney at his side, on their way to the beach. They are followed by Meegan, one of his two lumbering, oversized, and sometimes bad-tempered Saint Bernards. Bottom: A football game gets started. Right: David Kennedy with Meegan at his side. In the background looking on are his father and his grandfather, Joseph Kennedy, Sr.

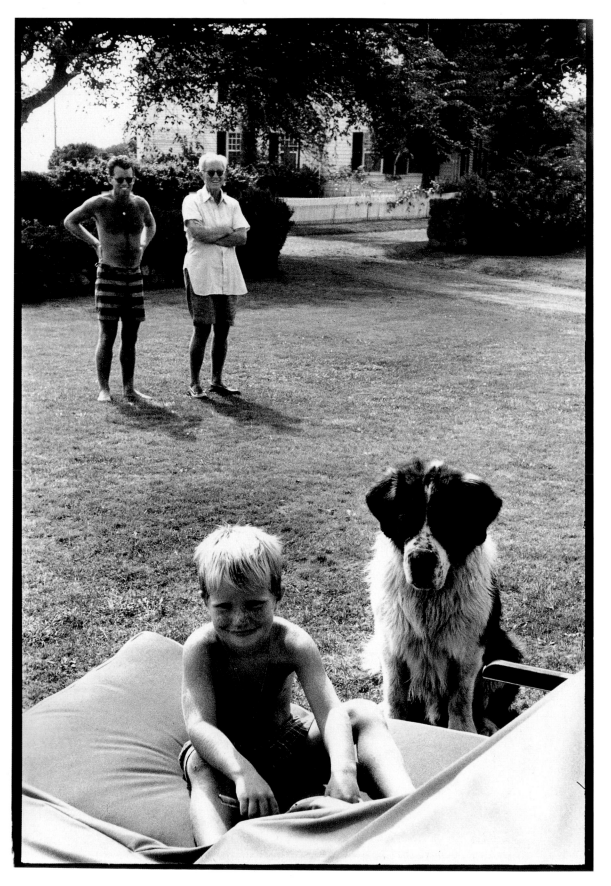

HYANNIS PORT, MASSACHUSETTS. SUMMER 1961

▲

Lee Bouvier Radziwill is the younger sister of Jackie Kennedy. Living in London at the time, she was married to Prince Stanislas Radziwill, a Polish nobleman. Here, Lee and her son Anthony enjoy the afternoon with Jackie and Caroline in an upstairs room of JFK's house.

▶

Jackie poses with Caroline on the sun porch in Hyannis Port for some international magazine covers.

He was under the handicap of being a very rich young man. Therefore he was not under the compulsion to do anything. He had a hard time making up his mind what to do. I remember talking to him about the time he decided to run for Congress, and I think he looked forward to that with great anticipation…when he got into the House and started serving, I don't think it interested him particularly, I think he was rather bored…it was at that time Jack became pretty much of a playboy.

As Jack began to raise his sights and aim for the Senate, he began to think in more controversial terms and controversial subjects. And of course…his father was very conservative. Jack was getting mature, making up his mind on controversial issues, and finding himself very often at odds with his father.

His decision to run for the Senate in 1952 was a surprise to many people… he asked me what I thought. I told him that I believed in every young man shooting for a star…. I thought from way back that Jack had a growth factor in him that many people didn't have.

By the time he got into the Senate, I was largely disappointed with Jack because he really had a…third-rate record as a senator. He got there, and, like getting into the House, it was interesting and challenging. And in his first years there…he had occasional streaks of serious work and effort.

I think that the whole thing changed, near as I can tell, about 1958, and Jack became a whole different person. What was behind that I never knew….

But about 1958 Jack became considerably transformed. Instead of a playboy, he stepped out more and became more of a thinker, a leader, with the world as his oyster. He had a new seriousness of purpose…maybe he was just heading up to decide to run for president. Joe came to my office…"Well, this afternoon we crossed the river." Jack had decided to make a go for it. I think it was '59.

I didn't have any reservations about that at all because I had the feeling that Jack had what I said earlier was a factor of growth, and a tremendous potential. Nobody would know whether anybody would make a good president or not, because the office changes the man, sometimes for better and sometimes for worse. But I thought that it would change Jack, if in any way, for better, and that he would respond and rise to the occasion.

William O. Douglas, Supreme Court Justice

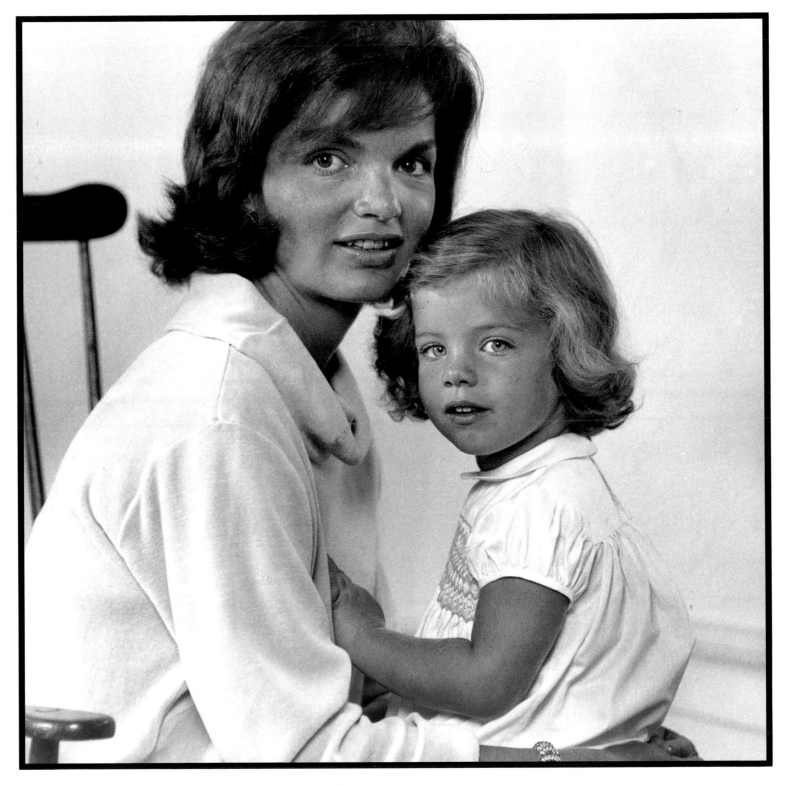

HYANNIS PORT, MASSACHUSETTS. SUMMER 1961

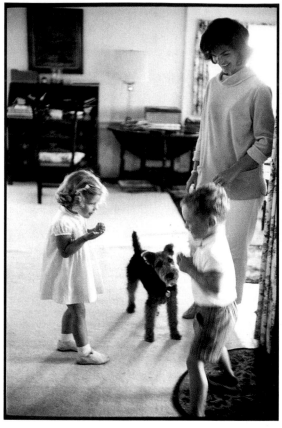

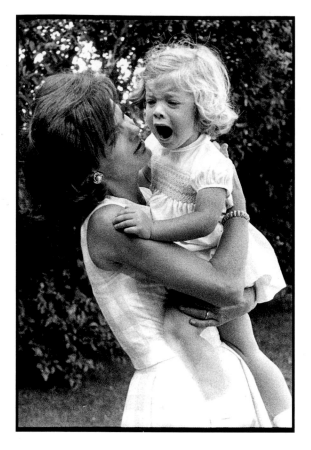

Carefree days before
the start of the general
election campaign.

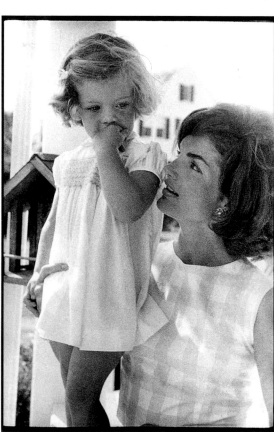

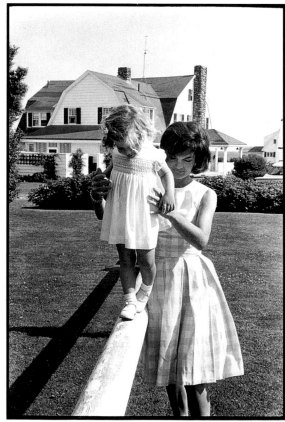

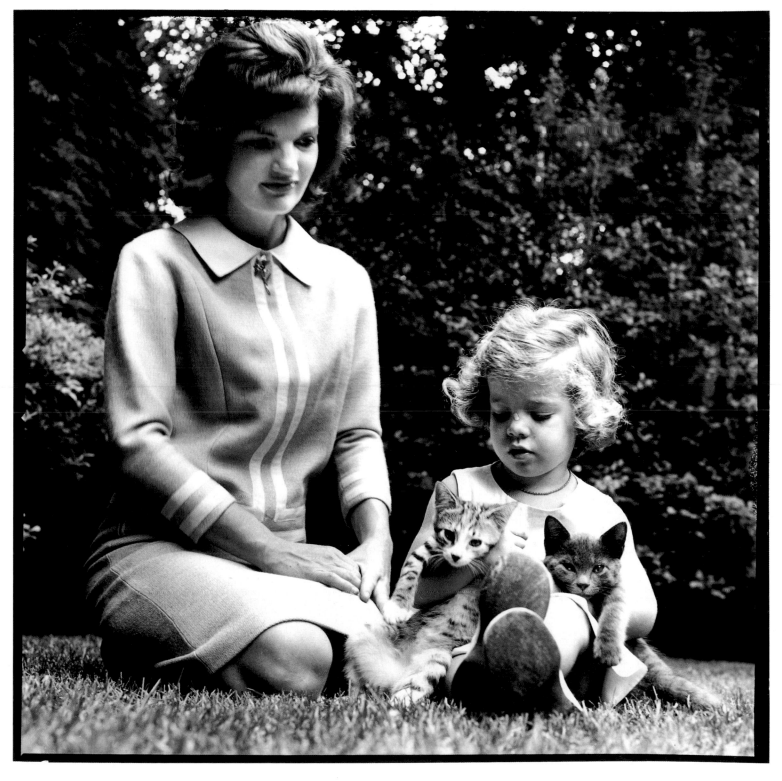

HYANNIS PORT, MASSACHUSETTS. SUMMER 1961

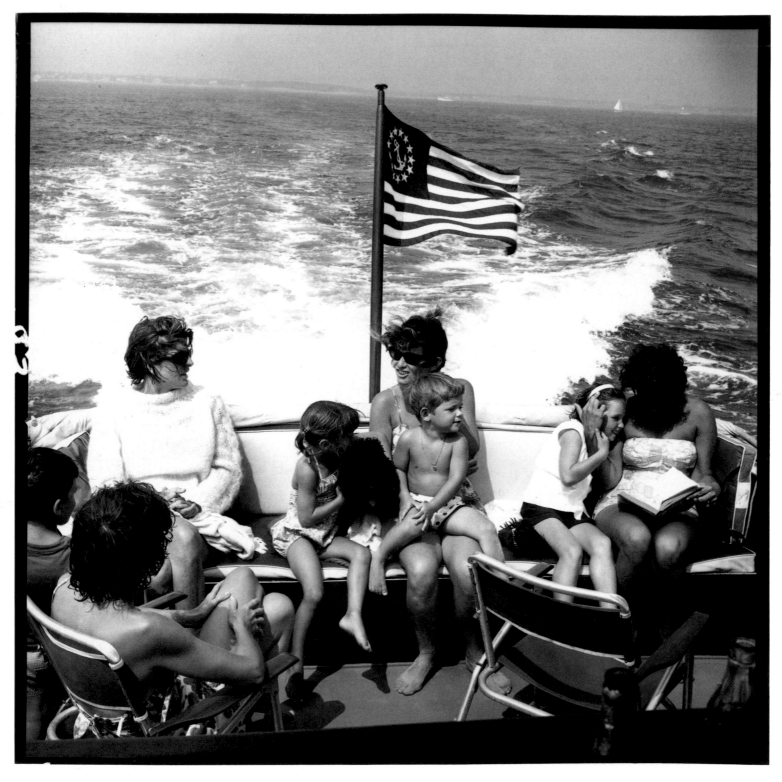

HYANNIS PORT, MASSACHUSETTS. SUMMER 1961

Picnics were an integral part of the Cape Cod summer activities. The various families, some with their own houses on the compound and some staying at the Big House, would gather their children and dozens of baskets of food and move to some remote part of the Cape or to an island via boats. The food was simple. Tuna-fish sandwiches, hot dogs, and soft drinks were the usual fare. Top left: John-John with nurse Maud Shaw in back, Willie Smith in front: Top right: Nurse Maud with Caroline, Michael Kennedy, and Stevie Smith (in dark shirt). Bottom left: Stevie Smith, Caroline, and Michael Kennedy in a hole they dug. Someone's friend walks by in the background. Bottom right: Maria Shriver in the foreground. A clutch of children in the back.

◀

Pat Kennedy Lawford, Jean Kennedy Smith, Ethel Kennedy, and children taking a ride on the *Marlin*, the family cruiser.

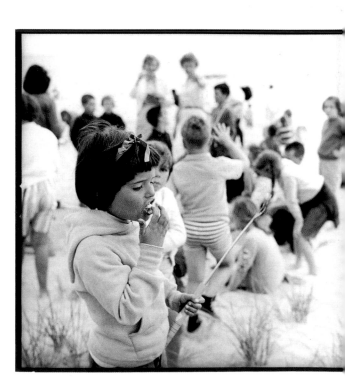

HYANNIS PORT, MASSACHUSETTS. SUMMER 1961

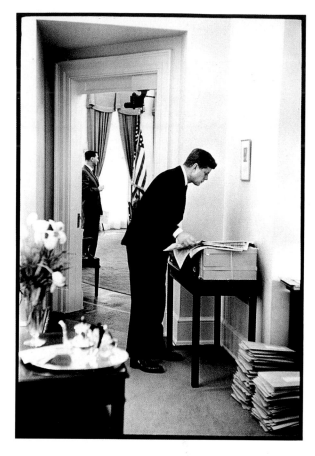

THE WHITE HOUSE. SEPTEMBER 1961

▲

The President stops to quickly glance at the papers in Evelyn Lincoln's office. His need to scan the papers was close to an addiction. His curiosity was insatiable. He would never tire of soaking up more news. But it would also affect him deeply. As the press became more critical of his administration he would complain, "I am reading more and enjoying it less." In the background, his appointments secretary, Kenneth O'Donnell, is waiting for him in the Oval Office.

▶

The President in the Oval Office, again reading. His stance again is for comfort; he leans hard on the table to ease his back pain. In his right hand he holds a cigar. JFK loved these little cigars, but they were Cuban. After he ordered the trade embargo on Cuba he realized that he'd be out of cigars. He therefore considered the decision a personal sacrifice as well as a national emergency.

There were, to be sure, areas of failure in the Kennedy administration by late 1963. The overemphasis...on the "missile gap" in the campaign had set the country on a course of larger and larger military budgets, and perhaps had led to the invasion of Cuba, the subsequent missile confrontation, and the humiliation of Khrushchev... the President, in committing approximately 16,000 troops to Vietnam, had changed our involvement there in a quantitative way.

Whether he would have escalated the war as did President Johnson, no one can know...his closest associates say that he would not have done so. There is reason to believe that they are correct. President Kennedy did limit American participation in the Cuban venture and ended it without the showdown that some were urging on him....

The spirit of America in 1963, the last year... of the life of John Kennedy, was one of optimism and hope. Quiet courage and civility had become the mark of American government. New programs of promise and dedication — the Peace Corps, the Alliance for Progress — had been presented....The promise of equal rights for all had been given, and a beginning toward fulfillment of that promise had been made. What the continuation...of the good spirit released in John Kennedy's administration might have done for the nation remains an unanswered question.

What...should be remembered is the promise and style of John Kennedy and of his presidency. For he brought to that office a willingness to accept with good heart the burden and responsibility of citizenship. He brought the spirit of public happiness which possessed the American colonists at the time of the Revolution and which was reflected in their delight in public discussion...in joy of citizenship and civic commitment....

John Kennedy brought to office a vision of the unity of Western civilization and, beyond that, the unity of all peoples in the world. He spoke of realizing the potential of all created things — a potential to be measured...by the infinity of human aspirations and of human achievement....

And he urged upon us an effort to secure the fullest possible development of every person — from the simple, and even the retarded, to those with the greatest talents — encouraging everyone to seek the goal that he had set for himself....

November 22, 1963, was a day out of season. It was a day both...of spring and fall, of beginnings and endings, but in the balance of time the ending has proved the stronger. What was changed was something of the spirit. We have not yet recovered.

Senator Eugene McCarthy

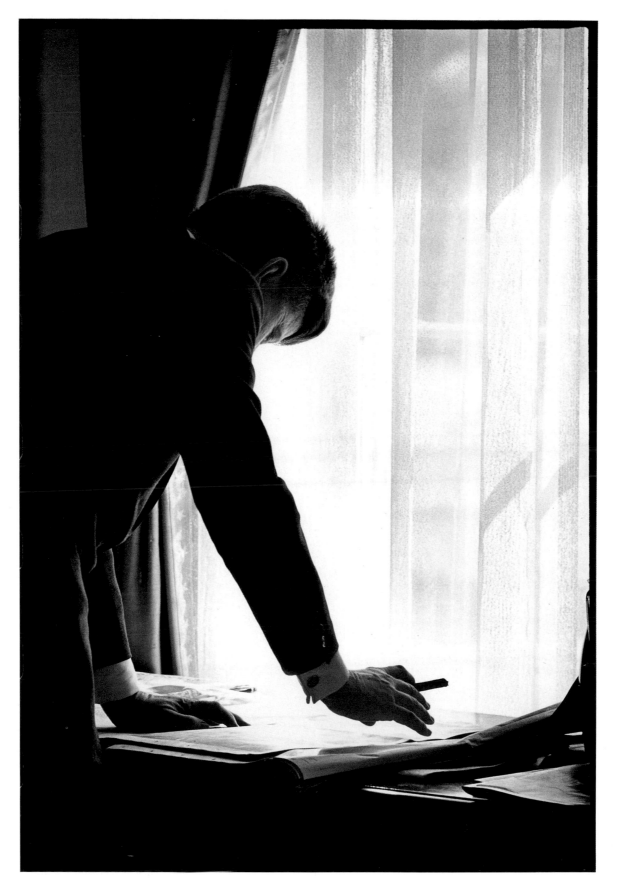

THE OVAL OFFICE. SEPTEMBER 1961

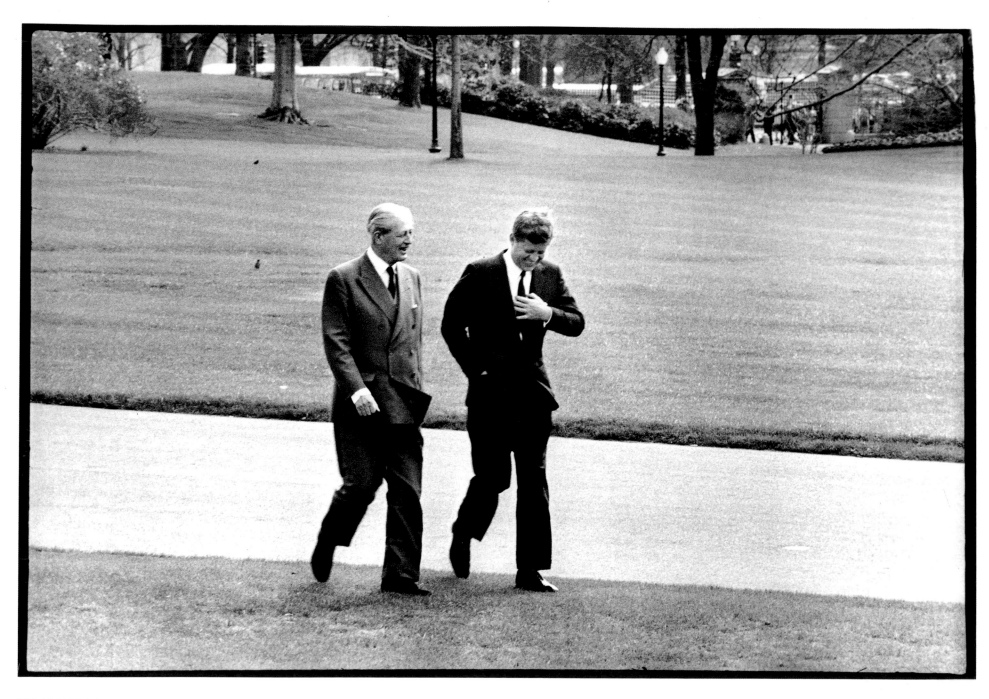

THE WHITE HOUSE LAWN. FEBRUARY 1961

I think it might interest Your Majesty to have some impressions of the President on this, my fourth meeting with him. He was naturally suffering from the blow of his father's sudden illness, for the Kennedys are a devoted family. The President owes a great deal to his father and is obviously very attached to him. Moreover, it is a great shock to see a man perfectly fit one day and two days later struck down and permanently immobilized. I also thought the President's own health was not good. He is very restless owing to his back. He finds it difficult to sit in the same position for any length of time. I noticed the difficulty he had in picking up a piece of paper that had fallen on the floor. We produced a rocking chair, which was of some comfort to him. It is really rather sad that so young a man should be so afflicted, but he is very brave and does not show it except…by his unwillingness to continue to talk for any length of time without a break. He is also a very sensitive man, very easily pleased and very easily offended. He likes presents…I gave him one…. He likes letters, he likes attention. To match this he is clearly a very effective, even ruthless, operator in the political field. I thought he was more interested in short-term than in large and distant problems but that is perhaps natural from his present experience. He is a most agreeable guest and carries the weight of his great office with simplicity and dignity….

Harold Macmillan, in a letter to Her Majesty the Queen of England, December 24, 1962

THE WHITE HOUSE. FEBRUARY 1961

◄

Prime Minister Harold Macmillan was one of the statesmen JFK greatly admired. From time to time he turned to him for advice. And oddly enough the young Democratic President and the aging Conservative British prime minister, known as "Supermac," got along famously. Here they are sharing a walk on the White House lawn.

▲

The British and American delegations were waiting outside the Oval Office for their respective leaders to return from their walk.

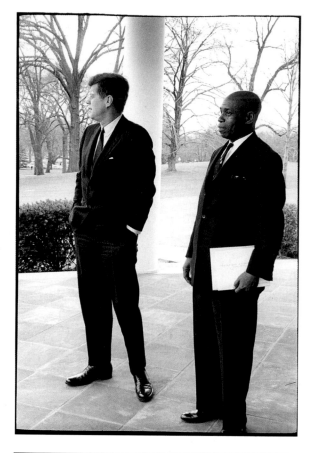

Kennedy's relationship with foreign diplomats and dignitaries was always quite informal. Once the "photo opportunity" had been completed he would take them for a walk around the White House grounds or at least out back to the Rose Garden. Top left: After accepting the credentials of the newly appointed Ambassador from Dahomey, President Kennedy took him out to the Rose Garden. The Ambassador felt honored by the unexpected courtesy, yet awkward in the presence of the president of the United States. Bottom left: The President returns from a short walk with President Kwame Nkrumah of the African Republic of Ghana. They had met before. On one of the early campaign trips to California Kennedy had toured Disneyland. As we approached the Magic Kingdom, shaking hands all along, our path crossed that of Mr. Nkrumah, who, like Premier Khrushchev and many other foreign leaders, considered Disneyland an important site to visit, as it represented, in their view, the true picture of what America was all about. The two politicians then and there proceeded to hold a kind of instant summit.

▶

President Kennedy with Prime Minister Viggo Kampmann of Denmark. Earlier he had honored Kampmann with a luncheon, a generous gesture to a small country.

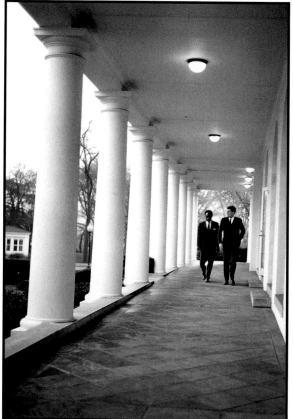

THE WHITE HOUSE. FEBRUARY 1961

He was intolerant of discursiveness, pomposity, pretension, and bombast, though a patient listener to one who espoused with passion and conscience a point of view with which he was in partial or complete disagreement.

He was endowed with personal grace in every aspect, attractive to men, women, and children. He commanded loyalty, and inspired romantic sentiments.

David K.E. Bruce

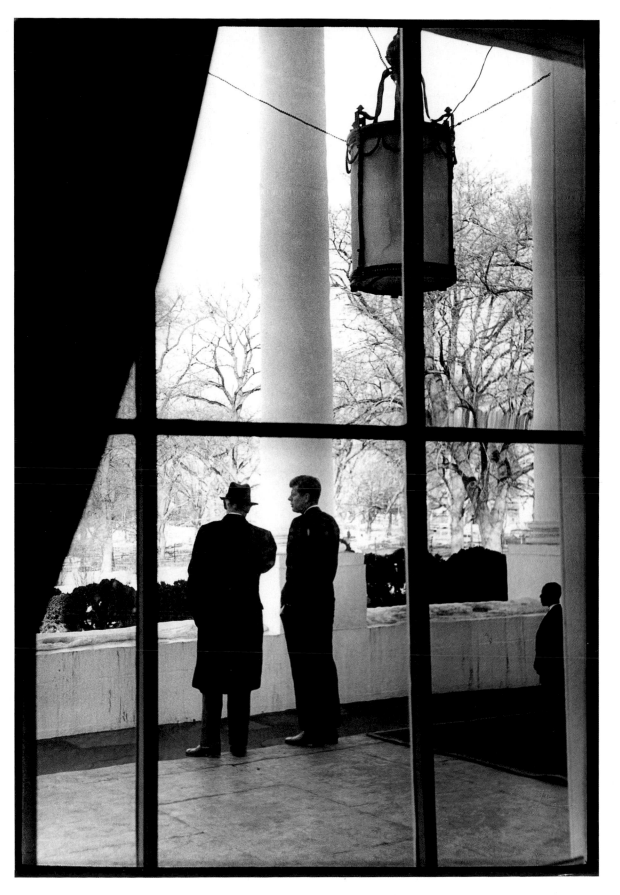

THE WHITE HOUSE. FEBRUARY 1961

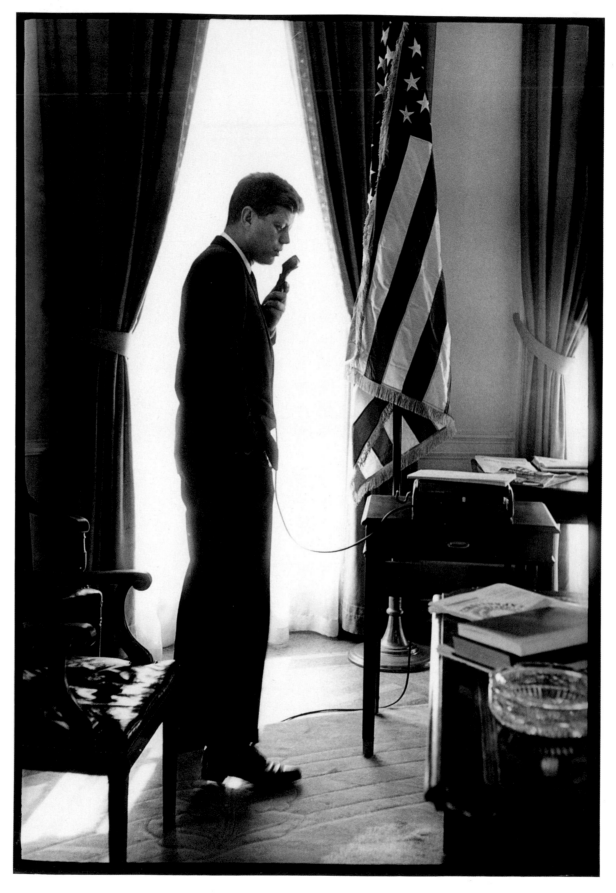

THE OVAL OFFICE. SEPTEMBER 1961

President Kennedy came to dinner at the Greek embassy. Strange to say we talked about the history of Greece. I was surprised to see how well informed he was, especially on old texts. After explaining his views, and expressing his admiration for the classical period, he ended by referring to Philip and Alexander the Great.

President Kennedy was in my opinion an apostle and a politician, maybe more an apostle than a politician. With his deeds he wished to set examples. He created a tradition. Thucydides relates that Pericles used to say about the Athenians that they were lovers of wisdom without the loss of manly vigor. For President Kennedy one can undoubtedly say that he was a lover of wisdom without the loss of manly vigor. Favorable or unfavorable comments will make no difference to the place President Kennedy is to occupy in history. History has already placed him as a luminous milestone in the universal conscience. There has been no leader whose loss mankind has so sincerely and so unanimously regretted. In his lifetime President Kennedy worked for mankind. After death he continues to serve it. He serves it as his untimely sacrifice has turned him into a symbol, urging and inspiring in the men of the young generations the noble ambition to imitate him. I consider myself very uniquely privileged for having had the good fortune of knowing this man. His faith, his kindness, his humanity were unique.

Konstantinos Karamanlis, Prime Minister of Greece

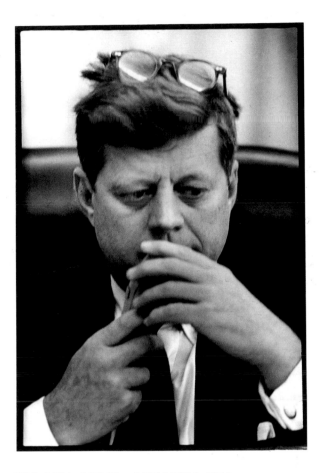

THE OVAL OFFICE. SEPTEMBER 1961

The President would normally dictate his thoughts and letters into a Dictaphone rather than have secretaries take his dictation. It was typical of his impatience. Most of the time he needed to get his ideas down at the moment they came to him. He just couldn't wait for someone to get ready and ask questions, and he would literally spend hours, mostly in the evening, talking into that device. Evelyn Lincoln and her staff would transcribe the material and put it on his desk the next morning.

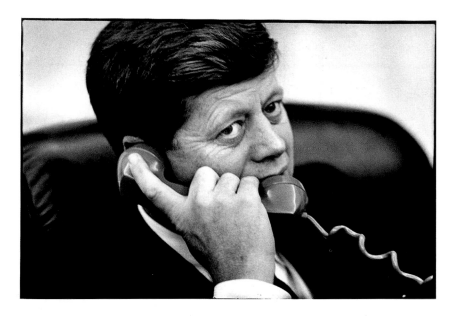

THE OVAL OFFICE. MARCH 1961

▲

President Kennedy was probably the first statesman who used the telephone to its full capacity. The written document was still the order of the day, especially in government. President de Gaulle of France, for instance, in sharp contrast, had refused the installation of a telephone in his own office at the Elysée throughout his term. The President would often dial the phone himself, bypassing the White House switchboard, and thereby completely startle the recipients of these calls.

▶

On February 13, 1962, Adlai Stevenson, by then the U.S. ambassador to the United Nations, was on the phone. I was alone with the President. I heard him groan, "Oh no," and his hand went to his head in despair. Stevenson's message was that Patrice Lumumba of the Congo had been assassinated. Many influential Americans considered Lumumba a leftist and a troublemaker, but Kennedy had a different view. His attitude toward black Africa was that many leaders considered to be leftists were in fact nationalists and patriots. He felt that years of colonialism had made it difficult for these leaders to resist the siren call of communism and that Africa represented a great opportunity for the West. During his years in the Senate he had made many friends in Africa; he had traveled to that continent, and as an American, unhindered by colonial heritage, had gained their trust. He knew that this murder would be a prelude to chaos in that mineral-rich, important African country. And he was heartbroken. A year after this photograph was taken I brought him a print of it and asked him to sign it for me. He wrote, "Is Jacques Lowe at the White House again?"

I vividly remember the day he was murdered. I was twenty-one, already in jail, and our only sources of information were official Soviet newspapers and radio. And yet, not just us, the inmates, but the official media too, displayed a genuine feeling of sorrow and tragedy. Surprisingly so, as he was routinely depicted previously like any other American president before or after him, as the very embodiment of imperialism, an archenemy of the Soviet people. The contrast was so stark, that we wondered — why? Could it be just diplomatic politeness? I still do not know.

It is much easier to explain why we, the inmates, felt sorrow and grief: it was not just because weakening of the United States has automatically meant worsening of our situation. Not just that. There was also a sense of a lost opportunity for the entire world, an opportunity of solving the problems in an intelligent and a radical manner. Somehow, rightly or wrongly, JFK has projected an image of a leader capable of changing the world.

Thirty years later we all have to reevaluate our beliefs and to reexamine our assessments. Later events, as well as later JFK biographers, may have given us enough ground to question our initial reaction. And yet, looking back to that fatal day, we still have that feeling of missed opportunity, or rather, of an opportunity stolen from us by someone's cruel hand, an opportunity of more radical and intelligent answers to our world's problems.

Vladimir Bukovsky, the first Soviet dissident exchanged for a Soviet spy, who was jailed in solitary confinement for eleven years. November 1992, from a letter to the author

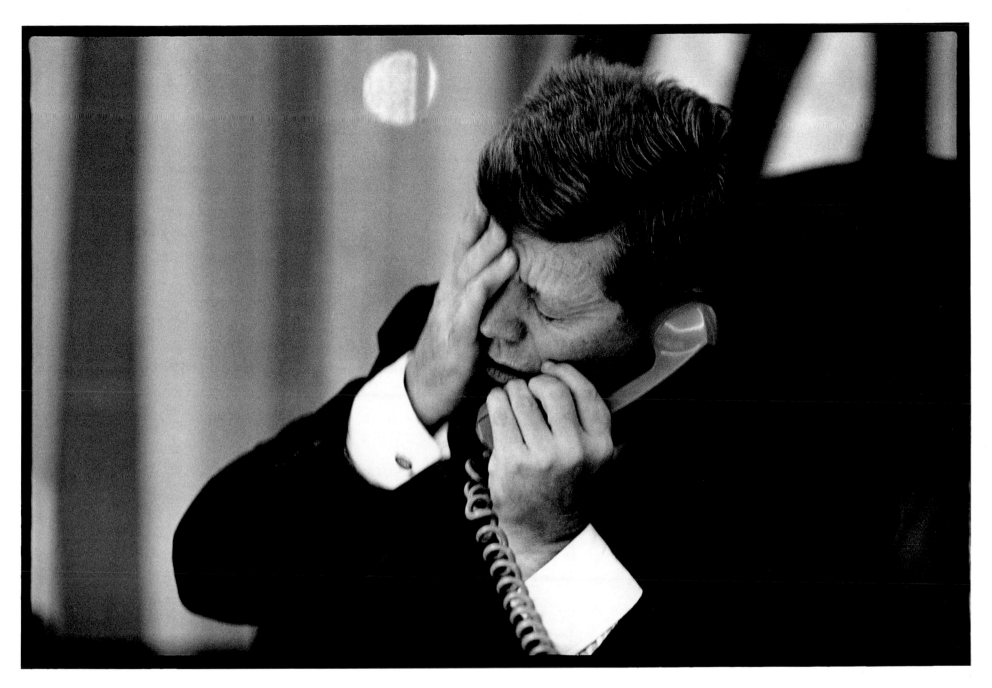

THE OVAL OFFICE. FEBRUARY 13, 1961

I went across the hall to knock on the door to get him over to answer the telephone. He came to the door in his shorts. And there were just a mass of photographers, and particularly a Time-Life guy right up in the front row with his camera all set to go, and I had visions of Kennedy in his shorts plastered all over the cover of every magazine in the country. So I stopped him and said, "Look, you don't want to go out like that; there is a Time-Life photographer right over there." And he sort of banged on the door and said, "Look, I know these fellows. They are not going to take advantage of me." And he said this in a voice that wasn't loud, but it was loud enough for them to hear. Then he walked across the hall, and nobody took a picture. It seemed to me that was pretty masterful. It was not only masterful in getting across without having pictures taken, but in establishing the sense of confidence and trust, and it made everybody feel good; everybody felt marvelous, and still nobody took a picture.

Abram Chayes, legal adviser to the State Department

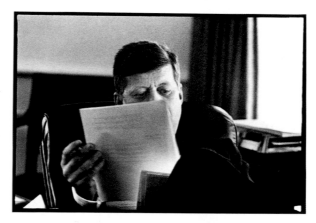

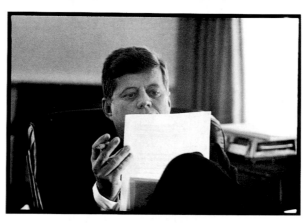

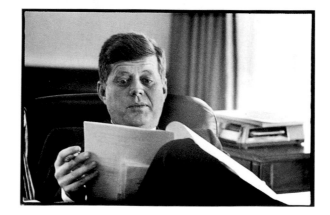

THE OVAL OFFICE. MARCH 1961

◀
The President's face was wonderfully expressive. In this sequence his reaction to a letter speaks for itself.

▶

As time went on the President seemed to become more and more somber and this infectious and happy laugh was a wonderful change of pace. I have hundreds of photographs of the President on the phone. Nearly all are serious.

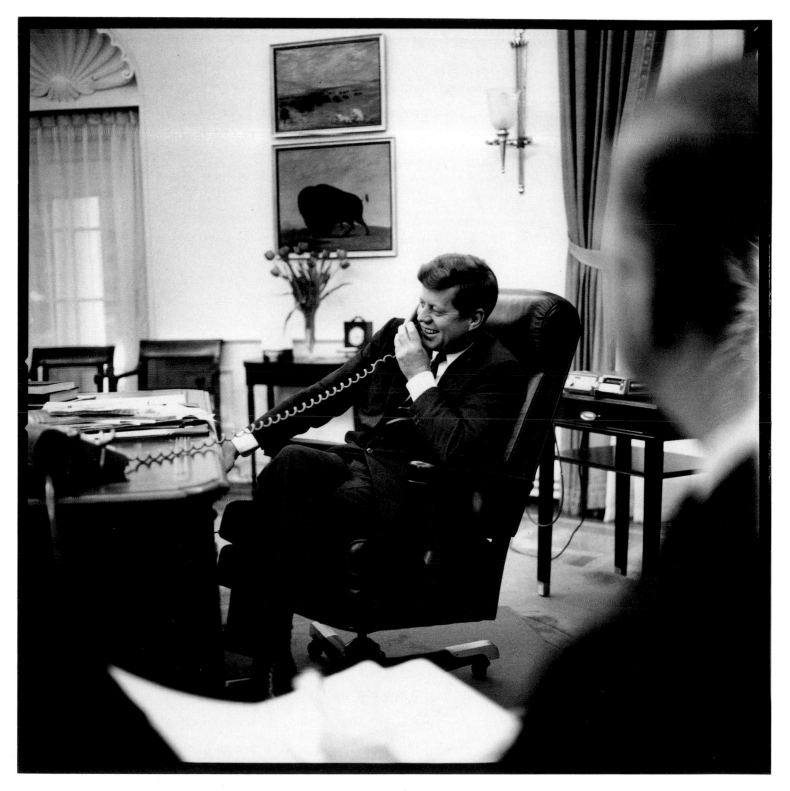

THE OVAL OFFICE. MARCH 1961

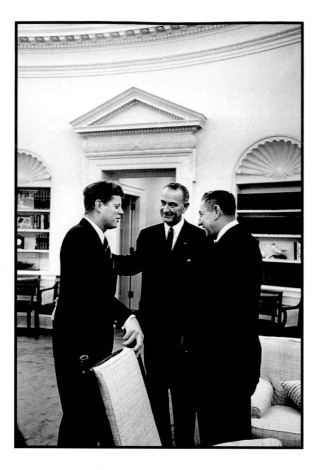

THE OVAL OFFICE. MARCH 1961

▲

JFK's relationship with Lyndon Johnson was a good one and remained so until the end. They weren't warm friends, but they respected each other. Johnson, though, was out of his element. No longer the powerful majority leader, he often resented his diminished role, and at times became quite paranoid about it. He harbored suspicions of a lack of respect toward him concerning some members of Kennedy's team, and he often felt awkward among some of the smart young men whose style represented Camelot. Here, in the Oval Office, he's made an appointment to introduce a friend, a Texas judge, to the President.

▶

Bobby Kennedy, Lyndon Johnson, and Secretary of Commerce Luther Hodges at a meeting in the Oval Office with the President during the Steel Crisis.

In July of '60, a month before the Convention... I went by and had breakfast with him in New York. This was the first time I met him. We discussed civil rights that morning, mainly, and I discussed with him my views. I was very frank about what I felt and the fact that I felt that there was a need for strong executive leadership and that we hadn't gotten this during the Eisenhower administration. If we didn't get it in the new administration we would still be set back even more. Now, at that time I was impressed with his concern and I was impressed with his willingness to learn more about civil rights. He did not have the grasp and the comprehension of the depths and dimensions of the problem at the time as later he had. Because I talked with him a few months later, after he had been nominated. In that short period he had really learned a great deal about civil rights and had been advised rather well.

He agreed that there was a need for strong executive leadership and that this had not existed and that he felt, if he received the nomination and was elected, he could give this kind of leadership. He assured me also that he felt the whole question of assuring the right to vote was a key and basic question and that this would be one of the immediate things that he would look into. I thought, at the time, that he had a long intellectual commitment but that he didn't quite have the emotional commitment. He didn't know many Negroes personally.... He hadn't had any experience as one who had been right out active... in the civil rights struggle. He knew that segregation was morally wrong, and he had certainly intellectually committed himself to integration, but I could see that he didn't have the emotional involvement....

I do feel that, as any man, he grew a great deal. I think we saw two Kennedys: a Kennedy the first two years and another Kennedy emerging in 1963 with a great concern about and a great understanding of the moral issues involved in this thing. I think Birmingham did it... Birmingham created such a crisis in race relations that it was an issue which could no longer be ignored. And I'm sure that, as the President faced this and faced the issues involved and the terrible brutality and inhumanity of a [Eugene] "Bull" Connor and all that went along with him, he [Kennedy] came to see in a way that he had probably never seen — and in a way that many other people finally did... that segregation was morally wrong and it did something to the souls of both the segregator and the segregated.

Martin Luther King, Jr.

154

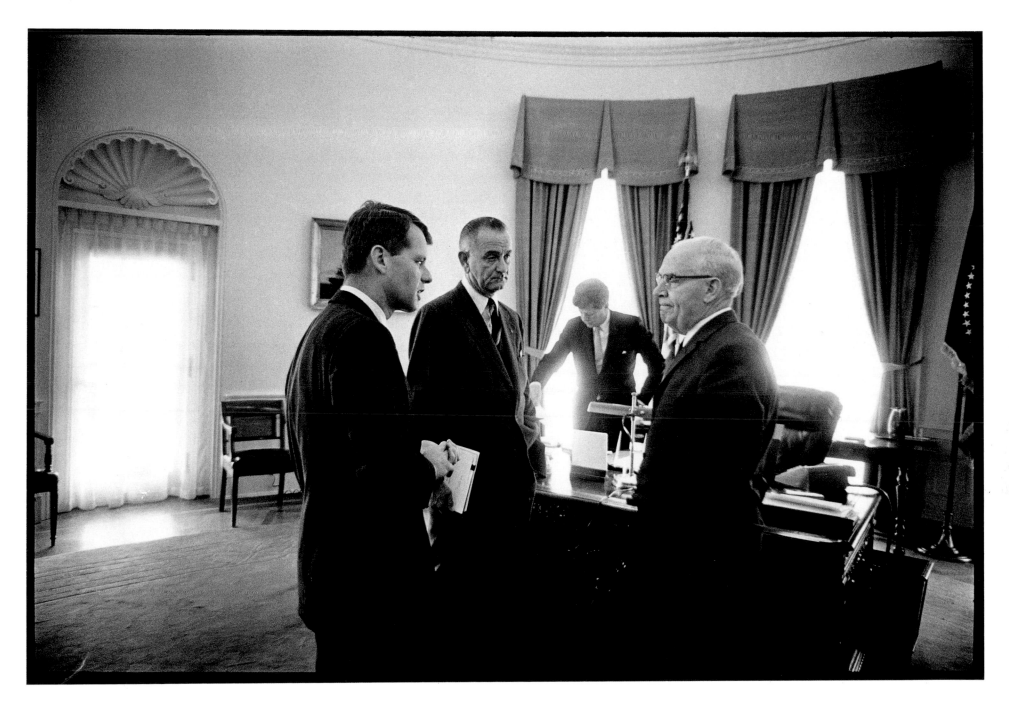

THE OVAL OFFICE. MARCH 1961

I speak of peace because of the new face of war. Total war makes no sense.... It makes no sense in an age when a single nuclear weapon contains almost ten times the explosive force delivered by all of the Allied air forces in the Second World War. It makes no sense in an age when the deadly poisons produced by a nuclear exchange would be carried by wind and water and soil and seed to the far corners of the globe and to generations yet unborn....

I speak of peace as the necessary rational end of rational men. I realize that the pursuit of peace is not as dramatic as the pursuit of war. But we have no more urgent task.

Some say it is useless to speak of world peace, or world law, or world disarmament — and that it will be useless until the leaders of the Soviet Union adopt a more enlightened attitude. I hope they do. But I also believe that we must reexamine our own attitude — as individuals and as a nation — for our attitude is as essential as theirs....

Let us examine our attitude toward peace itself. Too many of us think it is impossible. Too many think it unreal. But that is a dangerous, defeatist belief. It leads to the conclusion that war is inevitable — that mankind is doomed — that we are gripped by forces we cannot control. We need not accept that view. Our problems are manmade — therefore, they can be solved by man....

World peace...does not require that each man love his neighbor — it requires only that they live together in mutual tolerance.... History teaches us that enmities between nations...do not last forever. However fixed our likes and dislikes may seem, the tide of time and events will often bring surprising changes between nations and neighbors....

Let us reexamine our attitude toward the Soviet Union. It is discouraging to think that their leaders may actually believe what the propagandists write....

On the first night I worked with the President alone in the office he suddenly looked up and asked me to do something. I don't remember the exact request, but I remember the occasion vividly. I went to the door to carry out his wish, stopped, and turned around. "How do I do this, Mr. President?" I asked. "Just stick your head out the door and whisper, Jacques," he said. The moment taught me a lot. It especially taught me that this President fully understood his awesome powers, and of course the moment also reflected his undiminished sense of humor. I stuck my head out. I didn't really whisper; I had no time to. Someone showed up in seconds.

THE OVAL OFFICE. MARCH 1961

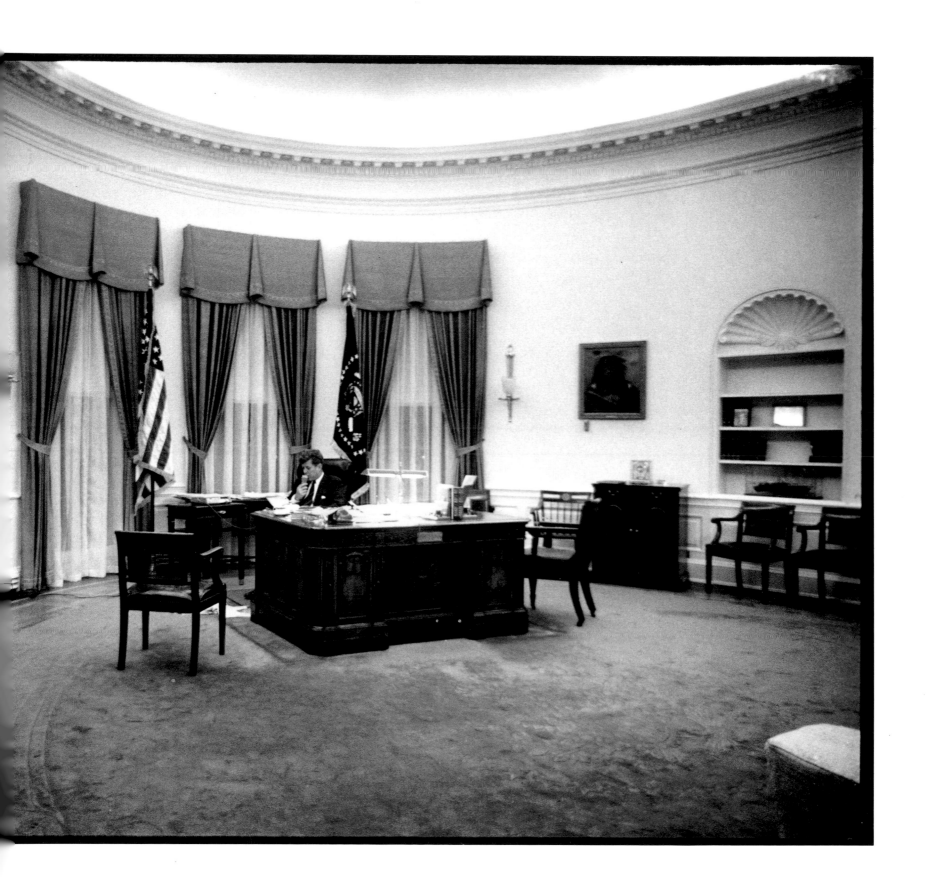

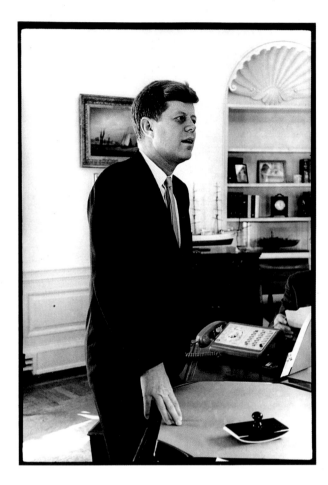

THE OVAL OFFICE. MARCH 1961

▲

The President in his office. Leaning again.

▶

On St. Patrick's Day a delegation of congressional merrymakers visited their "Irish" president. The reason for the Band-Aid is unknown.

But it is also a warning — a warning to the American people not to fall into the same trap as the Soviets, not to see only a distorted and desperate view of the other side, not to see conflict as inevitable, accommodation as impossible, and communication as nothing more than an exchange of threats....

It is an ironic but accurate fact that the two strongest powers are the two in the most danger of devastation. All we have built, all we have worked for, would be destroyed in the first twenty-four hours... for we are both devoting massive sums of money to weapons that could be better devoted to combating ignorance, poverty, and disease. We are both caught up in a vicious and dangerous cycle in which suspicion on one side breeds suspicion on the other, new weapons beget counter-weapons....

So let us not be blind to our differences — but let us also direct attention to our common interests and to the means by which those differences can be resolved. And if we cannot end now our differences, at least we can help make the world safe for diversity. For, in the final analysis, our most basic common link is that we all inhabit this small planet. We all breathe the same air. We all cherish our children's future. And we are all mortal....

Above all, while defending our own vital interests, nuclear powers must avert those confrontations which bring an adversary to a choice of either a humiliating retreat or a nuclear war....

At the same time we seek to keep peace inside the non-Communist world, where many nations, all of them our friends, are divided over issues which weaken Western Unity, which invite Communist intervention, or which threaten to erupt into war. Our efforts in West New Guinea, in the Congo, in the Middle East, and the Indian subcontinent, have been persistent and patient despite criticism from both sides....

The Communist drive to impose their political and economic system on others is the primary cause of world tension today. For there can be no doubt that if all nations could refrain from interfering in the self-determination of others, the peace would be much more assured....

Our primary long-range interest in Geneva is general and complete disarmament — designed to take place by stages, permitting parallel political developments to build the new institutions of peace which would take the place of arms....

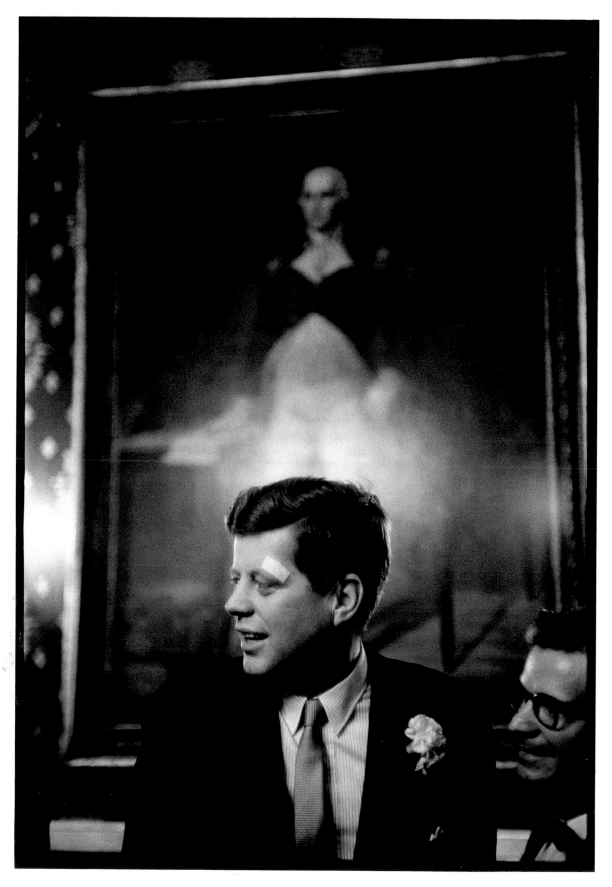

THE OVAL OFFICE. MARCH, 1961

To make clear our good faith and solemn convictions on the matter, I now declare that the United States does not propose to conduct nuclear tests in the atmosphere so long as other states do not do so… such a declaration is no substitute for a formal, binding treaty, but I hope it will help us achieve one. Nor would such a treaty be a substitute for disarmament, but I hope it will help us achieve it.

Finally, my fellow Americans, let us examine our attitude toward peace and freedom here at home. The quality and spirit of our own society must justify and support our efforts abroad… we must all, in our daily lives, live up to the age-old faith that peace and freedom walk together. In too many of our cities today, the peace is not secure because freedom is incomplete….

It is the responsibility of the executive branch at all levels of government… to provide and protect that freedom for all our citizens by all means within their authority. It is the responsibility of the legislative branch at all levels, wherever that authority is not now adequate, to make it adequate. And it is the responsibility of all citizens in all sections of this country to respect the rights of all others and to respect the law of the land.

"When a man's ways please the Lord," the Scriptures tell us, "he maketh even his enemies to be at peace with him." And is not peace, in the last analysis, basically a matter of human rights — the right to live our lives without fear of devastation?…

The United States, as the world knows, will never start a war…. This generation of Americans has already had enough — more than enough — of war and hate and oppression…. We shall do our part to build a world of peace where the weak are safe and the strong are just…. Confident and unafraid, we labor on — not toward a strategy of annihilation but toward a strategy of peace.

John F. Kennedy, commencement address at American University, June 10, 1963

The President was facing a Senator here who was asking for too much. When you got that look it was time to leave.

THE OVAL OFFICE. MARCH 1961

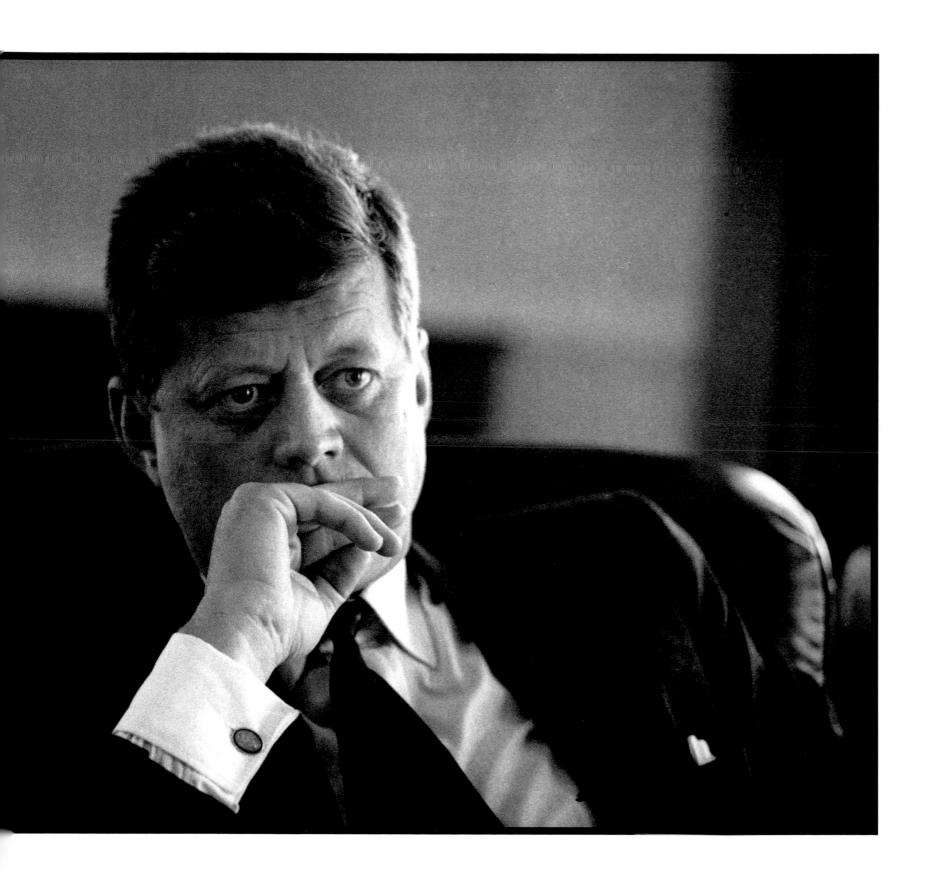

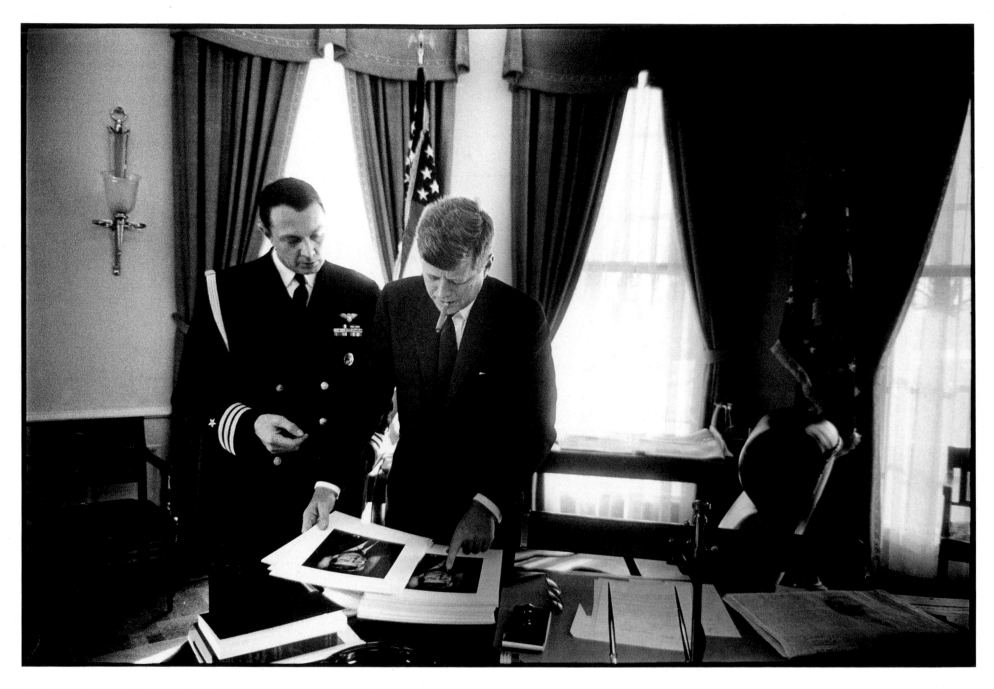

THE OVAL OFFICE. MARCH 1961

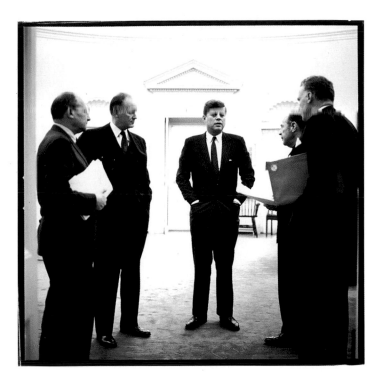

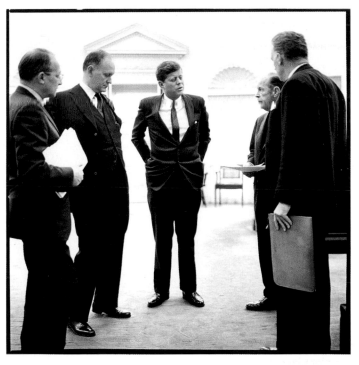

At a meeting with Under-Secretary of State George Ball, Treasury Secretary Douglas Dillon, Walt Rostow, and others in the Oval Office, the President displays his impatience. While the others hardly moved, the President's hands and arms were in constant motion.

◄

The President with his naval aide Captain Tazewell Shepard.

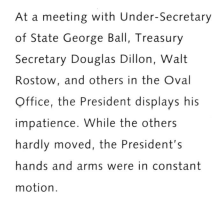

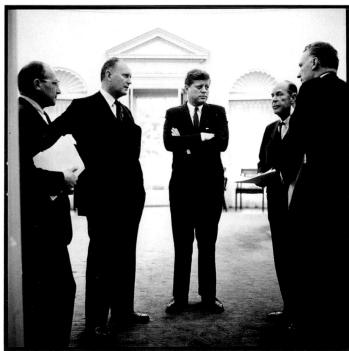

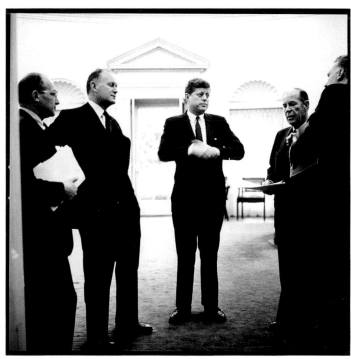

THE OVAL OFFICE. MARCH 1961

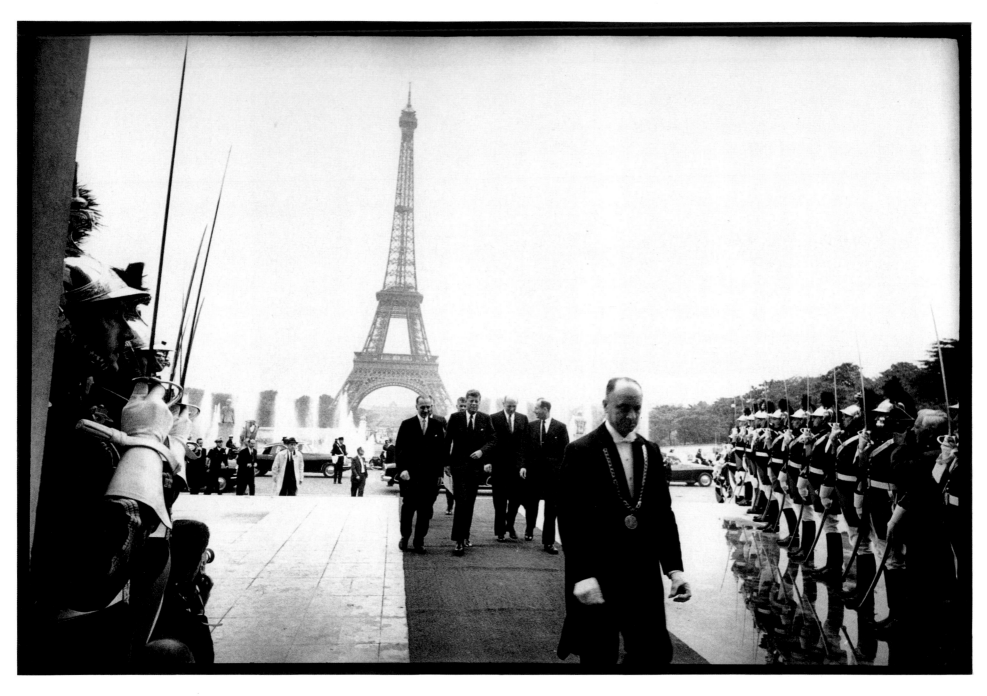

PARIS. JUNE 1961

In the late spring of 1961 the President decided to take his first trip abroad. He was to meet Nikita Khrushchev in Vienna; General de Gaulle, whom he greatly admired, in Paris; and Prime Minister Macmillan, another statesman whom he respected enormously, in London. He asked me to come along because he was also to be the godfather of the new baby of Lee Radziwill, Jackie Kennedy's sister. Jackie wanted no press coverage of the event, but the President did want it recorded.

I joined a distinguished group of government leaders, staff, and journalists on the special plane to Paris. Kennedy was to address a meeting of NATO ministers and confer with General de Gaulle. There were to be several public events as well as two great parties to be held in typically grand French style. From the beginning it became clear that, although De Gaulle reluctantly would allow a few select photographers at the public functions, he was firmly opposed to anyone photographing the private parties, especially the reception for President and Mrs. Kennedy at the Elysée Palace, the hottest ticket in town. Kennedy, of course, wanted full coverage. I am not certain who was involved in that tug of war, but finally three photographers were invited, two Americans and one Frenchman. It was to be white tie. Since neither I nor Paul Schutzer of *Life*, the other American photographer, had brought tails, but did carry tuxedos, we protested loudly. Eventually the dress code was changed to black tie. But the night before the reception, a Friday, it was changed back to white tie, obviously a maneuver by the French Press Office to prevent our coverage. But thanks to the great tradition of European hotels and especially the concierge of the Crillon Hotel, where we stayed, tails were produced and altered on that Saturday.

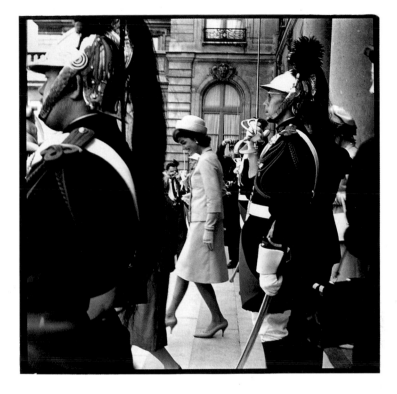

PARIS. JUNE 1961

▲

Jackie Kennedy descending the stairs of the Elysée Palace, the home and office of the French president, flanked by an honor guard.

◄

The trip to Paris in early June of 1961 was a very joyous occasion for the President. Kennedy addressed NATO, the members of the American embassy, and SHAPE, and he conferred with Charles de Gaulle several times. There were a great many official occasions. But the most glorious part was the reception the people of Paris, normally cynical, gave the President of the United States and his first lady. Jackie became the toast of the town, both Kennedys were wildly popular, and over a million Frenchmen lined the streets to catch a glimpse of and welcome the glamorous couple. Here President Kennedy enters the Palais de Chaillot for his NATO address.

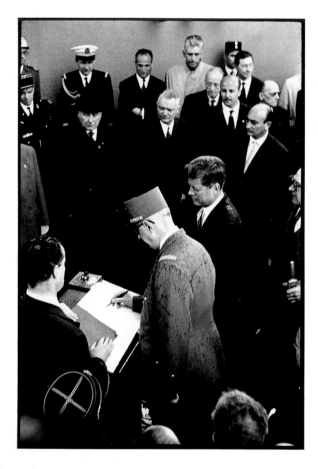

PARIS. JUNE 1961

On the day of his arrival, President Kennedy, accompanied by President Charles de Gaulle, the members of his cabinet, and other high officials, went to the Arc de Triomphe to lay a wreath and symbolically light the eternal flame in honor of France's war dead. Both presidents signed the official register.

When we arrived at the Elysée the two of us were relegated to a roped-off section at the far end of the ballroom, far from the very social crowd, and watched over by five gendarmes dressed in eighteenth-century, extremely colorful uniforms. It would be impossible to get any photographs from this corner, and neither Paul nor I could accept that. As the party livened up, some of the guests got closer to our temporary prison corner. One group included General James Gavin and Connie Ryan, author of *The Longest Day*, and a friend. Gavin had recently been appointed U.S. ambassador to France. I knew him well from the campaign and I had recently spent a week with him at the embassy. He waved me over and I jumped the red velvet ropes, leaving behind the furious guards who, of course, were not permitted beyond the ropes either. When President Kennedy — aware of the rules — spotted me he leaned over with a twinkle in his eye and whispered in my ear, "If they cut your balls off, Jacques, for mixing with the better classes, do not expect the President of the United States to come to your aid." Compared with that evening, the rest of the Paris stay was rather tame.

Vienna was even more restricted. Kennedy and Khrushchev were surrounded by a shield of security. The gala event at Schloss Schönbrunn was rather formal. The only diversion occurred when Art Buchwald, the humorous columnist, insisted to the Russian guards that a bug had been planted high up on the walls of the Russian embassy, finally succeeding, to everyone's amusement, in convincing them when three Soviet security men in bulky suits showed up with gigantic ladders looking for the supposed bugs. There was also some amusement when, later in the evening, a German photographer

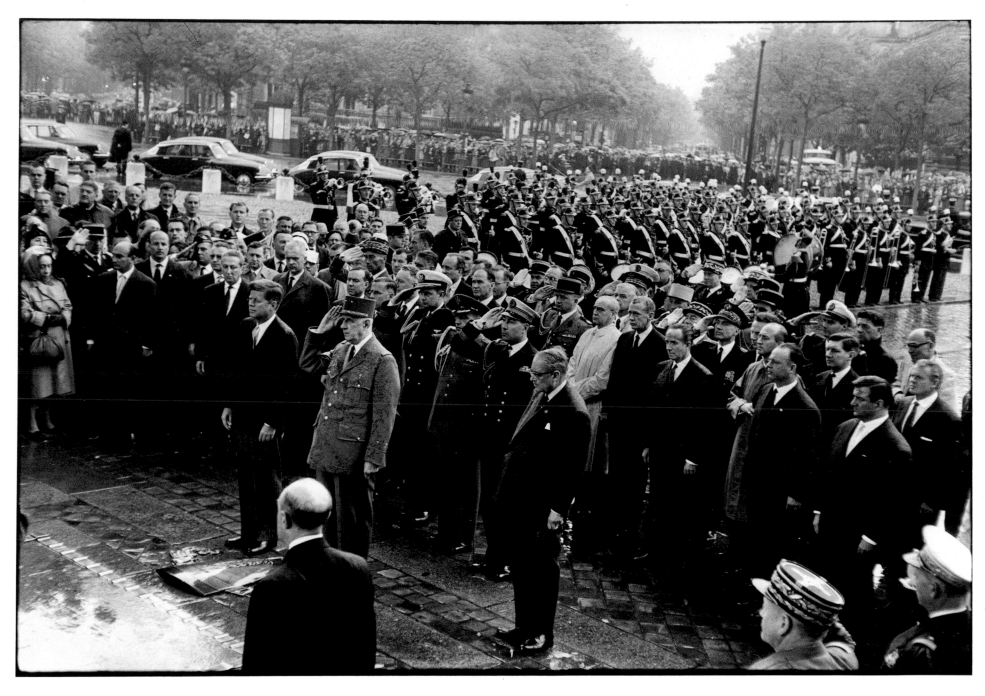

PARIS. JUNE 1961

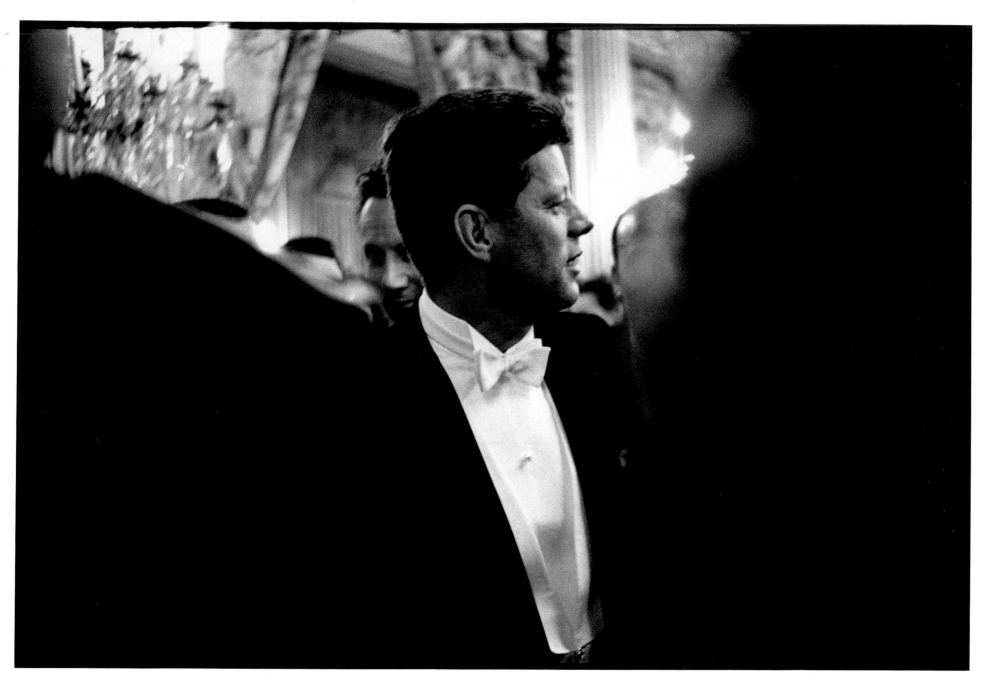

PARIS. JUNE 1961

who had been denied credentials marched in step with the orchestra to the pit, dressed in tails and carrying a violin case full of cameras. The Russians caught him.

The London visit was private. Kennedy met Macmillan only unofficially, although the meeting lasted four hours. But some two thousand reporters were on hand nevertheless. The christening was to take place in the crypt of London's Westminster Cathedral. Since I was the only photographer/ journalist admitted to the baptism and the later private party at Lee's house at 4 Buckingham Place, and since no one was to know about this, I had been handed over to officers from Scotland Yard, some of whom actually wore bowler hats, to get me to both places. As we clambered over roofs and through backyards to get to our destination, we startled many a resident who thought we were burglars. It was an experience I hadn't had before, nor particularly liked. It seemed high-handed and arrogant on the part of the Yard detectives not to inform these people ahead of time.

The party at Lee's was a sheer delight. The cream of London society showed up in that small mews house. Prime Minister Macmillan was in high spirits. And I got to meet some early icons such as Douglas Fairbanks, Jr. But the President was somber. He was still chafing from his meetings in Vienna, constantly reading the papers, which were not complimentary regarding the confrontation. Kennedy had left Khrushchev with the words "It's going to be a cold winter." That turned out to be a prophecy.

PARIS. JUNE 1961

▲

At an afternoon reception at the Elysée Palace, President Kennedy confers with France's foreign minister Couve de Mourville. A page proffers Cuban cigars.

◀

President Kennedy in white tie and tails at the reception in his honor at the Elysée Palace.

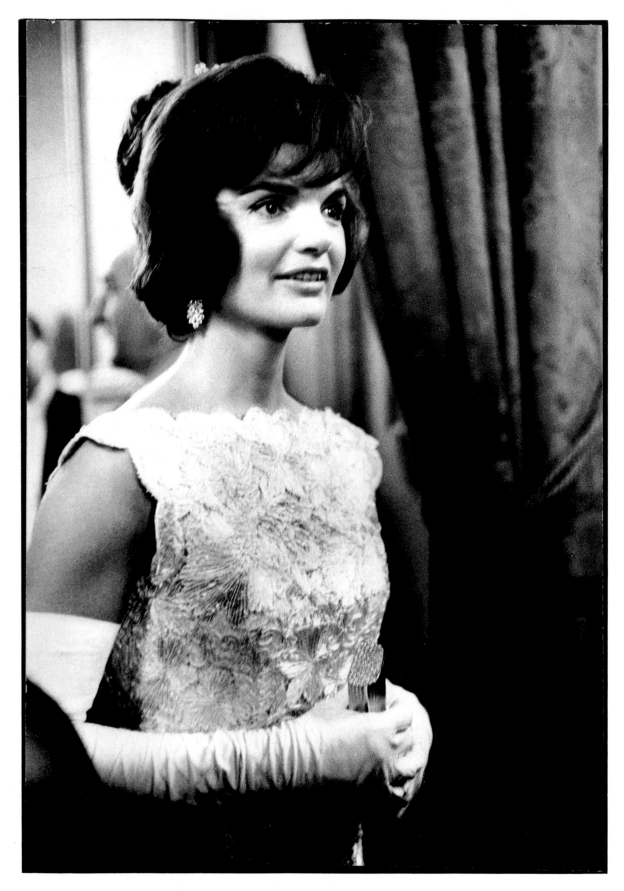

PARIS. JUNE 1961

It is naturally a great honor for any president of the United States to come to Paris. In this city in 1783, Benjamin Franklin signed the treaty which made us sovereign, independent, and equal…it is an interesting fact in history that John Adams, who was also a minister to France, and a successor to General Washington, should want, as his epitaph, to be written, "He kept the peace with France." … In this century, on two occasions, young men from my country have come to contribute to the maintenance of [France's] independence…. As an American I take pleasure in seeing people around the world salute the American Revolution and the principle for which we fought. As Frenchmen, I know you take satisfaction that people around the world invoke your great motto of "Liberty, Equality, and Fraternity."

President Kennedy, toasting President Charles de Gaulle at the
formal Elysée dinner

France congratulates herself on your visit…. For the United States — unique among the great powers — has never from its birth to this day found itself in conflict with France…if we value so highly the presence in Paris of a president of the United States, it is also because that president is yourself. Let me tell you how greatly Frenchmen have admired your intelligence and courage since you first grasped…the helm of the American ship of state. Already we have discerned in you the philosophy of the true statesman, who chooses his goal, who holds his course, who is neither halted nor diverted by vicissitudes, and who looks to no easy formula or expedient to lighten the responsibility which is his burden and his honor….

President de Gaulle in his reply

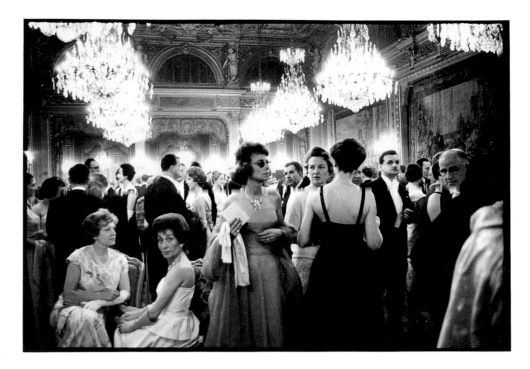

PARIS. JUNE 1961

▲
The reception at the Elysée was the occasion of the year. Members of Paris' high society fought bitterly to receive an invitation. Those lucky enough to be asked showed up in the most dazzling gowns, the most elaborate hairdos, and sporting jewelry that glittered as brightly as the massive crystal chandeliers. Many of the men wore their decorations and sashes of honor. By comparison, Jackie, wearing a pair of diamond earrings and no necklace, looked modest for the occasion. It was a night to remember.

◄
Jackie Kennedy, looking stunning in a silk dress, at the reception.

I'll always remember the late President with deep respect because, in the final analysis, he showed himself to be sober-minded and determined to avoid war. He didn't let himself become frightened, nor did he become reckless. He didn't overestimate America's might, and he left himself a way out of the crisis. He showed real wisdom and statesmanship.

Nikita Khrushchev

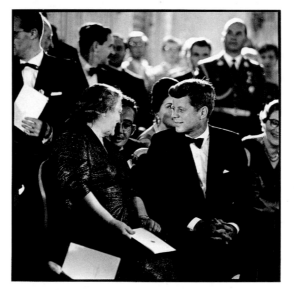

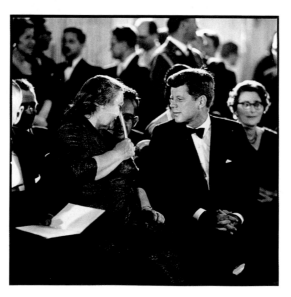

VIENNA. JUNE 1961

Vienna, the next stop on the President's agenda, where he was to meet Premier Khrushchev of the Soviet Union for the first time, was a frustrating experience for him. The Russian premier did not take this young president seriously. He underestimated him completely. He threatened and bullied. Kennedy had been warned by De Gaulle that Khrushchev would threaten to seize West Berlin, but that he was a bluffer, and Kennedy, though shaken by the vehemence of Khrushchev's threats, stayed calm. When asking Khrushchev what medal he was wearing and learning it was the Lenin Peace Medal, he said, "I hope you get to keep it."

On the evening of the reception, given by the Austrian chancellor at the historic Schloss Schönbrunn, the mood was lighter. Khrushchev, sitting next to Jackie, could hardly contain his admiration for her. But the President, having been seated next to the Premier's wife, had a more difficult time. She hardly spoke all night and when she did, she whispered remarks to her interpreter, who squatted behind her. Kennedy looked slightly lost.

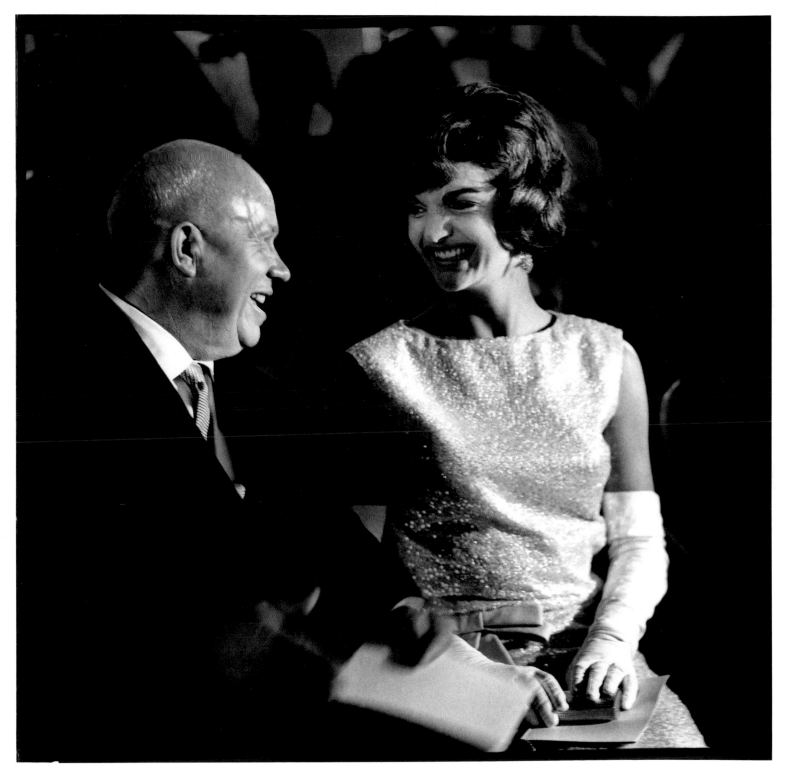

VIENNA. JUNE 1961

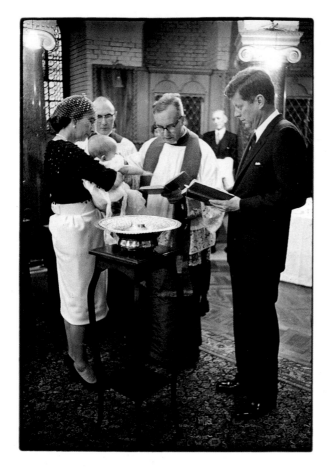

LONDON. JUNE 1961

London, our next stop, was billed as a private visit. Although the President was to confer with Harold Macmillan to report on his meetings with Khrushchev, visit the American embassy, and even have dinner with the Queen, his purpose on this visit was to become the godfather of his sister-in-law Lee Radziwill's new baby, Anna Christine. The christening was to take place in the early afternoon at London's Catholic Westminster Cathedral, followed by a private reception at Lee's house.

Although the visit was completely closed to the press, some two thousand newsmen had come to London anyway, clamoring for a press conference and a photo opportunity. The ceremony took place in an underground vault at the immense church. There was to be no hint of my presence at the ceremony, as far as Jackie was concerned. But the press knew anyway, and we all were aware of that. So I pleaded with Jackie to let me release at least one frame as a pool picture, but she refused. This was to be a strictly private event. And the President, though sympathetic to my problem, stayed out of this one. My colleagues were convinced I had made a private deal and therefore it was I who denied them a picture. But I hadn't made a deal. I'd had the offers, but I'd turned them down because it wouldn't have been ethical. It was a difficult moment.

There are many people in the world who really don't understand, or say they don't, what is the great issue between the free world and the Communist world. Let them come to Berlin. There are some who say that Communism is the wave of the future. Let them come to Berlin. And there are some who say in Europe and elsewhere we can work with the Communists. Let them come to Berlin. And there are even a few who say that it is true that Communism is an evil system, but it permits us to make economic progress. "Lass sie nach Berlin kommen." Let them come to Berlin.

Freedom has many difficulties and democracy is not perfect, but we have never had to put a wall up to keep our people in, to prevent them from leaving us....

I know of no town, no city, that has been besieged for eighteen years that still lives with the vitality and the force, and the hope and the determination, of the city of West Berlin. While the wall is the most obvious and vivid demonstration of the failures of the Communist system, for all the world to see, we take no satisfaction in it, for it is...an offense not only against history but an offense against humanity, separating families, dividing husbands and wives and brothers and sisters, and dividing a people who wish to be joined together.

What is true of this city is true of Germany. Real, lasting peace in Europe can never be assured as long as one German out of four is denied the elementary right of free men, and that is to make a free choice.

Freedom is indivisible, and when one man is enslaved, all are not free....

All free men, wherever they may live, are citizens of Berlin, and therefore, as a free man, I take pride in the words "Ich bin ein Berliner."

John F. Kennedy, Rudolf Wilde Platz, June 26, 1963

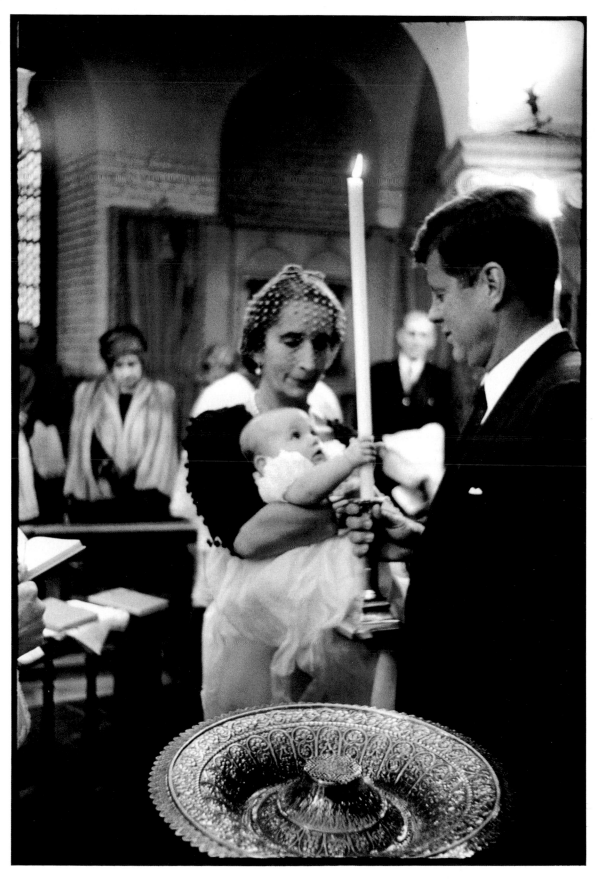

LONDON. JUNE 1961

I was with him the first day he walked, on March 1, 1955, and I saw the deep wound in his back — that metal plate they had taken out — and I said that must hurt like hell, and I'll never forget his reply — he said, "I don't have to worry about pain, I don't have time to be here on my back. I'm going to be back in the Senate in a few months. There's only a short time for me to do everything that has to be done and I intend to do what has to be done or die trying." I always wondered why he would say that in '55. He had a premonition?

…But he had no fear of death. He thought that when he survived PT-109 and the back operation, where he received the last rites of the Church, that he was indestructible. We talked about assassination. If someone wants to kill a president — I must have gone to mass with him in different Catholic churches a hundred times and I always thought that the nut that would want to kill him would do it in a Catholic church. But he said a high-powered rifle in a tall building, except it would be downtown, with the confetti, and the crowds would be so great and the noise, so no one could point, as they did in Dallas, and say, it came from up there.

David F. Powers

4 BUCKINGHAM PLACE, LONDON. JUNE 1961

The reception following the christening, at Prince and Princess Radziwill's house, was a lively affair. Prime Minister Harold Macmillan was in great form, and I met a few icons, such as Douglas Fairbanks, Jr., and Randolph Churchill. Others at the party were the Duke and Duchess of Devonshire, Hugh and Lady Antonia Fraser, and Elizabeth Cavendish, the cream of British society. Top: The Kennedys and Mr. and Mrs. Radziwill waiting for the guests to arrive. Bottom: Harold Macmillan, Angier Biddle Duke, and an unidentified guest. Right: Kennedy, in the garden, is reflected in the window.

4 BUCKINGHAM PLACE, LONDON. JUNE 1961

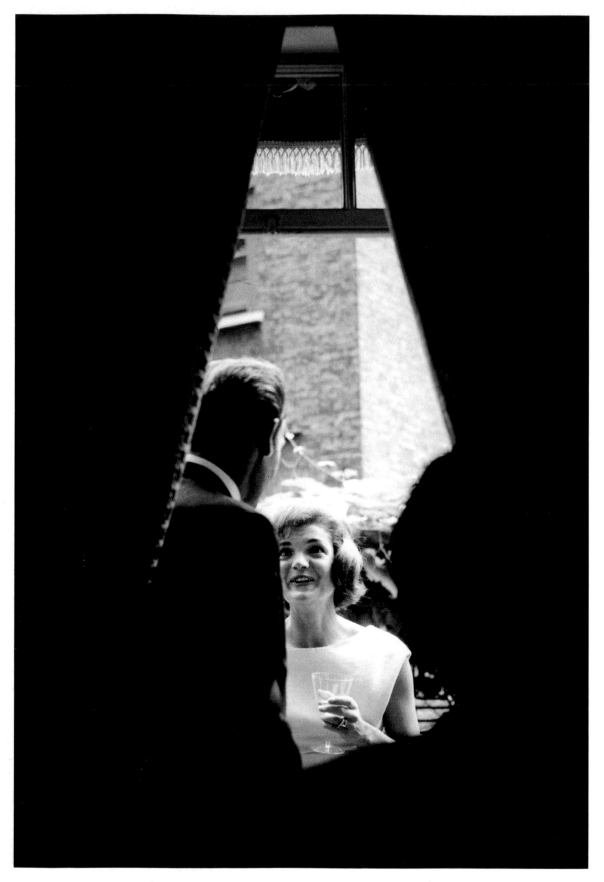

4 BUCKINGHAM PLACE, LONDON. JUNE 1961

The greatest leader of our time has been struck down by the foulest deed of our time. Today John Fitzgerald Kennedy lives on in the immortal words and works that he left behind. He lives on in the mind and memories of mankind. He lives on in the hearts of his countrymen.

No words are sad enough to express our sense of loss. No words are strong enough to express our determination to continue the forward thrust of America that he began.

The dream of conquering the vastness of space, the dream of partnership across the Atlantic, and across the Pacific as well, the dream of a Peace Corps in less-developed nations, the dream of education for all our children, the dream of jobs for all who seek them and need them, the dream of care for our elderly, the dream of an all-out attack on mental illness, and above all, the dream of equal rights for all Americans, whatever their race or color — these and other American dreams have been vitalized by his drive and by his dedication.

And now the ideas and ideals which he so nobly represented must and will be translated into effective action.

Lyndon B. Johnson

The loss to the United States and to the world is incalculable. Those who come after Mr. Kennedy must strive the more to achieve the ideals of world peace and human happiness and dignity to which his presidency was dedicated.

Winston Churchill

President Kennedy died like a soldier, under fire, for his duty and in the service of his country.

Charles de Gaulle

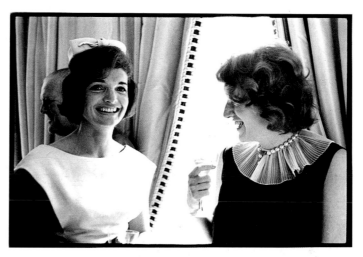

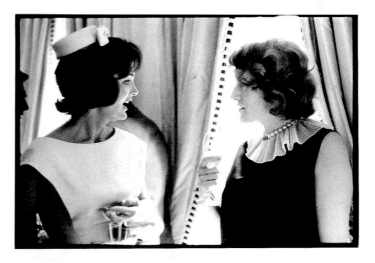

4 BUCKINGHAM PLACE, LONDON. JUNE 1961

Jackie, wearing one of her famous pillbox hats, chats with Lady Cavendish.

To anyone who lived during the Kennedy era, "Camelot" continues to evoke images of a refreshing, young, optimistic, and promising administration, and of...unfulfilled promise.

... For me personally, having been born in Ireland, his Irish roots have a nostalgic aspect.... As a second-generation immigrant, and a member of a religious group which had previously not attained the highest political office in America, his assumption of the presidency was a firm example of the characteristics and values common to our two nations. Both countries are true melting pots, which look...favorably upon immigrants and their offspring, and in both, stereotypes (ethnic, religious, sexual) are rapidly overtaken in favor of merit.

It is values such as these which have served...to cement our relationship, and Kennedy's actions...in Congress and in the White House, played no small role in this. Whether it was the bills effecting Jewish immigration, the substantial increase in foreign aid to Israel, or his attempts at peacemaking in the Middle East, JFK's attitude toward Israel and the Jewish people displayed throughout the same blend of idealism, humanism, and realism which have become his trademark.

The Kennedy Memorial near Jerusalem, representing a sturdy tree trunk with much potential for growth, which was cut off in its prime, serves as a fitting reminder of all that he may have become.

Chaim Herzog, President of Israel, from a letter to the author

At 4 Buckingham Place, the President was restless. Here, reading in Lee's foyer, he scanned the papers for reports on his meetings with Khrushchev. This was, after all, his first public exposure abroad, and he was wide open to judgment by the world's press. And few commentators were complimentary, most describing the meetings as a defeat for the President. But all wasn't lost. Khrushchev, instead of starting his war over Berlin and signing a separate peace treaty with East Germany, sent him a conciliatory letter, and two gifts — the model of an American whaler and Pushkina, offspring of the famous Sputnik dog that traveled in outer space. But he did build the wall, which Kennedy considered the lesser of two evils. Finally, the Cuban Missile Crisis changed the world's opinion. And the Cold War began to melt noticeably.

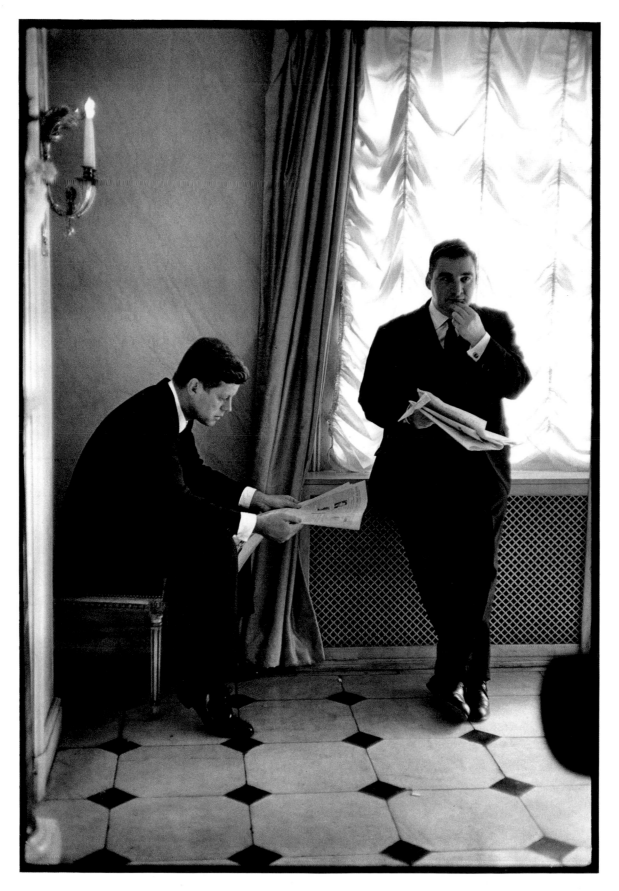

4 BUCKINGHAM PLACE, LONDON. JUNE 1961

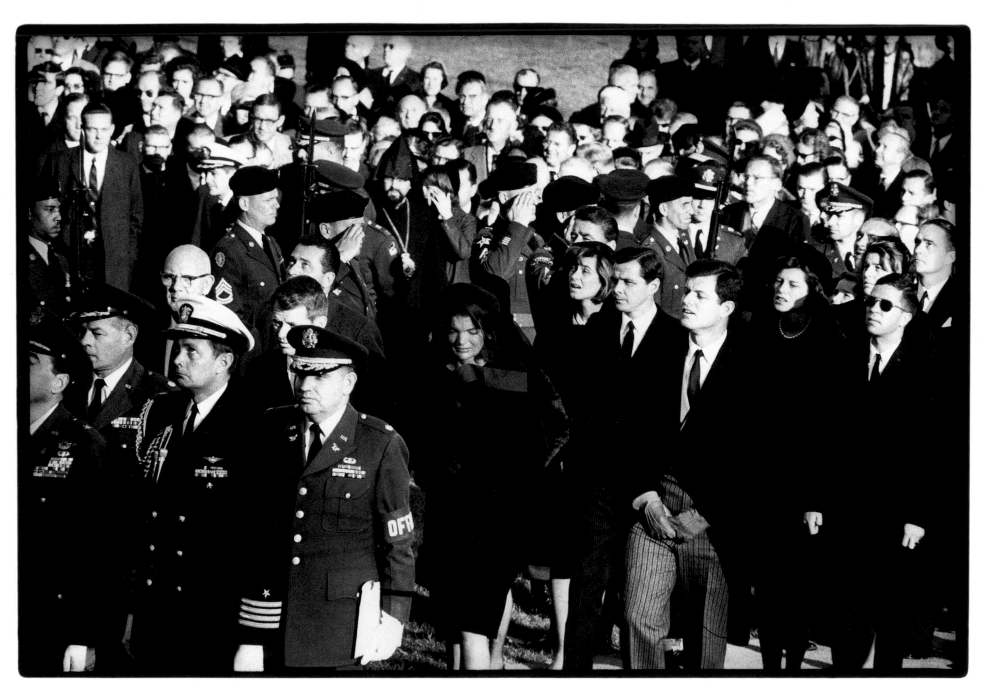

THE KENNEDY FAMILY AT THE FUNERAL PROCESSION

On the day of November 22, 1963, I was in New York. I had been in touch with the President, but I hadn't been back to Washington in a year. By 1962 I had photographed the secretaries of State, Defense, Labor, and the Treasury, as well as the leading staff members, hundreds of times. I had photographed the President in every conceivable situation, public and private, and I had covered dozens of foreign statesmen. My work had been featured on hundreds of magazine covers and on television, including the first prime-time television show nearly entirely composed of still pictures: NBC's *JFK Report #1*. I felt that I had fulfilled my assignment. I was also getting bored with Washington, D.C. Where New York offered a vitality and diversity in every field, especially the arts, Washington was a one-company, in fact a one-conversation, town, the only topic being politics. I realized that I had to get back to my business and my art, the greater world of photography. I longed to get back to New York.

That morning I had been assigned to do a Volkswagen ad for one of New York's leading advertising agencies. It was one of those silly ads photographers do in exchange for a great deal of money. I had photographed a woman sitting in a Volkswagen in Central Park, with a Great Dane reclining on the backseat. That afternoon I was to photograph a band of black musicians from the film *The Pawnbroker*. I had taken on the job with the provision that all photographs, including those of the film's star, Rod Steiger, would be taken in my studio against a plain white background, rather than on the movie locations. At the end of the morning's shoot I had sent my assistant back to my studio with the equipment. I had an hour to spare and was walking back to my studio, on Twenty-eighth Street, browsing through a bookstore and perhaps a gallery or two on the way. I sensed that something was wrong, yet I couldn't identify it. I suddenly realized that traffic had come to a near standstill and people were crowded around cars parked at the curb. I walked over to one group, asking what was the matter. "The President has been shot," a man said. "What president?" I asked uncomprehendingly. "President Kennedy!" he said.

I can still feel the chill running down my back. I started running. Along the way storekeepers standing in doorways shouted out bulletins to me, somehow sensing I was involved. "He's alive!" "He's going to be OK!" I ran up the two flights of stairs to my studio. There the musicians and my secretary were pacing the floor, tears streaming down their faces. I knew

ARLINGTON NATIONAL CEMETERY IN WASHINGTON, D.C.

it was all over. Five years later, when Bobby was assassinated, I could bear it no longer. I left the country and stayed abroad for eighteen years. I've been back nearly seven years. The pain is gone, but the feeling of what might have been has never left me.

Since that fateful day I've traveled the world and I've found that people everywhere, from simple peasants in India to confirmed Communists in the former Soviet Union, South America to Japan, remember where they were at the time of the Kennedy assassination. Some Americans remember although they were only three years old at the time. They remember, they tell me, because it was the first time they saw their mother cry. And they remember because it was the only time they were allowed to watch television around the clock. I saw an Indian poster showing Mahatma Gandhi standing on a cloud with his arms outstretched, looking down on Nehru and Kennedy. And in Poland the pictures grouped behind the burning candle in the corner shrine of a peasant's house showed the local saint, the pope, and Kennedy. Somehow the world has never forgotten these three short years called Camelot.

Epilogue

I've often asked myself, Why me? Why was I chosen? After all, I was a twenty-six-year-old, very naive, fairly inexperienced photographer when I met JFK for the first time. I think he liked the way I worked, quietly, like a fly on the wall. And he liked what he saw. I didn't miss the nuances.

But why did he ask me to stay on, instead of relying on White House staff? I believe he wanted to make sure not only that the images would correctly and powerfully reflect his legacy, but also that they would be widely seen, and not be buried in a government bureaucracy. I've come to understand that over the years. Recently I took my Kennedy exhibit to Paris and then to Moscow, where hundreds of sobbing Russians placed flowers beside the photographs. The exhibit soon will go to Switzerland, London, and Japan, and then travel around the world. Vietnam has asked for it. I think he knew. This was a president keenly aware of history and his place in it. I know I'm fulfilling what he wanted me to do.

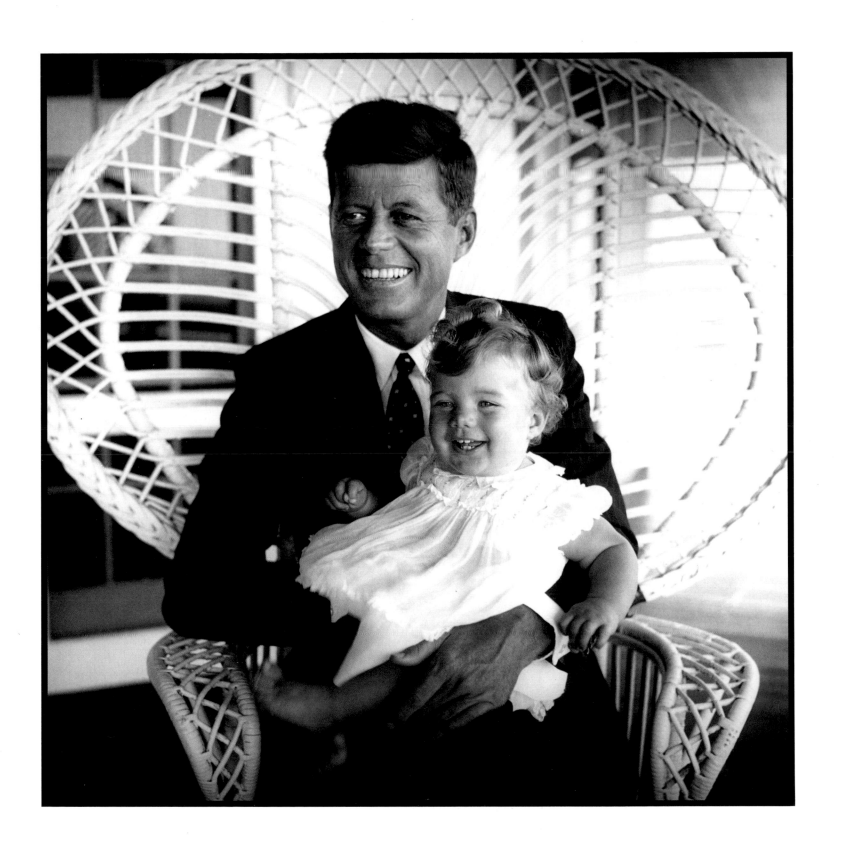

A Source of Inspiration

To think of John F. Kennedy, I recall a period of great expectation and awareness — not just in my life, but in the lives of many people in the three Americas. In the early sixties, many of us were struggling to free ourselves from the weighty dogma of bigotry, jingoism, and intolerance. We perceived that change was in the air and we searched for ways to contribute to the cause. I was studying at Boston University at the time, convinced that my future lay in the field of medicine. It was then that I began to hear the call of the great leaders around me: Dr. Martin Luther King, Jr., and John F. Kennedy.

I can still hear the voice of Dr. King beckoning Americans to enjoy diversity, to tolerate and respect each other, and to remove racial, religious, and other social blinders. The words of Kennedy were equally as powerful. As the youngest [sic] president in U.S. history, he called Americans to enjoy democracy through participation in public affairs and national issues. He understood that citizens could share democratic values as well as dreams for peace and prosperity. Inspired by this vision, I shifted my vocation from medicine to law, economics, and politics.

John F. Kennedy has continued to be a source of strength and inspiration. During his candidacy and his short yet productive presidency, he was not to be deterred by his religion, his age, or his health. Guided by his strong Christian morals, he governed with frankness and determination. He told the people what they needed to know, not what they wanted to hear.

His policy toward the small nations of the world was equally admirable. He perceived that the real instruments of democracy were neither propaganda nor rhetoric but development and higher living standards. The Alliance for Progress encompassed this view. It sought to bolster the labor force of less developed countries and to eradicate malnutrition and extreme poverty from every corner of the Americas. The Peace Corps, expanding on this policy, provided developing rural communities with greatly needed skills and labor, while it gave Americans a unique perspective on the struggle against poverty and ignorance in the Third World.

Renowned for his commitment to justice and humanitarianism, John Kennedy was acclaimed and welcomed in my own country. He was by far the most celebrated foreign president ever to visit Costa Rica. We were eager to show him that we too cherished freedom and democracy as well as the leaders who embodied these ideas.

In her recent inaugural poem, Maya Angelou... proclaimed that:

"History, despite its wrenching pain, cannot be unlived [but] if faced with courage [it] need not be lived again."

During my life, I have tried to emulate the way in which President Kennedy approached obstacles and decisions: with wisdom, honor, and above all, courage.

Oscar Arias, former President of Costa Rica and winner of the Nobel Peace Prize, from a letter to the author, February 1993

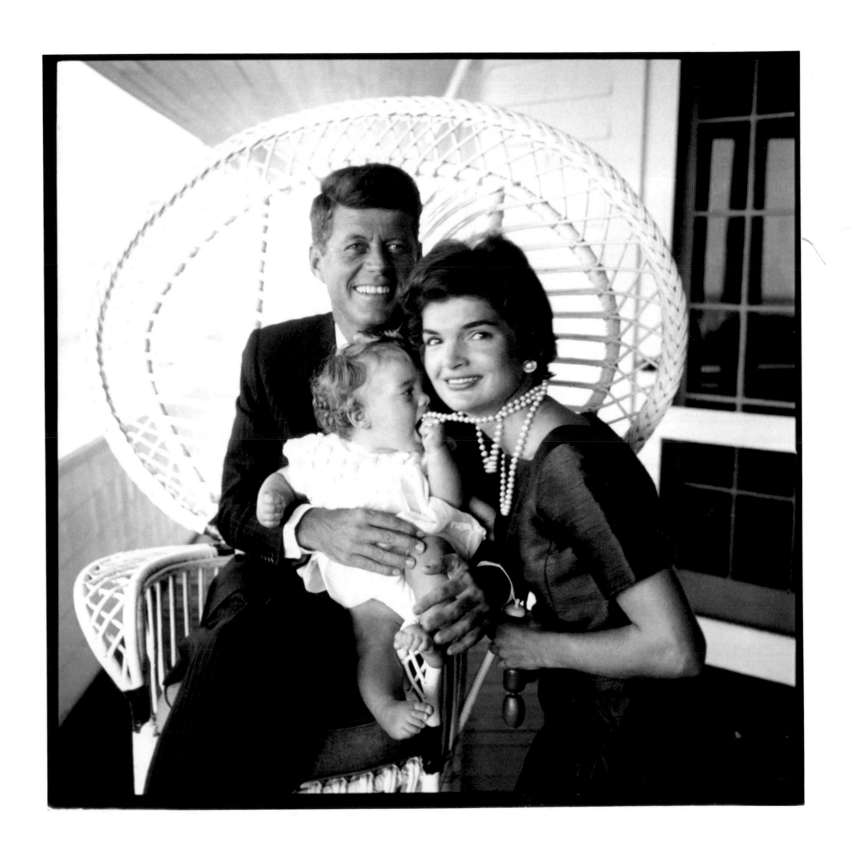

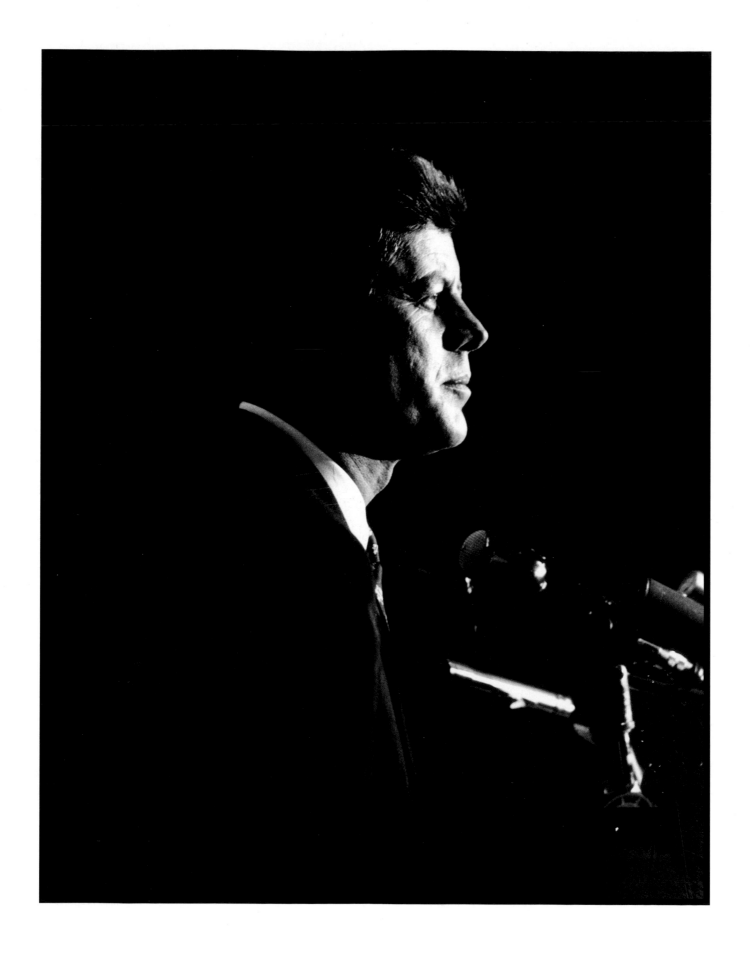

The great legacy left to us by John F. Kennedy is a matter not so much of the apparently endless search for the historical truths that repose in his presidency and his quest for it, or even less of the huge mythologizing of his life and personality. His gift was to energize and make legitimate the aspirations of ordinary Americans for a role in their own political and economic destinies. The New Frontier really was new. He stood for things — he taught the young and the old what it meant to be a Democrat — and, after the meanness of the witch-hunting years, he taught all of us what it meant to be an American patriot. There is, as well, a sense of tragic loss, a wound in our public life and private hearts that will not heal, a man taken before his work was done, a great gift never fully ours. But his photograph hangs on the walls of homes everywhere — somewhere near FDR's photograph and probably in homes that are more poor than fortunate. That is because people knew that John F. Kennedy gave them all he had — a richness of courage, toughness, intelligence, understanding, and humor in the White House that we have not seen since.

Mario Cuomo, Governor of the state of New York, from a letter to the author, December 1992

One way or another, he was going to win you over.

He was going to charm you.

You never had a chance.

He would do it with his logic. Or with his wit. Or with his smile.

You could be charmed by pictures of him at the tiller of a boat or strolling barefoot on the beach.

Wearing tails or with his shirttail hanging out.

Now, gone these far too many years, he continues to captivate us by the indelibility of the memory of him.

Who, sitting in the place of power that suited him so well, has since endowed that space with such a sense of style, of unerring civility, of being so offhandedly regal?

Other kings have followed, to be sure. We had our own Richard III, and we had yet another George.

But in JFK, we had better than a king. We had a prince. And with a prince there is always promise. The promise of a future that would reflect John Kennedy's keen awareness of the past; the promise of an America that mirrored his own ambitions for Her sense, fairness, and purpose; the promise of great and better times to come.

One blink or two in a gun sight, and all that turned out to be too good to be true.

All that we are left with is an image of a smile that will not fade and of all that princely promise never to be fulfilled.

What a mixed blessing it is to see him in snippets of film we've come to know by heart.

To still thrill to his bringing down the house, before they brought down the wall, in Berlin.

To still empathize with a father denied the joy of lifting his own children in his arms.

To still somehow hope that the motorcade will make it safely to the underpass, its occupants whole and unhurt.

From a time so long ago, and from a place far beyond far, he wins our hearts still.

We are his forever. We are eternally charmed.

Larry Gelbart, playwright, from a letter to the author, January 1993

Author's Notes

I wish to thank Arthur Schlesinger, Jr., for allowing me to use his generous words of introduction to this volume, originally written for the catalogue of my Kennedy exhibit that currently travels the world.

I also wish to thank the staff of the John Fitzgerald Kennedy Library in Boston, especially Allan Goodrich, chief archivist, for letting me research and make use of the Oral History Project and for helping to trace some quotes by and about JFK.

It has been said about Henry David Thoreau that he never met a publisher whom he did not loathe. Walter Weintz, associate publisher of Random House and my supervising editor on this book, thoroughly disproves Thoreau's assertion. He is an absolute delight to work with. The rest of his staff—Jon Karp, Kathy Rosenbloom and a very picky Beth Pearson, who drove me to distraction with endless fact-checking questions—also have my respect and thanks for encouraging me to "write" a book that I only wanted to "photograph," and agreeing to let production quality reign over cost considerations, requests not normally granted to an author. I am grateful to them all.

I want to thank Joseph Guglietti, whom I worked closely with in designing this book, for spending all those long nights and extra week-ends to make changes, some caused by the fickleness of my own creative decisions. There was never a moment of tension.

Finally I want to thank Alan Kellock, my agent, for his ongoing effort on behalf of my many ideas, and for being able to sort out the brilliant from the half-baked proposals with his short, no-nonsense comments.

I consider myself fortunate to have been a witness to these years, at an age that allowed me to be perfectly innocent about it all, enabling me to simply observe and record, without the restrictions of awe and moment that would have inhibited my coverage at a more mature age. Through this book I express my gratitude. A gratitude not only to President Kennedy, and Bobby, who introduced me to the circle and encouraged me, but also to the entire Kennedy family—especially Steve Smith, who guided me, Ethel Kennedy, and, in the early days, Jacqueline Kennedy—and to all those who allowed me into their midst, their homes and their official functions, demurring rarely—Ted Sorenson, Pierre Salinger, Arthur Schlesinger, Jr., Kenny O'Donnell, Larry O'Brien, Jerome Wiesner, and so many others. It is thanks to all of them that this historical record of the Kennedy years is preserved for all time.

Designed by Joseph Guglietti

Set in Monotype Bembo and Syntax

Composed by the designer on the Apple Macintosh

Printed and bound by

Arnoldo Mondadori Editore, S.p.A., Verona, Italy